Game Dev Stories

Game Dev Stories

Interviews About Game Development and Culture

Volume 1

David L. Craddock

CRC Press
Taylor & Francis Group
Boca Raton London New York

CRC Press is an imprint of the
Taylor & Francis Group, an **informa** business

First Edition published 2022
by CRC Press
6000 Broken Sound Parkway NW, Suite 300, Boca Raton, FL 33487-2742

and by CRC Press
2 Park Square, Milton Park, Abingdon, Oxon, OX14 4RN

CRC Press is an imprint of Taylor & Francis Group, LLC

ISBN: 978-1-032-05906-8 (hbk)
ISBN: 978-1-032-05905-1 (pbk)
ISBN: 978-1-003-19978-6 (ebk)

Typeset in Garamond
by SPi Technologies India Pvt Ltd (Straive)

To Mom and Amie.

Table of Contents

Part II
Ad Hoc

Acknowledgments

Thank you to all of the developers and personalities who gave so generously of their time to talk to me for the multitude of projects I've written over the past several years: Dan Amrich, Scott Miller, David Brevik, Richard Aplin, Allen Anderson, Tom Hall, Matt Householder, Milton Guasti, Steve Rothlisberger, Alex St. John, Scott Coleman, Jay Cotton, Kyoko High, John Romero, Brian Fargo, John Hancock, "Infidelity," and Meagan Marie.

Thank you to Jason Chen and Simon Carless, the curators of Story Bundle's game development books, for another opportunity to share in the company of so many talented writers.

Last but never least, thank you to my mom and my wife, Amie, who deserve more praise for their love, support, and encouragement than I will ever be able to give them.

About the Author

David L. Craddock lives with his wife, Amie Kline-Craddock, in Canton, Ohio. He is the author of over two dozen nonfiction and fiction books, including the bestselling *Stay Awhile and Listen* series chronicling the history of Blizzard Entertainment, and *The Gairden Chronicles* series of epic fantasy novels. Follow David online at davidlcraddock.com, facebook.com/davidlcraddock, and @davidlcraddock on Twitter.

Introduction: Minding My Qs and As

Have you ever wished you could be a fly on the wall while your favorite game developers talk craft?

I did. I was. Now you can be, too.

Over the past 13 years—quickly approaching 14 as of this writing—I've been fortunate enough to ply words about how video games are made in exchange for a living. Fortunate, and busy. I've written hundreds of articles and nearly a dozen books, all assembled from countless hours of research and interviewing designers, programmers, artists, writers, user experience researchers, and other specialists in the wide world of games.

This book collects some of the Q-and-A sessions that informed many of those articles and books. Light edits were made to each interview for the sake of clarity. I enjoyed each of these conversations the first time around, and had even more fun assembling them for this book. I hope you enjoy them, too.

–David L. Craddock
14 September 2017

Part I

Old-School

1

The Rise and Fall of Cheat Codes

Video game trends come and go. Yesterday's popular genre, title, or game mechanic is today's relic. Of all the trends I've seen come and go in 30-plus years of playing and writing about games, cheat codes hold a special place in my heart.

Cheat codes meant different things depending on the game I was playing. When I was a kid, I was only allowed 30 minutes of "Nintendo" time on school nights. Some NES games offered a password system as a way of picking up where you left off. Fewer still used batteries to save progress. Most of the games I loved, such as *Teenage Mutant Ninja Turtles 2: The Arcade Game*, offered neither. Every weeknight felt like a slice of Groundhog Day: I'd pick my turtle, beat the first two-and-a-half levels, then get halfway through the sewer before Mom told me to turn off the system and put away my controller.

TMNT 2 benefitted from the vaunted Konami code. A dozen or so button taps later, and I beheld a cheat menu that let me choose the level where I wanted to start. I was amazed and grateful. Using a cheat, I could resume my progress, after a fashion.

In 2016, I pitched Waypoint (formerly VICE Gaming) an article about the history of cheat codes and devices. The site was interested, and the article did well, but even with a generous word limit there were all sorts of fascinating morsels I had to cut.

Here are those interviews in their entirety, divided into parts in order to better organize the perspectives of developers, editors, and cheat-device makers.

Part 1: Dan Amrich, Editor—*GamePro, Official Xbox Magazine* (OXM), and *Games Radar*

When I set out to write about the history of cheat codes, Dan Amrich topped my list of people to talk to. Before I go any further, I should apologize to Dan for ending that sentence with a preposition. Not only was Dan one of the leading voices in gaming magazines from Game Pro to OXM and *Games Radar*, he was one of the first editors with whom I worked (better, Dan?). When I entered the freelance scene in 2007, OXM was one of my first clients, and Dan one of my first contacts.

This was the first occasion I'd had to pick Dan's brain about his work. As expected, he was a font of fascinating tidbits, among which was the revelation that he helped to disseminate one of my favorite cheats: The DULLARD menu in *Mortal Kombat* for Sega Genesis.

**

Craddock:	What was your earliest experience with cheat codes? Discovering one, trying one, etc.
Dan Amrich:	I grew up in the era of Atari and arcades, so cheat codes were not as prevalent. I was fascinated with Easter eggs in games—the secret dot from Atari's *Adventure* was the first significant one I remember. They were basically urban legends at that point, and I would trade stories with friends at school, then we'd spend an afternoon trying to see if we could find this hidden stuff. It wasn't until the 16-bit era that I started hearing about cheat codes, and to be honest, I was not really a fan of them. I was very into the idea of playing the game "with honor" and facing the challenge that had been designed for me. If the game was too hard, I didn't want to get 30 free lives—I wanted to get better. So I liked the idea of hidden stuff, but I didn't like the idea of cheating to win.
	I have always been into puzzles and hidden treasure stories, so while I didn't get into using the cheat codes myself, I did enjoy hearing about them and trying to test them. My college social circle was small when it came to games and none of us could really afford enough games to test out a bunch of stuff. I wound up helping find and test them when I joined the media.
Craddock:	At *GamePro*, one of your primary duties was answering letters from readers. You mentioned to me that you have many memories of fans asking for cheats. During your tenure, what codes/secrets were especially in-demand?
Dan Amrich:	Whatever the last game was that came out. That's what bugged me, actually— a game people had anticipated for a year would finally ship, and the next day we'd get an email asking for cheat codes for that game. I had issues with that approach: "I can't wait to play this game so I can not play the game." This attitude exists today in the form of people who watch YouTube playthroughs but never actually play the games. For some people, knowing what the game contains was more important than the experience of playing the game itself. The information of knowing more than your friends is more valuable to them.
Craddock:	What were some of your favorite rumors or theories around codes and secrets during your time at *GamePro*? And was *GamePro* behind any of them?
Dan Amrich:	Now we're at the intersection of cheat codes and cruelty. For the April issue, both *GamePro* and EGM [Electronic Gaming Monthly] used to do jokes. *GamePros* were clearly labeled under a section called LamePro; it was basically a four-page section of terrible puns and jokes that weren't as funny as any of the writers had hoped—but hey, it was openly called LamePro, so it was often lame. EGM took a different approach; they would just put in a fake news story about, say, *Sonic and Tails* being unlockable in *Super Smash Bros Melee*, or unlocking different versions of *James Bond in Goldeneye*. Their most famous one was that there was a secret unlockable character named Sheng Long in

Street Fighter II, but the phrase "Sheng Long" was really just a translation error from Japanese to English.

The very real problem about EGM's joke stories is that people would write in and ask *GamePro* to confirm them—so we'd have to be the wet blanket and tell these poor kids that they would never be able to play the game they now dreamed about playing. I felt that was the responsible thing to do. I just hated the idea of someone saying, "I can't trust this magazine, they lie to me," so I went out of my way to let the kids know we were being honest with them at every turn.

At *GamePro*, a lot of kids would read a code in one magazine and then immediately copy it down and send it to another magazine, hoping to get the prize or fame. We'd usually get 30 or 40 letters with the same code around the same time. We did test the cheat codes before printing them in *GamePro* or OXM—I was in charge of the small cheats section at OXM when I worked there.

> The Konami code (up, up, down, down, left, right, left right, B, A, Start) is one of the industry's most famous cheat codes, and virtually essential to stand a chance of beating tough games like Contra.

Craddock: Given that *GamePro* consisted of many types of content, how important were codes and secrets to the magazine's success?

Dan Amrich: Early on, very. Cheat codes were the currency of cool—a way to show your friends that you knew more secrets than they did, that you were more into gaming than they were. In the same way that fans buy t-shirts or cosplay [to support] their favorite nerdy culture things, gamers who knew all the cheats were considered hardcore. That knowledge was power, and everybody wanted to play with power.

Being a magazine that had The Latest Information and was one option of many, cheats were as important as the newest reviews or previews—to some readers, more important, because it was tangible and something they could use to prove themselves. The fact that Tips & Tricks was one of the longest-running video game magazines in the industry was not a coincidence; the lure of forbidden knowledge was strong.

Craddock: How did editors go about finding cheat codes? Did publishers/developers supply codes and secrets to the magazine? Did the staff have to hunt and peck for them themselves?

Dan Amrich: A mix of all of the above. We'd often get them directly from the publishers or developers, but some were sent in from readers who were more diligent in scouring Usenet for snippets of info. By the time I got to *Official Xbox Magazine* in the late '00s, I had to scour the Internet for them myself and ask publishers if they had any to share.

Craddock: Did editors have to work out with publishers which codes and secrets they could share, and when?

Dan Amrich: Sometimes if we were doing a feature or a big review, we might get some codes as part of that arrangement, but usually the codes were supplied by our PR contacts three or four months after a game had gone on sale. It was clearly a way to renew interest in a title that might have fallen off the radar, so they were really used as promotional tools by some publishers. They were valuable—the audience wanted them, we wanted them—so I never saw harm in that. It was also assumed that, by that time, gamers who were really interested in that game would have finished it legitimately, so there was no reason not to let them loose with a cheat code.

Craddock: I remember reading that Nintendo kept its secrets, codes, and walkthroughs for *Nintendo Power*, then published in-house. Did *GamePro* have access to Nintendo's first- or third-party games, or did that happen over time? And if access was restricted, how did that affect the magazine's ability to publish codes, strategies, and other material in a timely manner?

Dan Amrich: When it was time to review a game, Nintendo would send a console with an EPROM locked into it and a person from the Treehouse [Nintendo of America's product development division] to accompany it. You had to review the game while they were in the room; they'd take it with them back to their hotel room that night and bring it back to the office the following day. So doing in-depth strategy guides was generally done after the fact with Nintendo games. Stuff like RPG walkthroughs would take so long to create that the delay almost didn't matter.

Craddock: Have you ever discovered a cheat code? How did you do it, and were you looking for a code, or just messing around?

Dan Amrich: I was the guy who sent the big DULLARD cheat code in to *GamePro*, Fresh out of college, I preordered *Mortal Kombat* for the Genesis in 1993—it was supposed to come out September 13 on "Mortal Monday." Stores broke street date and I was able to pick it up on Friday the 10th instead. That same day,

my friend Carl said "Hey, there's this code that someone posted on Usenet, but nobody really knows what it does—did you get your copy yet? Can you test it?" The code was not the ABACABB blood code, but a different one—Down, Up, Left, Left, A, Right, Down. DULLARD opened a developer debug menu that let you not only toggle the blood on and off, but several other dev-test things, like making Reptile appear. The problem was, they were all designated with nondescript FLAG tags—eight of them, if I remember. The only way to determine what they did was to go through, methodically, and test them. So I did that basically all weekend and came up with the definitive guide for what seven of the eight flags did. So on the day the game was supposed to come out, I had written up an exhaustive document explaining the DULLARD code and I asked my dad to fax it to *GamePro* magazine—I really wanted the free t-shirt they promised for sending in a code! A few days later I got a phone call from one of their editors, Lawrence—"scary Larry"—asking me how I got the code and if I was using this on a retail copy of the game. They had the EPROM for review, but they hadn't gotten final retail versions yet. I assured them that it was legit and told them how I'd figured out all the flags.

He said "I have to tell you, this is really well-written, too—we don't usually get cheat submissions that are this clear and complete." I said "Thanks, and you know, I'm a freelance writer, so I'm looking for work." Alas, it didn't turn into anything. They wound up running it as a full page in *GamePro* and as a two-page spread in their cheat code special issue, *S.W.A.T.Pro*.

Two years later I was writing for other outlets and I met Lawrence in person at E3, while waiting for a Sega demo. I introduced myself as the guy who sent in the DULLARD code, and I totally got the "Yeah, whatever, kid" brush-off from him! I remember swearing with my tiny fists that one day I would have that guy's job. I liked to tease Lawrence about that moment once we started working together (E3 is a blur and I came to understand how distracted he probably was), but eventually, when he moved on to work for Pokemon USA, I did assume his duties as Features Editor. So I literally did get that guy's job!

The sad part: I wrote several letters after they printed my code and begged them to send me that t-shirt, and when it finally arrived many months later…it was too small. When I worked there later, I remember finding a *GamePro* shirt in a storage area and loudly proclaiming "THIS IS MINE! YOU OWE ME THIS!"

Also, I'm a secret character in NBA Hangtime, but that's another story.

Craddock: The Konami code is arguably the most prolific code ever made. What do you feel accounts for its popularity?

Dan Amrich: Its ubiquity! Not only was it powerful and gave players a huge advantage, but it was consistently used across several games. If you knew the Konami code, you could cheat in just about any of their games, so that made it worth memorizing. As time went on, people who had used it and loved it decided to honor it by using it in their own games. It kind of belongs to everyone now.

Craddock: The code industry evolved in several stages: from POKE and PEEK commands in memory, to button presses like the Konami code, to utilities like Game

Genie and Game Shark, and PC programs like "Trainers." At what point, if any, do you feel cheat codes and their kin compromised game development, or playing games as a consumer?

Dan Amrich: I think they compromised the player's experience right away. As for compromising game development, that's a strong way to put it, but I do think it became an intentional thing that developers and publishers wanted to put in there to keep people talking about what may or may not be hidden in their game, and therefore give you a reason to pick it up. NBA Jam is a great example: People would hear about a combination of initials and birthdate that unlocked a secret player, so they'd go back to play again and put more quarters in to see if it was true, and try them for themselves. NBA Jam brought in a billion dollars—in quarters. I really think the secret characters were part of the reason it made so much. It was a great game, but it also had a ton of secrets that people were willing to pay to experience for themselves.

The Sega Genesis version of *Mortal Kombat* had two cheat codes to enable blood and the gory fatalities from the arcade version.

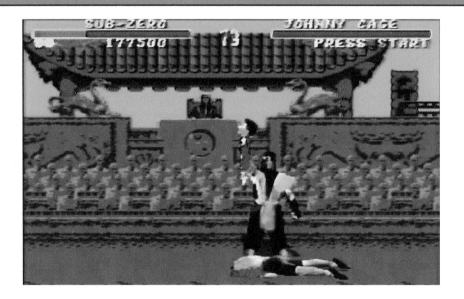

Craddock: Along the same line, cheat codes transitioned from overt cheats like god mode and extra cash, to more "just for fun" modifications like big-head mode. Were you aware of that shift? What do you think was responsible for it?

Dan Amrich: I don't rightly know. I like the cosmetic stuff more; big head doesn't give one player an unfair advantage. It's the same way DLC has evolved too: You can buy gun camos for *Call of Duty* weapons, but you can't buy more bullets or more accuracy. Fun or personalized stuff is cool with me, but I don't know when it made the shift.

Craddock: You mentioned being at OXM when cheat codes were "no longer a thing." Could you walk me through your transition from *GamePro*, to *Games Radar*,

and then to OXM, and discuss how and why cheat codes declined relative to their popularity during the 1980s and '90s?

Dan Amrich: Wow, big question. I was at *GamePro* from 1997 to 2003, and cheats were major attractions during those years. GamesRadar had a cheats editor, Joe McNeilly, whose whole job was to find, test, and document cheats with videos. It was not glamorous because he had so much information to sort through, some of which was bogus. But it was a big enough deal that Joe was hired for that position, with business cards and everything.

OXM, which for me was 2006–2009, was the last gasp of cheat codes. Achievements wound up taking their place. That was a publicly sharable metric of your gaming accomplishments, so cheat codes became less important to the audience as well as the developers. Cheat codes were no longer the currency of hardcore gamers once Achievements appeared. They were another creative outlet for the dev teams and they were required by Microsoft, so the effort that would go into cheats went into Achievements instead.

Craddock: How did the decline of codes affect OXM and/or *Games Radar*? Or had the magazine and web mediums pivoted to emphasize other content and coverage by that time?

Dan Amrich: Both of those publications didn't really hang their hat on cheats as much as features, listicles, and reviews. Cheats were the side dish. The last few cheat codes I ran in OXM were 1/3 pagers or less space—and sometimes I wouldn't run any if they were just not interesting or something I felt the audience would find fun.

Craddock: The ubiquity of the Internet can make any attempt to stash codes and secrets in a game feel futile: most if not all codes and secrets will be widely available within a day or so of a game's release. How can developers maintain an air of secrecy? Should they bother?

Dan Amrich: Well, the DULLARD code appeared on Usenet. I think the Internet has always been a vehicle for cheat codes. Where it really excels is being a storage facility for them, too. As soon as one person knows your cheat code, everyone will know it, because it gets posted to a public discussion. I still don't think that's a bad thing—it gives your game community something to discuss and a reason to bond and share information.

In addition to the clear promotional benefits, cheat codes always felt like a gift from the developers to the players—"we're not supposed to show you this, but we like you, so here's something special." At least, that's how I interpreted them. The developer became your older friend who hooked you up with insider info. I think it made some gamers feel closer to the people who created the games, because they got to see things and play the game in a way that was outside the realm of normal. Remember, you often had to seek out cheat codes—there was effort involved in finding them, testing them, and verifying them, even for the players. So a code that worked felt like a reward, and that reward came straight from the people who made the game.

Craddock: I wouldn't go so far as to say that today's games are less fun or mysterious for their lack of codes (relative to older games), but I do miss the aura of mystery

and possibility they added to gaming. What are your thoughts on the decline of codes? Do you miss them, or are they better left in the past?

Dan Amrich: I didn't miss them until doing this interview. I see them differently now; I understand the role they played in making that player/developer connection. ARGs [alternate reality games] now exist as a way to engage your fan base in something creative and secret; lots of games have used those to tell more interesting stories but still impart that sense of insider info. There are still other secrets too—collectible items in-game, alternate outfits, sometimes even narrative things like character audio logs or journals in *BioShock*. The air of mystery is still there; it just takes different forms.

I think bringing back cheat codes now would be pretty awesome. Gaming culture has properly elevated the past and respects retro gaming at a level I did not expect to see, so I would like to see them reappear from time to time. There could be no greater tribute than to make a thoroughly modern game with an old-school wink and smile.

Part 2: David Brevik and Scott Miller

During the heyday of cheat codes, editors like Dan Amrich were on one side of the desk. Developers such as David Brevik (co-founder of Blizzard North, co-creator of *Diablo*) and Scott Miller (founder of Apogee Software) were on the other. Brevik, Miller, and other developers were the ones up to their eyeballs in code, burning the proverbial midnight oil to write fun games. While they were translating design into code, they were also creating cheat codes—not to cheat, exactly, but to give them an edge while testing.

Brevik and Miller talked to me about how cheats were used and why they weren't removed from code before games shipped to retail.

<div align="center">**</div>

Craddock: Could you recount one of your experiences implementing a cheat code in a game you developed? What was the code, and why did you create it?

David Brevik: Originally I put cheat codes in to test products. It was much easier, when testing cartridge games without a keyboard, to put in a cheat code. You had to have them to debug and test. Eventually developers put even more sophisticated cheat mechanisms like [text] consoles that allowed commands to cheat.

Scott Miller: For me, it was back in 1985 with my first text adventure game, *Beyond the Titanic*. I added cheat codes to help me develop the game, with some of the codes jumping me from early parts of the game to later parts of the game. All of my games, and Apogee's games, had cheat codes, like my many *Kroz* games, *Supernova*, and so on. As for what these codes were, I've long forgotten them. In *Supernova*, I remember there was a road very early in the game, and if you walked along that road 20 steps, then typed in a special word, it'd take you to the final third of the game, and your inventory would be updated to include all the needed items to finish the game from that point.

Craddock:	This might seem trivial or overly technical, but what is the process of creating a cheat in a game's code? Do you just tell the program to look for a specific string of keystrokes or button presses? Is there a thought process behind creating codes? For instance, DNKROZ in *Duke 3D* is an obvious homage to Apogee's *Kroz* adventures.
Scott Miller:	Creating cheat codes is usually easy. More often than not, you're just taking advantage of functionality already built into the game for debugging purposes, or adding a simple command, like: *If GodMode=true Then Health=Full.* Most cheat codes are just taking advantage of code that's already in the game. Rarely do cheat codes require a lot of specific coding solely for the purpose of creating that cheat ability. As for naming the codes, we're usually trying to by funny, or give a nod to what the code does.
Craddock:	Cheat codes started because, in part, developers needed quick ways to test code: getting to a new level quickly rather than proceeding through them linearly, fighting a boss without dying, etc. Why leave those cheat codes in a game, rather than remove them before it ships to market?
David Brevik:	Honestly, sometimes people just forgot. The process was very different back then. You couldn't patch games. You sent the code off to get approved and it was rejected or approved by the console manufacturer, and that was it. During those last builds and back and forth, sometimes people just plain forgot to take codes out.
Scott Miller:	For the most part, the codes are left in the game because it's kind of a crap shot knowing when to remove them. You don't want to take them out during the final days of testing because you still might need them. And once you really think you have a final gold master of the game, you don't want to open up the code and remove the codes because that could break the game in some unexpected way. So, the safest play is to leave them in.
	With the release of the first *Wolfenstein 3-D* and the first *Duke Nukem*, we learned that when players discover the codes it doesn't hurt the game. This was a big revelation back then. We learned that players used the codes to explore the game, and extend the game's life, but for the most part they still played the game in the non-cheat mode to enjoy the game as it was meant to be played. So with all future games we made sure that they all had discoverable cheat codes, and even leaked a few to the press for them to include in their stories.
Craddock:	One report I read said that these codes stayed in commercial versions of games because they were too difficult for developers to remove. Was that true, in your experience?
David Brevik:	Never. I can't imagine a situation where that would be true unless the game was built on top of those cheat codes and they were essential to the game. In that case, are they really cheat codes? Often they were just a few lines of code that could be easily removed.
Craddock:	One of my fondest gaming memories was hearing rumors of a blood code in *Mortal Kombat* 1. There was a mystique around codes: when you heard about one, you scoured magazines and made friends with total strangers to learn

more about it. As a player or developer, what were your thoughts on the culture that stemmed from cheat codes and secrets in general?

Scott Miller: We quickly learned to add a few codes that would boost the experience. For example, in *Rise of the Triad* we add a Ludicrous Gibs code to make bad guys die in a really messy, over-the-top way. We also added Dog mode for fun. These might be the first ever examples of secret codes added to a game that were not cheat codes, but game enhancing modes. Mostly, they give the player super-hero abilities, like invincibility and running through walls, and this is a fun form of empowerment. And also, they're still sort of thought of as secret codes, and so players feel like they're beating the system when they use them.

David Brevik: Cheat codes were incredible. They still are. It is really fun to find hidden secrets in a game. It was important to add that to any product and it's still true today. It may not have to be a cheat, but having some sort of secrets, social references, jokes or hidden content remains as exciting today as it was back then.

Craddock: What do you feel is the psychology behind cheat codes? What makes them appealing to search out, find, and try?

David Brevik: I'm not really sure. I think when you love a game, it is really fun to know as much about it as possible. To have a fun game and then find a secret inside of the product is always like opening a small door into the developer's mind and finding more out about how the developers think and their process. It's also fun as a fan to get a small secret between you and the developer. It feels intimate. It feels like they care about the audience. Ultimately you are asking the impossible question of "What is fun?" and how do you define it. Not easy to do.

Craddock: Have you ever discovered a cheat code? How did you do it, and were you looking for a code, or just messing around?

Scott Miller: I've never discovered one on my own. But I don't remember ever trying. But there have been dozens of times I've looked up a code on the Net. I tend to only use them to get past a shelf moment in a game. If a game has a super hard section or boss, that's the time I'll cheat, but as soon as I'm past that really hard part I go back to normal mode. I've done this maybe a dozen times over the years and it's been a real life saver, because otherwise I would have never finished those games.

Craddock: Old-school magazines like *Nintendo Power* and *GamePro* devoted entire sections to codes and secrets. As a publisher/developer, did you dictate which codes a magazine could share, and when?

David Brevik: Absolutely. People would put codes in the game to get coverage and release them on purpose. They started out as something fun and secret and became a marketing tool eventually.

Scott Miller: Yes, we'd give codes to the magazines. We'd usually give the codes to the press when they got review copies, and the press could use the codes to play the game, test weapons, get past hard areas, and so on. But, we'd always have an understanding that they not print the codes in the same issue as they reviewed the game, but to wait one or two issues later to give the game another cycle in the press.

Craddock: Cheats evolved from POKE and PEEK commands, to button presses like the Konami code, to utilities like Game Genie and PC programs like trainers. Trainers were, in part, responsible for the rash of cheating that broke out in *Diablo's* Battle.net service. Do you think it's fair to say that "cheats" like trainers crossed a line and compromised game development?

David Brevik: No. It's our fault for coding the game the way we did. If you leave your data open to cheating, there will be cheats. The biggest difference between when cheats started and *Diablo* was the way that cheats could be accessed. Without the Internet, it was difficult to find and distribute cheats. After the Internet anyone could download them. Also, when people were making cartridges, it was difficult to hack or cheat. You needed a device which severely limited the audience. Eventually cheating became super easy and many people were doing it.

Scott Miller: I don't think codes are bad in any way at all. They've definitely helped me many times. Can some players ruin their game with them? That might happen a few times, but very quickly these players will likely stop abusing them. Mostly, codes are fun after you've finished a game for the first time, and the codes give you a reason to replay and explore the game using the codes.

Craddock: Codes are not as prevalent in contemporary games as they were during the 1980s, '90s, and even '00s. What factors do you believe are responsible for the decline of cheat codes, speaking from the perspective of a developer?

David Brevik: I think that there is a belief amongst developers that putting cheat codes will lead to cheating. With competition such a huge part of gaming today, any cheats are frowned upon. Gamers want all competitive games to be on equal footing. Cheat codes still exist today in development, but the only things that make it into final products are harmless or cosmetic, not true cheats.

Scott Miller: There's not nearly as many independent studios left making AAA games. I think that publishers see more of a downside to codes than an upside, especially with the prevalence of online competitive play, leaderboards, and tournaments.

Craddock: The ubiquity of the Internet can make any attempt to stash codes and secrets in a game feel futile. How can developers maintain an air of secrecy? Should they bother?

David Brevik: It is possible. I'm not sure many know what the chat gem in *Diablo II* does. It's fun to have that sort of thing in a product. Yes, for the most part, don't bother. Anything you put out there will be discovered quickly, but there are ways to put secrets in games and keep them going for a long time.

Scott Miller: I wouldn't bother [including codes], unless there's a very good reason like competitive play.

Craddock: What are your thoughts on the decline of codes? Do you miss them, or do they no longer have a place in modern games and development?

Scott Miller: I don't really think about them. We still put them in the games that I'm involved with. As for other studios, they all make their own choices, I guess.

David Brevik: Yes, I do miss them. But those innocent days of gaming are gone forever. Times have changed and there won't be any going back. Again, there are ways to put

in cheats or secrets and still have them remain a mystery for a long time. That's the best solution I can think of to keep the spirit going.

Part 3: Richard Aplin and Allen Anderson—Game Genie

As a kid, the Konami code made sense to me. I pressed a certain combination of buttons on my controller, and like punching in a code on a security pad, a secret door somewhere in the game code opened. Inside that door was a room containing a present wrapped in shiny paper, and within that shiny present were 30 lives.

Game Genie, on the other hand, mystified me. Moon walking? Unlimited lives? Wait—I can't die? What black magic is this?! Immunity to death was not a gift-wrapped box locked behind a secret door. Entering a Game Genie code felt more like strapping on a pair of safety goggles, hefting a sledgehammer, and knocking down walls never meant to be breached.

When I chanced upon interviews with Richard Aplin and Allen Anderson, both former Game Genie engineers, I relished the opportunity to step behind the device's curtain.

<center>**</center>

Craddock: How did you come to work on Game Genie?

Allen Anderson: Galoob Toys used a development firm named Microsystems Development based in San Jose, California, to create the Game Genie, and it was MSD that contracted me to finish the Game Genie for the SNES. I worked with MSD as an independent contractor. The project was originally started by another developer who ended up disappearing near the middle of the effort which I took over and finished. My friend who did the SEGA version of the Game Genie was the one who got me involved in the project.

Richard Aplin: I didn't work at Galoob. They were the toy company that manufactured and distributed Game Genie. It was invented (and all the technical stuff; development, cheat-finding, etc.) was done by Codemasters, a company in the UK. I worked for Codemasters in the '90s for a few years. When I arrived at Codies they'd just shipped the NES Game Genie and were working on other consoles; I did the reverse-engineering and hardware design for the Gameboy, Game Gear/Master System, and SNES—although on the SNES I designed the Game Genie 2, which had a lot more features although sadly was never released; there's some info on Wikipedia about it. I was recommended to Codemasters by a friend who worked there. I had built a home-made Sega Genesis development system (and had written a bunch of video games) in the years prior.

Craddock I wonder if you could give me an overview of how the Game Genie worked. Take moon walking in a *Super Mario Bros.* game, for instance: how does entering a combination of letters and numbers into the Game Genie interface tell the game to let the player do something he's not ordinarily able to do?

Allen Anderson: Almost all console games on the SNES were written in 65816 assembly language—same as the Apple IIgs. Because of this, memory was fixed in place and rarely moved even for scratch RAM [temporary memory used for high-speed

calculations]. Things such as lives and health were almost always stored in fixed locations. We used scopes on the electronics to figure out these memory locations while playing the cartridge. All the Game Genie did was constantly replace those values with the new values over and over. So, for instance, if a lives counter went from three to two, it would replace it with 99 every refresh. The cheat codes were a combination of memory location offset plus value. Extremely simple.

I'm not a hardware electronics guy so take what I say for what it's worth on this. The "Scope" was a device they had hooked to the Nintendo and the Game Genie test rig. I had a round screen with a wave sign going across it that would speed up or slow down based on whether it had what they wanted. They always told me they would "Scope the connection" until they found the memory location that was being changed when they would lose a life or something.

When I was writing for the SNES I used my own dev system (trying to remember the name of it, but I still actually have it in my basement) that connected to a "fake" SNES cartridge that plugged into the Game Genie test harness.

Richard Aplin: In those days carts contained ROM chips which stored the program code and graphics. The console obviously contained a CPU and chips to generate the video and sound, plus some RAM but, in those days, did not contain any program ROMs; a console without a cartridge just sat there with a blank screen because there was no program for it to run. Some, like the Gameboy and Genesis contained small boot ROMs that displayed a manufacturer logo on startup, but nothing of substance.

The ROM chips in the cartridge contained all the program code to run the game. The connector that connected the cart to the console consisted of a bunch of electrical connections, most of which were used for the address bus and the data bus, plus a few for power and other control signals. A bus is a group of connections, each of which can be at a high or low voltage, a 1 or a 0. Together they make up a binary number, so an 8-bit data bus is eight separate wires, and can represent a number from 00000000, or 0, to 11111111, or 255.

Most 8-bit bit machines had an 8-bit data bus and a 16-bit address bus, allowing for 64K of memory to be addressed. There were simple tricks to allow larger cartridges than 64K bytes, called bank switching. 16-bit consoles typically used a 16-bit data bus and a 24-bit address bus. The main reason to use a wider data bus is simply to transfer data faster: you're effectively sending two bytes at once.

When the CPU wants to read a specific location in memory it sets the address bus wires to indicate which location it wants to access, and sets one of the separate control wires—let's call it CS for "chip select"—to an active state. The ROM chip inside the cartridge looks at the address bus, internally retrieves the appropriate stored byte, and sets the data bus wires to the appropriate ones and zeros to return the value back to the CPU.

The CPU reads the data bus wires to get the value, and interprets it as either an instruction byte or a data byte. Let's say that you have a video game where

the main character has three lives. Somewhere buried in the ROM code for that game is going to be a sequence of instructions for when you start the game that store the number "3" somewhere in the RAM memory inside the console. Somewhere else in the ROM code there will be instructions for when you die that fetch that number and subtract one, then store it back to RAM again. There'll also be some instructions that check to see if that number has reached zero, and if so, game over.

The game itself was stored in ROM chips, which can't be changed. The Game Genie had a custom chip that was located in a cartridge that sat in between the console and the game cart being played. The address and data bus connections are connected to the Game Genie chip, as well as being passed through to the cart, and some of the wires go into the Game Genie chip and come out the other side. The Game Genie can basically intercept and modify [code].

When you first turn on the console, the Game Genie disables the ROM in the cart by not passing the chip select to the cart, and instead provides its own values, which comprise the Game Genie code-entering menu. The user enters one or more codes which, when unscrambled, comprise a specific address location in the game ROM and a replacement data value for that location. For example, the location in the game that normally contains "03" for number of lives might be replaced with "FF," or 255, meaning you get 255 lives.

When the user starts the game by exiting the Game Genie menu, the Game Genie switches back to the game ROM, and starts watching the address bus. When the CPU in the console requests the data for the specified address, the Game Genie chip momentarily disables the cartridge ROM and instead provides its own value on the data bus. Hence the CPU effectively sees a modified game program, and gives you 255 lives.

Other modifications to gameplay were done by altering different instructions or data values in the game: to let you jump higher, make you invincible, and so on. The Game Genie allowed you to modify up to three separate ROM memory locations, meaning enter three codes.

Craddock: How do Game Genie devs decide what types of codes to create? Building on our previous example, do you look at a *Mario* game and decide that moonwalking would be something players would want to do?

Allen Anderson: They looked at the main counters that determined the game. Lives were of course the first thing they would look at but after that it turned to things like immunity and such. I wish I could tell you that it was a very organized process but it wasn't. It was a few guys in a room tinkering with each cartridge.

Richard Aplin: There was a guy, Graham Rigby, who sat in a room walled with literally thousands of game cartridges and used some custom hardware built around a Commodore 64 that let him look inside the cartridge ROM data and he would then figure out which bytes in the ROM to modify to do specific things by a combination of skill and trial and error. He would usually start by finding the easy things, such as lives, and then go on to more esoteric stuff like jumping through walls or whatever.

Craddock: What are some of the memories you have from working on Game Genie? Particular milestones you hit, for instance.

Allen Anderson: I finished the Game Genie on a Sunday sometime in September of 1991 at 4:00. I would finish a build and they would take it out to test it on the spot. I was in the process of moving from San Francisco to Salt Lake City, so I was working in their offices in San Jose and staying at [a hotel]. We had gotten a case of Jolt Cola earlier that evening and were all wired to the hilt. Once complete, I left MSD and went to San Francisco International Airport where I boarded a plane to Salt Lake City two hours later at about 6:30am and never went back.

When I first started working on the Game Genie, the hardware wasn't quite solid yet so the Game Genie rig would burn out the Super Nintendo devices. We were on a massive time crunch so I called MSD telling them I had burned out the last SNES and needed more. They sent a courier to some Bay Area game store who bought 20 SNES systems and brought them to me. Over the course of the next month I burned through 14 of them. Each time I would burn one out I would take it to the garbage chute in my apartment building on Strawberry Point and drop it down. The last six leftover machines I gave as Christmas gifts to friends and family that year.

Craddock: What's your opinion on cheats and codes of the sort Game Genie offered—cheats that weren't precisely allowed by the game? Do you feel they made games more fun? Did they make them too easy?

Allen Anderson: Ironically, I wasn't a fan of the Game Genie. Once you cheat on a game it becomes not really worth the effort to do it the hard way. I remember finishing the original Lemmings and seeing the four lines of text that said I did a great job. It wasn't much, but I knew how hard I had worked to do it. With the Game Genie you could get to the end of a game without actually spending the effort. I like really hard games so I wasn't pleased with the final product.

Richard Aplin: That's subjective and up to the user; it certainly changed the games, in some cases allowing people to see parts of the game they couldn't otherwise master or experience it in a different way. It was a very popular device so clearly there was a widespread interest in doing that.

Craddock: Game Genie led to Game Shark, but few cheat devices exist today, if any. Why do you think those types of devices became extinct?

Allen Anderson: It's just insanely harder [to modify a game's data] nowadays. Modern language memory managers allow things like lives counters to be anywhere and they can move when garbage collection happens. Plus there are tons more moving parts in a subsystem so that simply scoping the wire between the cartridge and the machine isn't going to get you anywhere.

Richard Aplin: From a technical perspective the landscape changed when CD-based consoles came out: it required a different approach as there was no physical cartridge that could be intercepted and modified. This was still generally do-able, such as using Action Reply on PlayStation with some clever hackery. It became essentially impossible on later console generations because you had to find a way to

bypass the protection systems, and obviously a consumer Game Genie product has to work without requiring the user to open up their console and solder stuff inside; it needs to be easy to use. Once we had consoles, starting with PS2, that supported network connections and firmware updates from the manufacturer, it became largely impossible to reliably make a Genie-style product: manufacturer updates effectively closed doors that might have been used to implement cheats.

For example on the PS3, there was the USB key hack which was a complex hack that exploited a subtle bug in the PS3's USB handling code, and could jailbreak the console, which is exactly what you need to implement a Game Genie-style device. However, Sony rapidly fixed that bug and issued a mandatory software update for the console, which was either downloaded over the air or actually built into the game discs for newly released games. You can't really release a serious commercial product that exploits bugs that are so readily patched by the manufacturer. The design of modern consoles is completely different to those of the '80s and '90s—they're obviously hugely more complex but also very much more engineered for security, primarily to prevent piracy, but the same mechanisms also prevent Game Genie-style devices.

The NES version of the Game Genie.

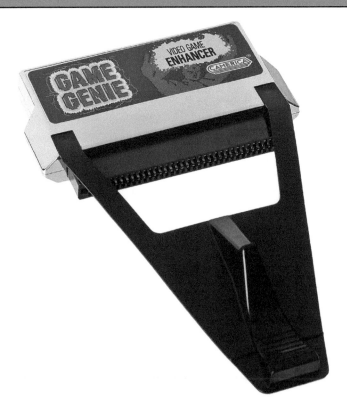

Craddock: What are your thoughts on the decline of cheat codes and devices? Do you miss them?

Allen Anderson: I'm still an avid gamer. I got into programming when I was 11 because I loved it. Programming video games was just the next level of that fun. I would spend all my lunch money on *Pac-Man* and *Galaga* back in 1982–1983 after I got home from school. Because of this I love games that are challenging. Cheat codes take away from the mystique of doing something really difficult. How many of us finished *Ultima IV* and [took screenshots of] the ending screens? That was really fun! Cheat codes allowed people who didn't spend the effort to see these things but frankly it's no longer needed. With YouTube and the various game-streaming services, less committed gamers can see all of the endings without having to put cheats in.

Richard Aplin: The Game Genie was very popular. I don't think anything has fundamentally changed in terms of gamers wanting to modify their games—either to get further in the game or just experience it differently. I imagine if it was technically practical to release a PS4 or Xbox One Game Genie, it would still be a popular product for the same reasons as the original.

2

Scott Miller
Apogee, Shareware, and id Software

If one were to sculpt the Mt. Rushmore of PC gaming, Scott Miller's rugged visage would deserve a prominent position besides the likenesses of other visionaries such as Sid Meier and Will Wright. Miller almost single-handedly laid the foundations for the video game industry's arrival in Texas with the founding of Apogee Software, Ltd., which helped studios such as id Software get their start. Arguably even more famously, he pioneered the concept of shareware—splitting full games into episodic chunks and giving away the first chunk for free.

Miller talked to me about his competitive drive, how his father's work ignited his curiosity and imagination, the founding of Apogee, and how he decided to apply the shareware model to games, which shaped the foundation on which Apogee would build successful products such as *Commander Keen* and *Wolfenstein 3-D*.

Craddock: What did you like to do for fun as a kid? You know, before computers and video games came along and rotted your brain?

Scott Miller: I'm the firstborn and I have a brother who is younger and a sister who is 10 years younger. I pretty much did things on my own with those kinds of age gaps. I was always pretty active. In my teens I got into martial arts. I love sports like baseball, big-time into swimming and bike riding. Definitely into a lot of outdoors stuff. My dad inspired my adventurous nature.

When I get into something, I try to become an expert at it. When I got into mountain biking, I very quickly got really good by just pushing myself. I also had a lot of friends who were very competitive by nature. Everything we got into, we tried to push into the top 10 or 20 percent of the sport as far as the amateur level goes. When I get into stuff, I just dive into it head first and strive to become really good at it. I think it's just a natural desire to do the best at whatever you're doing. If you're doing something, why not be the best you can be? We would push ourselves to the highest limits. Like snow skiing for instance: I started out when I was 32 and that first year we ended up going five

times. I got good pretty quickly. The better you get at something, the more you can enjoy all it offers. It's just more fun at the higher skill levels, I guess.

Craddock: Were your friends as competitive?

Scott Miller: I guess the friends I hung around with—I don't want to say "the friends I picked" because it never works out that way—but the friends I've been attracted to, we all had the same competitive nature. Like now, we've got these social games you can play on your phones. There were always competitive elements; they're not always friendly games. We were always trying to push ourselves to be the best we could be, to master all the little tricks to things.

It's just my nature and the nature of the friends I've been with. Having friends like that around me forced me and them to really push ourselves. We used to do a lot of smack talk. We don't do too much of that anymore, but the goal's always the same: to crush each other, and sometimes exchange some of that talk.

Craddock: So many children inherit traits and interests from their parents. What did your parents do while you were a child?

Scott Miller: My mother was pretty much a full-time mother. She had a couple other jobs while I was growing up, but nothing really career-wise. Just for fun. Actually, she worked for Apogee for probably a good two years. She was a very early employee back in the early '90s. Back in the days when we were a direct order business and had people calling in, she was involved with fulfilling orders. I would definitely say [we were close].

I definitely took an interest in [my father's] work when he worked at NASA during the Apollo program. I was definitely into space things as practically all kids are. We'd never miss an episode of the original *Star Trek* when it was first being aired. It was always an exciting time when there were the two Apollo missions. So I was pretty aware of it back in those days when I was 8, 9, maybe 10. His job was very interesting to me because it was all about the space program. I don't know if that kicked off my interest in science or played into it, but as a kid I found it very interesting, that whole side of things. Space is interesting.

My first idea for a career was, I was going to be a scientist. In fact, very early on I thought I was going to be a scientist. That was a very fascinating subject to me. Even at 13, 14 years old, I was reading all sorts of science, physics, and astronomy books. I don't know if that was because of exposure to my dad's work or just a natural thing, but I was always interested in science. He was always building electronics. He was building digital clocks well before I can remember them being sold in stores. We had all sorts of new electronics around the house growing up that were not sold in stores. He was always making things out in his workshop.

I don't know if that was a source of pride; I didn't think of it that way back then. I just found it interesting that my dad could build these amazing things. In fact, he was probably using components that would have made them way too expensive for retail sale at that time and built them simply for the design challenge. These are things he would tell us weren't available in stores, but he was never trying to show off. I think he made things purely for the fun of it: to

design things that were ahead of their time. I was fascinated that he could just build stuff like that. There were times when I would go out there and try to think of some cool electronic device that I could make. I was always a big James Bond fan, so maybe something that was a cool secret spy-something-or-other. But they didn't work, frankly. I could never figure it out because it was all way too advanced for me at the time, so I never did anything like that.

I kind of tinkered around and soldered things here and there, but nothing more than simple little switches. That was all I ever built.

Apogee made a name for itself as one of the first PC gaming companies to embrace the shareware model of software distribution.

Craddock: You're known as one of the frontiersmen responsible for planting the seeds of the video game industry in Texas. Have you always lived in Texas?

Scott Miller: Back in 1972, the Apollo program came to an end. My father got a job with E Systems, which was later bought by Raycon, which of course is the big military contractor. In central Australia, right in the middle close to a town called Alice Springs, there was a place that had the big space base. It's kind of like the Area 51 of Australia: it's supposed to be really top-secret, really well guarded. They did a lot of secret stuff there, but primarily what I think it is, is a satellite tracking station for that part of the world. We were there for five years. We moved back here for me to graduate from high school, and [my parents] actually went back for two more years while I stayed and started going to college.

I vaguely remember not being too happy about [moving to Australia]. I grew up in Florida and had a lot of friends, but when I moved to Australia I quickly made new friends, so it wasn't that big of a deal.

Craddock: What brought you back to the States?

Scott Miller: As far as I can remember, I grew up in Florida, then we moved to Australia and stayed there for five years, basically my high school years. We moved to Texas and I've been here ever since. So really the hardest part was, for me, leaving

Australia, where I had really solidified some strong friendships as a teenager going to high school. Coming back to Dallas to live meant starting fresh at 17, 18 years old. By that time people have already developed cliques and groups and so on. It's kind of hard to break into those friendship circles.

I remember six months to a year of not having the social circles that I wish I would have had, the ones I had back in Australia. I remember going to high school and spending a lot of time in the computer lab. I actually became friends with the computer teacher. We had an Apple II computer at the high school and I would spend a couple hours after school in there. That's where I met George Broussard, who later became my business partner. He became my first good friend here in Dallas.

Craddock: When did you discover computers?

Scott Miller: It's funny: through high school, the only time I got a grade less than a "C" was my computer science class. I got a "D" in it. I think the issue there was, someone donated a computer to the school. It was a Wang 2200, and very PC-like. It had a built-in floppy drive, built-in keyboard, built-in screen. It was really ahead of its time, looking back, but the teacher didn't know anything about it. It was his first computer.

I remember that as we went through the course, the teacher couldn't always explain things very well because he wasn't very ahead of the class as far as learning it. Because he didn't explain things that well, it didn't seem very exciting. I remember most people in the class received a "D" just because the class wasn't put together well and wasn't very interesting. Computers seemed very boring to me, like large calculators. But then, a month or two after that course, a friend said, "Hey, you want to go play some games?" I said, "What do you mean?" He said, "You know, on the computer." He'd gone and found some magazines—one at the time was called Freedom Computing—and every issue had a game written in BASIC that you could type in.

So I walked over to the lab and saw what they were doing, and I thought, *Oh, okay. This makes the computer kind of interesting.* I started to look at these programs that people were typing in, and that's how I taught myself BASIC. I started typing them in and started to modify code to make the games more interesting. It almost became an obsession, like, "If I'm going to learn this, I'm going to learn it inside and out."

I didn't have enough time to learn during school so I'd leave a lab window unlatched. After hours I'd go back over, just crawl through the window and stay for around three hours at a time, just me and the glow of the computer screen as I typed in my games. I got to the point where I was coming in on weekends, and I finally got caught. I had to go in front of the principal, and he looked at all these programs I'd done and saw that I hadn't vandalized a thing. In fact, I was doing this really advanced programming. My computer teacher saw the stuff and said, "My gosh, this is really advanced stuff."

The principal said, "Tell you what: we're going to give you the key. You don't need to break in anymore. But only under the condition that if the teacher needs any questions answered, you help him out." It was a done deal. There I was, 15

years old, and I had the key to the school so I could go in and use the computer. I did that for the last six months that we lived in Australia before we moved back to the States. As soon as we got back, my first priority was to get my father to give me the money to buy a Commodore. I've had a computer ever since.

Craddock: What intrigued you about programming?

Scott Miller: You'd play with values, you'd change the logic around and see what happened. It was very hands-on learning, and you finally get to the point where you're staring at a blank screen one day and you say, "You know what? I'm going to make a game from scratch." There was some sort of very powerful, creative thing that you tap into. It's really like, you're building something from your mind. Even back then it was like I was creating these worlds purely from my imagination. I'd play those old text adventure games like Zork, and it's funny: even though they were just text, you'd have these very vivid pictures in your mind of what those worlds looked like.

So even just making games based on text, it was still tapping into something very powerful. It was world building. It's almost like you're playing God: you can make the worlds you want to make with the rules you want to make. I think it's absolutely crucial that if you have any desire to be a coder, you have to have it within you to want to express your own creativity and come up with your own ideas, and make them become real on the computer. Anyone who is going to college to learn how to program and doesn't go home and spend 10–20 hours a week on their own coding what they want to do—those people aren't going to go far.

You have to love it, and you have to want to be doing it outside of school projects. You have to be thirsty for knowledge. A painter has to paint, a writer has to write, and I think a coder has to code. You have to have so much experience because coding is all about solving problems, and solving them in very elegant and efficient ways.

Craddock: What about video games? Did your interest in computers kind of sync up with your interest in games?

Scott Miller: When I was in Australia, as far back as 1975 or '76, I'd heard there were a couple of arcade games, but they were very simple and not really compelling. It all kicked off, I think, with *Space Invaders*, which I think came out in '79. That was the game that really shook the whole arcade industry worldwide. That was the game that was the ground zero for everything.

I was totally into that game and tried to master it. Very quickly after that game came out, a ton of other games followed: Atari games, *Asteroids*, *Missile Command*, *Defender*. The industry exploded for a couple of years. I loved playing games at the time. I was writing a weekly column for the *Dallas Morning News*—which didn't pay much of anything at the time, maybe six dollars a column—and I ended up having to work other jobs. One of those other jobs was at an arcade. My business partner George and I worked at arcades during that time. That's another good example of adding to our background for what we later started doing, which was making games. We worked at arcades and played games.

After arcades would close, we could play all the games we wanted for free. We played and played and played, mastered many games and learned what made them fun. Looking back, I see all that as more of an educational foundation than going to college. I hadn't really thought of it until now, but I guess I applied my drive to video games, too. I really maxed it out, tried to understand strategies and be an expert at games. George and I ended up writing a book back in 1981 about how to beat arcade games, won a few local tournaments. So it's almost like no matter what the interest or profession, if you're going to get into something, you might as well do it all the way.

Craddock: How did you get involved in the games business, in as much as the "games business" existed then?

Scott Miller: When I was going to college, I was actually changing degrees. I enrolled and started taking computer science courses. I figured, "Okay, I love computers." I was learning languages like Fortran and Cobol, but these were not the languages that I cared about because those were languages used in business and science environments. I wanted to do something more fun. The computers I had at home—I had one or two at home—used the BASIC language, and other languages like C and Pascal. Definitely C became the language of the games industry; it's a very powerful, simple language.

So at the time there was no college degree that had to do with gaming as a career choice. It was all very business oriented, and it just wasn't very interesting, honestly. It also wasn't very challenging. The assignments were very simple. I got good grades; any subject within computer science was very easy. The whole time I was in college, I was also trying to start businesses and make a career path that was more interesting. I didn't want to get a computer science degree and end up working as a systems analyst somewhere. I didn't see a future in that. I was really focused on learning how to make games on my own and find some way of selling them.

After I wrote that book on beating arcade games, that allowed me to parlay that into starting a weekly computer games column in the *Dallas Morning News*, and I did that for four years. Then I thought, *You know, I like writing.* I thought that was going to be my avenue into the industry. I was always making little games on the side, but I wasn't sure I could make a career out of it. I thought I could probably make a career of writing about the industry.

It turns out that writing that column was another really good bastion of education as far as leading up to what I'm doing now. When you write about things and you're critical of things, analyzing things, you can see what people did right, what people did wrong. It's very educational. That background, when I finally did realize I could become a game designer as a career move, that background of writing about the industry—I also wrote freelance for several magazines at the time; that background really helped out, looking back.

Craddock: How did all of these interests and experiences lead to Apogee and the shareware model of distribution?

Eventually, in 1987, I started using shareware through online distribution. That all came about because I was trying to find an avenue to make money making [the *Kroz* series of] games, and the kinds of games I was making were not the kinds of games that appeal to publishers. They wanted games that were big-budget, elaborate games. Mine were more simplistic games. But when online distribution sort of became a reality through BBSes [bullet board systems], a little light bulb went off. I thought, *I don't need a publisher. I can do this on my own.*

There were some games out there that were pretty good, but no one was making any money. I had several little games that I'd made and wanted to use to make money, so I contacted these authors and they basically said, "If you release your game online, you won't make any money. No one's going to pay you any money." Something else: Back in the mid-'80s, I really developed an interest in marketing. I read tons and tons of marketing books; I've probably read over 300 marketing books over my life, now. So this was a subject I was just devouring. Somewhere along the way in reading these books, the idea hit me that if I release my games online like many people were doing, I'm not going to release the whole thing; that won't make any sense.

Instead, I would release a portion of it. That portion would serve to advertise the full product that people could buy. I think I first did that back in 1987. It was a slow start, but it became successful. People started sending me checks, and that was really the start of the business back in 1987. I quit my day job at a computer consulting company in 1990 and devoted all my time to Apogee. I thought, *This whole idea of releasing part of a full game as shareware seems to be paying off. It doesn't really make sense to keep my day job.* That's kind of how it all got started.

Kroz, Scott Miller's first commercial game, and the shareware that put Apogee on the map.

Craddock	Were you able to apply your shareware model to other games in between *Kroz* and Apogee's breakout hits like *Wolfenstein 3-D*?
Scott Miller	I made other games, one called *Beyond the Titanic* and another called *Supernova*. These were text adventure games, and I had sold these games to some magazines that were kind of popular at the time. There was one that focused on IBM games. I think they paid me a thousand for *Supernova*, and I think they held the rights for one year. I think after the rights expired, I released the full thing online. I didn't know how to break it up, and I hardly made any money. People aren't going to pay for what they already have, so when I released the *Kroz* games, I release just the first episode, and people started sending me checks. It started with a couple checks a week, then a couple checks a day. Then I just started adding it up and realizing, "Wow, on some days I'm making $500 to a $1000."

It takes a lot of effort for people to write a check and mail it out. I figured I was probably losing a lot of payments, so I thought if I had some way to take credit card orders, I could probably do five or 10 times better. That's the reason why I decided to quit the day job in 1990 and focus solely on Apogee.

Craddock:	And it was shortly after that that you met the guys who would go on to form id Software.
Scott Miller:	I set up a call center. Also, I'd reached the limit of my programming talents. I saw that there was a magazine out there called *Softdisk* and there were some really nice EGA and VGA games on [their subscriber disks]. They were just small games, very simple, but perfect for breaking into episodes. That's how I ended up meeting John Romero: he was one of the authors of one of those games called *Dangerous Dave*. I realized that there were programmers out there who were way ahead of me, so instead of continuing to make games, why not find other game programmers and enter into a partnership with them? I could work with them to make the kind of game that would work in the shareware market. My company could handle the distribution of games and all that kind of thing.

That's really kind of how I got set up: back in the early years we weren't really making games anymore, we were making partnerships.

Craddock:	You've obviously enjoyed great success in a number of facets of the games industry, but I'm curious: Do you miss programming?
Scott Miller:	That was just what had to be done. I basically had this really interesting model, this episodic model, so what I really needed was just a lot of games. I started looking at games that were out there, made by these shareware authors that weren't making anything. I was also looking other places like on these monthly subscription magazines. I was looking for people I could contact and see how they felt about working together.

I had also worked for some of those guys, and I knew that [some magazines] were ran by a guy who was very paranoid of losing his talent. So when I saw *Dangerous Dave* and wanted to contact John Romero, I knew I couldn't just write him a letter saying, "Hi, John. I started a company called Apogee and

would love the chance to work together. Would you call me?" I knew that letter would get filtered by *Softdisk's* management.

Craddock: How did you get it past the perimeter, so to speak?

Scott Miller: I knew I'd need to write him a stealth letter, so what I did was I wrote in as a fan, saying, "I love your game *Dangerous Dave*, but you know, I found a bug. If you call me, I could tell you where I found it." I didn't get a call back for a couple weeks, so I thought, *I'd better send another letter.* I sent three letters total, using a different name every time and a different way of getting him to call me, but of course the phone number was the same. I couldn't change that.

It turns out that he'd posted those three letters on his wall and hadn't called me back, until—I don't know what the fluke was—he noticed they all contained the same phone number, but all written by different names. He responded, saying, "I don't know what kind of crazy nut you are, writing these different fan numbers under different names. What kind of crazy person does that? But anyway, here's my phone number." [laughs] I wish I had that letter somewhere, but over the years I've lost it. It would be so precious if I could find that.

Anyway, I called him back and said, "I'm sorry, John. Here's why I did that." And when I explained the situation to him, he said, "Oh, okay." I went on to say, "The reason I'm trying to get hold of you is because I've got these games, *Kroz*." I don't think he'd ever heard of them, but I said, "I'm making around $100,000 a year and I've got this system in place. If I could get you to make some games, I think we could do really well."

Craddock: Did Romero jump aboard right away?

Scott Miller: I remember talking to him later after he'd played *Kroz* and he said, "There's no way you brought in $100,000 a year. These games are crap!" They weren't that great; I knew that. They were just simple text-character-based games. But the model was what made the sales possible, not the games themselves.

So John sent me this disk in the mail that was this beautiful, side-scrolling demo of *Mario*. It looked exactly like what you'd find on the Nintendo; it was just the most amazing piece of technology I'd ever seen. So they had this technology and they didn't know what to do with it. I said, "Look, there's so many games you could make as shareware. I promise you guys you'll hit it big. Your technology is so ahead of its time." It really was. They were very disbelieving, so I said, "If you could just develop something, I'll fund it." They figured they could do that, so they were taking their *Softdisk* machines home at night to work. John Romero was working with John Carmack, and there was also Tom Hall, who was also the artist and game designer there at the time. I ended up talking to all these guys and they said, "Yeah, we'll put together a game idea for you, and run it by you to see if you like it."

Craddock: And that was *Commander Keen*?

Scott Miller: Maybe two days later, Tom Hall sent me this one-page concept for *Commander Keen*. I thought, *This sounds like a fun game. I'll totally fund it.* I think they wanted $5000, and I had that, so I said okay, sure. Over the next months they developed the game, building it over time. I'd send a couple design ideas that

made it into the game, told them how to structure the three episodes for shareware, gave them all the shareware screens—all the shareware wrappers to make sure everything was put in place.

We released the first episode of the game on December 10th, I think. I remember releasing the game to all the BBSes I had partnerships with because they would feature the game on their front pages. Then I went away on a ski trip. Before I left, I put a message on my phone machine because I didn't have customer relations at the time, so I just used a message machine. Two days into my ski trip, I called the machine. It was maxed out. It was maybe 30 straight minutes of people placing orders. I thought, *Oh my God.* I remember having my mom go to my house, write down all the orders, and reset the machine so it could take more orders. I left the ski trip a couple days later and immediately hired a guy to go to my house and take orders. That was Shawn Green.

Shawn would come to my house and man the phone all day to take orders. In the first month, I think we made $20,000. My deal with id was we were splitting things 50/50. So *Keen* just took things to a whole different level from my *Kroz* games. Once my company was associated with *Commander Keen*, the game became the rage of the shareware world. Not only was the game great, but we'd worked it out so that it made the authors and Apogee tons of money. Suddenly, people were calling me. [Epic Games founder] Tim Sweeney sent me a demo of his game and said, "Hey, would you be up for working with me?" I still kick myself to this day for not working with him. He was brilliant. His game was cool and all, but it was kind of like *Kroz* and we were working toward getting better in graphics. Of course, Tim went on to become a big success at Epic Games.

So yeah, the floodgates open. We started releasing probably 5–10 games a year for a few years there. We were making a lot of money. Those were good times.

Craddock:	I'd like to backtrack and dig deeper into your use of shareware, which became known as the "Apogee model" of game distribution following the success of *Commander Keen* and *Wolfenstein 3-D*. Shareware was a form of distribution for software before games. When was your first brush with the model?
Scott Miller:	Probably around '85, '86, somewhere around there. I think I was using a lot of utilities. There was something called Lists, I seem to remember, that was really popular back then.
Craddock:	*Kroz* was the first game you divided up into episodes. Did your discovery of shareware coincide with development of *Kroz*?
Scott Miller:	I was writing games for a magazine called *i.a.magazette*. When I sold my games to them, they just got a year exclusive, so when the year ran out, the rights came back to me and I was thinking, *What can I do with this now to make money?* I was aware of people putting things online and asking for money, so I thought, *It can't hurt. I've already made money off these games. Why not try to make a little more?*

So I put both of my games—*Beyond the Titanic* and *Supernova*—out there using the traditional way, which was to release the full product and ask for

money if people liked it. I think I was asking for 5 or 10 dollars. I made very, very little money. I remember asking other shareware game authors—there weren't that many, but there were a few—and they all kind of said, "Yeah, don't expect to make much money doing this. It might help a little bit, but for the most part you're not going to see much." When I did *Kroz*, that was also a game I had released on *i.a. magazette*, and it actually won Game of the Year. The magazine held a Game of the Year contest and it won. So when the rights came back to me, I had written three *Kroz* games in total. Instead of releasing all three to the public via shareware, I had an idea: I was just going to release one and not make the other two shareware. At the end of the first, I would advertise the other two and see how that worked out.

That's when everything took off.

Craddock: Why do you think other shareware authors weren't getting much interest from consumers?

Scott Miller: I don't know if it was so much that games weren't taken seriously. I think it's human psychology. If you've got something in your hands already, why go to the effort of paying? Especially because paying for something was a considerable effort in those days. For the most part, people didn't use 800 numbers or things like that. You had to send someone a check, and that meant writing it out, putting it in an envelope, getting stamps—all that kind of stuff. It was quite an effort and made for quite a barrier.

It took more motivation for most people to send a check, and the motivation was, "Gee, if I send a check, I'll get more levels for this game." That was the ice I broke.

Craddock: How well did the games do?

Scott Miller: For three years, about '87 until around 1990, I worked at a company, a computer consulting company. What they did was they installed payroll software at various Fortune 500 companies around the United States. They had a whole bunch of consults they would send out. Everyone was always on the road doing work. I was at the main office sort of as support staff helping put together documentation they needed, setting up their laptops, all that kind of stuff. Nothing too intensive, really.

The year that led up to when I quit, which I believe was June of 1990, I had made about a $100,000 a year [from *Kroz* sales]. My day job was paying $30,000. It didn't take rocket science to figure out, "You know." But even though I quit my job, it was still a scary decision because I was quitting a stable thing. You didn't know how long the *Kroz* train was going to keep rolling forward. A lot of my friends really thought I was crazy for doing that, when I told them what I was doing. But you don't get many opportunities in life to take a chance like that. I figured, "You know, it's now or never."

Craddock: Did you report your success to other shareware authors? Give them a few pointers?

Scott Miller: For at least a year, maybe two years, people said, "Yeah, he's just making up those figures." You could hear the talk on the 'Net and various bulletin boards.

I don't think I was even bragging about it, but I was out there saying that you can make money from shareware as a game author, and I was probably the only one out there doing it at the time.

I guess what made the story even harder to believe was, there were other games out there that were much better than my games, especially in terms of graphics—EGA graphics, scrolling engines—and my games was just this ASCII-based game. And yet here I am saying, "Hey, you can make money, and pretty good money." It was a hard story to believe because my games weren't the best games out there. There were better games out there but they weren't making money because the authors were giving the whole game away. That's what they did wrong.

I remember there was one game in particular, I think it was called [*Captain Comic II:*] *Fractured Reality.* The author's name was Mike [Denio]. He was recognized as having the best shareware game out there. It was a really nice sort of side-scrolling game, and he just wasn't making any money at all. I would talk to him and say, "What you need to do is try marketing it with a whole other set of games." I was trying to recruit Mike and have him sell his future games with me. I told him I was going to set up a whole new company, get 800 numbers, get credit cards, just do it right.

But for some reason, he just didn't believe that it was going to happen to where you could actually make money. I remember talking to him about 10 or 15 years later, and he admitted he should have followed my advice and jumped in. But back then it really was a hard story to believe.

Craddock:	How did your schedule change after Apogee was formed?
Scott Miller:	It was a full-time job. I'd get there at 8:30 or nine o'clock every day, get off around five. I would get home and eat, and I would sometimes work until two, three, four in the morning on a workday. On the weekends I'd work all the way through the nights and wouldn't even get to bed until 10 in the morning the next day, wake up around three, start going again. I was pretty hardcore back in those days. For about a year there, my schedule was pretty hardcore.
Craddock:	And that was around the time George Broussard got involved, correct?
Scott Miller:	All I was doing was selling my games at the time. Before I quit my job and started running Apogee full-time, all I was doing was writing my own games and selling them. Basically I was writing a bunch of *Kroz* games, there were seven in total, I think. The idea of starting a company really didn't occur to anyone at the time. It was more about, write your own games and get them out there.

George actually started working at the same company I was at, during my last year. We were working at the same office, and every day I would come in and say, "Guess how much I got in the mail yesterday? Five hundred dollars!" He would say, "Oh, man!" So hearing this over and over, how much I kept making from my little side job, it finally occurred to him, "I'm going to start writing my own games and see if I can't start making some side money also."

He started writing his own games, and it didn't occur to either of us that we should join forces. And even after I quit my job and started my company,

it wasn't until about 8–10 months later that I approached him and said, "You know what? We should do this together. What we'll do is, we'll roll your games into Apogee and we'll do this together." Apogee was definitely more known and definitely making a lot more money than his company. I had also partnered with id Software at the time and *Commander Keen* had come out. That had taken things to a whole new level. I was also working on the first *Duke Nukem* game.

Craddock: Did the financial security brought on by *Commander Keen's* success afford the id Software guys the opportunity to break off from the *Softdisk* magazine and work on more games?

Scott Miller: Id was taking the *Softdisk* computers [home] to work on *Commander Keen* at night. I guess they didn't have better hardware and software of their own to do that, and they didn't want to develop the game at *Softdisk* because it would have become *Softdisk* property. Well, it turned out that even taking *Softdisk* computers home and developing a game on their computers, kind of makes the game *Softdisk's* property.

After *Commander Keen* came out, suddenly id thought, *Shareware makes us tons of money. Let's do that full-time.* I said, "You guys should quit *Softdisk*, form your own company, and keep making games, and we'll grow rich together." They were totally sold on the idea, but *Softdisk* didn't like the idea of losing those guys. When *Softdisk* found out they'd made Keen on *Softdisk* computers, that gave them sort of a legal angle to threaten the guys for doing that, and that Keen was rightly *Softdisk's* property.

Craddock: How'd you get them out of that jam?

Scott Miller: *Softdisk* was making all of these allegations. I jumped in and said, "I'll hire an attorney to protect you guys and we'll figure a way out of this." Our attorney got *Softdisk* to back down on the threats and basically calm down a little bit, but still, some agreement had to be reached because *Softdisk* still had a case they could pursue. *Softdisk* said, "You can keep *Commander Keen*, but we want 10 more games out of you guys."

At the time, that seemed fine. Okay, 10 more games. Id had to come up with a game a month for *Softdisk* or something. They were using their engine and came up with a game called *Keen Dreams* or something for *Softdisk*. At the same time, they started making games that explored 3D graphics. They did a game called *Hovertank 3D*. During this whole time, id had moved to Dallas and I was becoming good friends with them. We'd go out to dinner a lot and talk about what we were going to do next in shareware: Maybe another *Commander Keen* game and so on, which later became *Goodbye Galaxy*. But when I saw their new 3D technology, I thought, *Oh my gosh, this is so far ahead of the time. We should use it for shareware.*

They said, "You know, we totally agree, but we have this *Softdisk* agreement hanging over our heads. We have to finish games for them." By this time I'd brought on George as a partner at my company. I was bugging George: "There has to be some way we can help these guys out here. What if we made games

and gave them to id, to give them to *Softdisk*?" While we did a game that month, id could keep working on their 3D technology.

That's the deal we worked out with id. George and I developed a game called *ScubaVenture* that was released as an id Software game. During that time, id worked on what became *Wolfenstein 3-D*. They got the project off to a good start and then they finished a couple more games for *Softdisk* and said they were done with their commitment to them. Then they could focus on *Wolfenstein* full-time.

Craddock: I think *Wolf3D* was the first shareware game I ever played. I didn't even realize it was one-sixth of a game at first. The experience felt complete: lots of levels, lots of guns, secret areas, a final boss.

Scott Miller: We really felt like that was the point: To not shortchange people with the free version. My thinking was, if we gave them enough to play for several hours, they would feel like they'd spent some quality time with the game. If you give them 30 minutes or less, it's such a small enough amount of time that they could blow it off. But three or four hours into an episode? That shows them an exhilarating game and makes them say, "I've got the controls down and am starting to really get good at this thing. Hell yeah I want to keep playing."

Publishers hate—hate—giving away too much for free. It totally rubs them the wrong way. I remember when we started working with other publishers, one of their first comments was, "You know you guys are giving too much away, right?" We were always fighting them on that point, because we believed that we needed to give so much away that the player would really become invested in it. They're hooked; they've got several hours behind them and they want to keep going.

Craddock: One thing I remember very clearly about those shareware games was they didn't bug me to buy the full product while I played. That's become the norm in mobile game development, especially in cheap and free-to-play games.

Scott Miller: Our lack of nag screens was totally by design. The last thing I wanted to do to any player was find a way for them to lose interest in playing. I wanted to create a fully positive experience. There had to be nag screens somewhere, of course, so we just felt that the final screen after you're done playing the game would be the best place to have it. Once you're done playing, a screen pops up saying, "Hey, if you enjoyed what you played, there's a way to get more." You just make it natural. You don't want ads to pop up and interrupt you playing your game.

Craddock: A lot of consumers miss shareware, and even smaller demos that only consist of a couple of levels. As you say, that model was a good way to get your feet wet. Why do you think fewer developers release demos?

Scott Miller: I think there are two things in play today. One thing is, content is so expensive to make that publishers hate to give away any of it for free. A two-hour experience of *Uncharted* or *Call of Duty* is a huge monetary investment. The other thing is, I think games are shorter than they used to be, so giving away three to four hours of a game nowadays would be like giving away half the game.

Craddock: After publishing *Commander Keen* and *Wolfenstein 3-D* through Apogee, id went their own way with *Doom*. Could you talk more about how that split occurred?

Scott Miller: We eventually released *Wolfenstein*. Whereas *Commander Keen* was making us $20,000 a month, *Wolfenstein 3-D* was making $200,000 a month. Apogee and id split everything 50/50. After a year of making $200,000 a month, Apogee and id were rolling in the money, enjoying good times. George and I decided that we didn't know if id would always want to work with us, so at some point we should start our own internal development team using our money.

Id Software came to the right decision of, "We really needed to work with Apogee, but we've got tons of money now and can set up our own projects and keep the money for ourselves." So that's what they did. They outsourced a company to handle their orders, and it's funny: we used the same company. We said, "We're really growing, but the ordering part of our company is more of a burden than anything else. Why don't we outsource that?"

I was talking to Jay Wilbur, who was the manager at id at the time. I said, "You guys should do the same thing: start taking your own orders. Let's go in as a unified front. We'll be bigger that way." So that's what we did: we started working with outsourcing companies to take our orders.

They went on to release *Doom* around a year-and-a-half later, and that was strictly an id Software game. They were always kind of upset that the games they were releasing through Apogee were known as Apogee games. They felt that their personal company brand, id, wasn't being represented well enough. I think more than anything, that was what led them to parting ways, but I can't fault them because I would have done the same thing in their shoes. At that point they had become a very wealthy company and there was no more reason for them to work with us. They'd learned everything they could from us at that time.

I was totally calm and I kind of expected it, just because if I were in those shoes, I'd have done the same thing. Even with *Wolfenstein*, I was a little worried that they'd do that without us. They'd made enough money from *Commander Keen* to go off on their own, so I felt fortunate that we were able to continue our partnership long enough to do *Wolfenstein*. I had no expectations of working with them past *Wolfenstein*. They'd started hiring a lot of their own people. They'd hired Jay Wilbur, who's a very smart business guy that they'd worked with at *Softdisk*. They kept him at id for many years.

So, I just saw the writing on the wall. Those guys were building up their infrastructure to become fully independent. Looking back now—not that I really think about this too often—but if I'd been a little smarter, I might have been able to get a small piece of their company, 10 percent, let's say, back when we were helping them get started. It would have been very easy to get a small part in all the companies we'd been working with—just a little, not too much.

The whole pitch I presented to companies at the time was, "If you work with Apogee, unlike those other publishers, you keep all of your IP rights, and we split everything 50/50." That was the best partnership you could probably have. That was how we presented ourselves. We always tried to be very fair and talent-focused.

Wolfenstein 3-D, Apogee's most successful shareware game, and the title that gave developer id Software the confidence to strike out on its own.

Craddock:	That coincides with the development of *Rise of the Triad*. It was a first-person shooter, [a genre] which Apogee had gained experience working on by publishing *Wolfenstein*, and also a direct competitor to *Doom*. Was that the idea? To take what Apogee had learned from working with id—as id had taken what they'd learned from working with you—and try your hand at it?
Scott Miller:	*Wolfenstein* came out and did spectacularly well, and it was still doing very well later. Then, id released a sequel called *Spear of Destiny*, which they released as a retail-only game. Then they began to work on their next technology, which they used for *Doom*. While *Doom* was underway, Apogee was building its own internal development team. The thought was, what game are we going to do?

My thought was, *Why not do another Wolfenstein game and keep that IP rolling? While id works on their next project, we'll keep Wolfenstein going.* I vetted the idea to id and they actually liked it, so we started putting the project in place: a new *Wolfenstein* game with id as the creative oversight. That was totally fair. At some point during all of this, Tom Hall ended up leaving id. We hired Tom because he was definitely a very good talent. It made sense to us, after hiring him, to make him the project lead of this new *Wolfenstein* game. We came up

with the idea of *Rise of the Triad*, which told the story of what happened after *Wolfenstein*.

The whole idea was that Hitler was not the mastermind behind the Third Reich. It was actually this triad of people and Hitler was only their figurehead. There were other powers behind the scenes. Now that Hitler was dead, the three people would rise up. So we had the story in place, we were making the game and keeping id in the loop. About four to six months into it, we got a call from John Romero, and he said we needed to shut the project down. He said id was unhappy with it and they were taking our right to work on it away.

That was the end of that. We had all these assets we had done, so it was up to Tom Hall, mostly, to build a new game that allowed us to use all the assets we'd been making for several months. We kept the name *Rise of the Triad*, and the game that was eventually released basically rose from the ashes of what would have been the next *Wolfenstein* game.

Craddock: What was the process of performing triage on *Rise of the Triad* in order to spin off the assets that didn't belong to id?

Scott Miller: The game suffered by being originally a *Wolfenstein* game but then having to somehow remove those elements. It went through a very turbulent development. So the game ended up being kind of a mishmash in lots of ways, a little incoherent. So much hard work had been done, especially on creating all the characters. It was such a pain-in-the-butt process and was such a huge deal that we just needed to make those assets work.

Craddock: Did anyone from id explain why they didn't want you to work with the *Wolfenstein* IP?

Scott Miller: I think John [Romero] cited quality issues. Honestly I thought that was premature because we were still very early on in the project. Every project has quality issues at that early a stage. But I've always secretly suspected that they didn't want another game out there that would compete with the magic of *Doom* coming together. They said, "Holy shit, we're on to something with *Doom*," and maybe they didn't want anything to detract from that. I've never talked to anyone from id to confirm that, but that's what my suspicion is.

Craddock: What was your level of your creative input on projects?

Scott Miller: A lot more with some projects than with others. With id, not so much, because obviously id had proven themselves an extremely talented team. They were always the least hands-on team we worked with. But there was some key input. With an early version of *Wolfenstein*, there was an early version of the game in which you would kill a soldier, then you would grab the body using a hand icon, and you could drag it to a room so the other patrolling guards wouldn't see it.

I remember playing the game and sending id a note saying, "You've got such a great action game here that these stealth parts don't jive." There were a few other things like that that just slowed the pace down; I argued that they needed to be deleted. Sure enough, they were deleted in the final game. I don't know if that happened because of my ideas or if they had similar ideas, because they are

very smart game makers. They play their own games quite often. I also had a key role in making *Wolfenstein* a VGA game versus an EGA game. The original design called for an EGA game, but we had the VGA technology. They needed artistic help, so they were working with additional artists that we loaned to them to take the EGA version of the game to a full VGA version.

I also talked them into going from three episodes to six episodes, with the idea that they were going to release the first episode for free. You could get the first three episodes for around $35, or all six episodes for $50. Each episode was around 10 levels with a secret level. It turned out that 90 percent of the people who ordered *Wolfenstein* bought the full six-episode version.

It really paid out to do all six episodes, which was honestly very little work for id to do. They could make a level or two levels a day, so it was an extra two weeks of work that resulted in an extra $15 in profits per game.

Craddock: *Doom* was *Rise of the Triad*'s biggest competitor in 1994. What do you feel *ROTT* did as well as, or even better than id's flagship shooter?

Scott Miller: *Rise of the Triad* was originally intended to be a new sequel to *Wolfenstein 3-D*, but never a true competitor to *Doom*. However, it did some things pretty well, such as deathmatch taunts, looking up/down with a mouse, and some really radical weapon designs. But really, *Doom* is a revolutionary game, and stands above nearly every game made.

Craddock: Before *Duke 3D*, the Duke games were 2D sidescrollers. What prompted Apogee/3DR to take Duke into the third dimension?

Scott Miller: 3D was where the industry was going, and after *ROTT* we wanted to continue with 3D development. There was too much thought put into it; the decision was basically an obvious one.

Craddock: Duke was a wisecracking badass even in the two side-scrolling games, but he turned the volume up to 11 in *Duke 3D*. Could you talk about how 3DR decided to highlight Duke's personality and swagger as one of the game's defining elements?

Scott Miller: Id was taking a serious approach to their games, so to differentiate ourselves we took a less serious approach. This manifested itself with all the humor in the game: the pop culture references, and by making Duke a stronger personality by having him talk during the game.

Craddock: As time went on, *Doom*'s arsenal became stock: every FPS had a shotgun, a chaingun, and a rocket launcher. *Duke 3D* rolled those guns into its arsenal, but added more innovative weapons of mass destruction like the shrink ray, as well as more strategic weapons like the pipe bomb. Was it a conscious decision on the part of your developers to shake up the repertoire at Duke's disposal compared to those of competing games like *Doom* and *Quake*?

Scott Miller: It was our goal to be different than *Doom*, rather than a copycat, so we purposely designed weapons that weren't *Doom*-like. We also tried to design weapons that added tactical gameplay value to the game, so that these crazier weapons had both pluses and minuses. We didn't want to make any all-powerful weapons like the BFG in *Doom*. As you mentioned, the pipe bomb is a good example of

a weapon with tactical implications, in that it's powerful but only goes a short distance. But, you can trigger it from far away, which leads to interesting ways to use it.

Craddock: Level design is another key area where *Duke 3D* differed from *Doom* and *Quake*. Duke's levels felt more realistic in terms of their construction and flow, and the build engine seemed to allow for a good deal of malleability, such as using pipe bombs to blow holes in walls. What were some of your favorite maps from *Duke 3D*, and why?

Scott Miller: Duke really pushed level design in many key ways, such as real-world settings, changing/destructible structures, and levels that flowed into each other in logical ways. My favorite two levels are the first two, simply because we polished those levels to extreme perfection knowing that they would be the levels that would make or break the game. For their time, they were simply jaw-dropping levels of pure perfection and fun. In a way, they carried the game because many of the following levels weren't nearly as fun or polished.

Craddock: One minute, *Doom*, Duke, *Quake*, and *Unreal* reigned supreme. The next, arena-based shooters seemed to disappear. Why do you think those games got pushed aside for games like *Call of Duty*?

Scott Miller: *Call of Duty* and Halo, and later, *Gears of War*, were designed for consoles and that gave them a huge advantage. I think the pure shooter era is behind us and we've entered the shooter-plus era [of games such as] like *Borderlands*, which is a shooter plus a RPG. *GTA* is essentially a shooter plus vehicle missions. If Gearbox brings back Duke they will need to add a "plus" to it, otherwise it will appear to be stuck in its long-past glory days.

Craddock: In the 1990s, FPS games came in all shapes, sizes, and colors. We had fantasy themes, sci-fi themes, horror themes. Now, it seems like *Call of Duty* and *Battlefield* are the top dogs, and most triple-A FPS games are militaristic in theme. What are your thoughts on the state of FPS games?

Scott Miller: Halo, Gears, *Borderlands*, *Warframe*, *Titanfall*—these all represent a maturing evolution of the 3D shooter category. Even *GTA, Dishonored*, and other belong in the category. The lines have been seriously smeared.

Craddock: One of the cornerstones of *Doom* and Duke was modding tools that let users build their own maps and campaigns. Today, many FPS games are closed off. What do you think of that trend? Do you believe publishers who keep their authoring tools to themselves are stunting innovation?

Scott Miller: On consoles it was harder to provide modders an opportunity, but I think we'll see that changing soon. I think everyone sees the benefit of an open modding community, so efforts will push this toward further and further feasibility.

Craddock: What's next for the FPS genre? Where would you like to see it go?

Scott Miller: FPS as a genre is sort of dead. Everything now is a hybrid in some way, like *Uncharted*. And frankly, I like this a lot. Let's just make good 3D games inside super compelling interactive 3D worlds, and let the term FPS fade away.

3

Tom Hall
Apple II and the Early Days of id Software

Tom Hall is a game development sage. Since 2013, he's been designing social games at PlayFirst Studio. A few years prior, he set the creative direction for an MMO in development at KingsIsle Entertainment, a studio based in Austin, Texas. A few years before that, he co-founded another popular Texas-based studio, id Software.

Maybe you've heard of it?

Although he's working around the clock to launch new game projects, Hall was gracious enough to set aside time to talk about some of the formative steps on his journey in the games industry.

Craddock: I understand you wrote your first games on the Apple II. That computer sent so many designers on their maiden voyage into game programming. How did you discover it?

Tom Hall: We were going to get a family computer, and I was actually lobbying for a TRS-80. But luckily, Dad was smarter and got an Apple II Plus. We got it on June 9th, 1980. So I was 15, and had the whole summer to learn this new computer. It was an amazing time of learning, fun, and empowerment.

Craddock: What were some of the Apple II games that got you excited about playing, and then making, your own games?

Tom Hall: One of the first games we got was Scott Adams' [*The Adventure Sampler*]. (The Apple II coder/designer, not the cartoonist.) They came on cassette tapes, so you'd read them in with the arcade commands that I still remember:

]CALL-151 (to get into the computer's machine language area)
]800.5777R (read in from tape into those memory locations)
]800G (800 "Go" or run code starting at 0×800)

 I loved those games—they really lit up my imagination, even though you just control them [by entering combinations of] VERB NOUN and they were

in terse text. The puzzles were fun and the subjects exotic. Early interactive fiction.

So all my first experiences were buying cassette-tape programs in little baggies with labels from THE BYTE SHOP in Milwaukee. And some came in cardboard with Styrofoam holding the tape, like the adventures.

Craddock: Do you remember the first game you wrote?

Tom Hall: The first game I wrote on the Apple II that I can remember is *TANK*. You entered speed and angle to fire at a tank that moves every turn, and then it plots dots (on the HI-RES screen) until your "Mortar" lands and either misses (try again, tank moves) or hits the tank (draws a graphic X on tank, exits game). Just that little inkling of playability, learning, and visual reward was the first little baby step in learning game design.

Craddock: What was it about that experience that caused you to catch the game-development bug?

Tom Hall: The Apple II+ made it so easy to start learning to code, as it came with Applesoft BASIC. It was really easy to get an idea going from nothing. You thought of it, then you did it. Learn more, and go a bit further down the rabbit hole. And as I started to do little adventures, they were actually really close in quality to the ones I was buying.

I thought, *I can actually do this for a living.* My other passion at the time was making little short effects films—being a Trekkie as a kid, and a sci-fi reader, and *Star Wars* came out when I was 13—but I knew I'd eventually need a crew and others to do stuff. I could do near commercial-quality from the get-go all by myself.

Craddock: What aspect of game programming gave you the most trouble when you were starting out?

Tom Hall: Actually, the programming came easy; it was finishing all the ideas I had that was hard! I'd do a ton of little demos, but it was so wide open, I was doing a bit of everything. I finished 50 games, but made probably 100 more little demos. That's still a problem: so many ideas, so little time. But you incorporate things to enhance larger ideas, and of course, when it doesn't fit, you have to kill your darlings. Maybe when I retire, I will do a bunch of little games again.

Craddock: What were some other early games you made?

Tom Hall: Since I loved adventures, I made, like, 15 text adventures, each getting better and more elaborate. I had started with code from a book called Strategic Simulations (still have it!) for my first little forays into that idea, but once I started doing my own, I just kept going. My mom and I would play the adventures together, so she would play mine—a built-in audience!

Then I got into graphics, made arcade games, mostly shoot-em-ups, like *Gunner, Space Peepers, Superzot, Madvoober, Mass Poopage, Death Ships from the Ninth Galaxy*, and on and on. I also did a really horrible three-vine, get-to-the-top-as-stuff-came-down-the-screen *Donkey Kong Jr.* game. Later, I did an *Ultima*-style engine in machine language, for a game called *The Silver Cow.* It wasn't quite *Ultima*, so I called it Penultima. Heh.

Craddock: John Romero talked to me about getting many of his early games published in magazines. Did you go that route as well?

Tom Hall: I read those religiously, entered most of the game programs. I actually got a letter published in *Softline* magazine. I actually [submitted games for publication] a number of times and got rejected for [submitting] similar games. A coder/designer that later became a friend scooped me like three times; then I wrote *The Silver Cow*, and it was rejected for being too big! Eventually most of those got published on *Softdisk* [magazine], so they got their day.

Commander Keen, a 2D sidescroller in the vein of Super Mario Bros.

Craddock: You have a reputation for caring about story and character development in games. Was this true during your formative game-programming years?

Tom Hall: The adventures were definitely tales of, well, adventure. And a lot of the early graphic games had characters—I really loved *Donkey Kong Jr.* in college—they had [a coin-op version] at the cafeteria near my dorm at UW-Madison. So as soon as there were characters to latch onto in games, that's the way I went.

Craddock: You entered game development as a programmer, but you are known as the creative mind behind many of id Software's early hits, most notably *Commander Keen*. Did you find yourself more drawn to designing games than coding them? Was programming more a means to the end of making your own games?

Tom Hall: Ha-ha, yeah, exactly. My dad was a professional engineer and my mom was a writer, so I got both sides of the brain. So to me, programming games was just a way to express myself in another medium, like writing fiction or poetry, or doing photography.

Craddock: How often do you get to write code these days?

Tom Hall: Rarely, but I want to get back into it. It's another resource for ideas. Probably will [experiment] with some iOS apps.

Craddock: How did you discover *Softdisk* magazine, and how'd you land a job there?

Tom Hall: Well, I graduated from college with a BS in computer science and prepared to get a "real job." I did a bunch of interviews, they liked me, then I did plant

trips, as they were called back then; now it's just "flying you out for a second in-person interview." They all went well: IBM, Gould, and such, but they all said at the end of the interview, "We like your resume, we like your skills, we like you. Just one last question: is this what you really want to do?"

And I flew home and thought. And the answer was, "No, this is boring, I want to make games, however I can."

So I applied to like 30 game companies, and got rejected. I waited a few months until the next hiring phase, and mailed out another set. I got a great letter from *Softdisk*, saying they were looking for someone "with exactly my qualifications": 30,000 lines of Applesoft [and] assembly language experience. My mom said it was the most positive response letter she'd ever seen. So I interviewed, got the job, and started working for a third the pay of "real jobs," but infinite times the happiness.

Craddock:	What stories can you share from your early years at *Softdisk*, before other future id Software developers showed up?
Tom Hall:	I started working at *Softdisk* as an assistant editor, working for Jim Weiler. He was a great boss. It was super hard work for little pay, but boy, was it a great training ground. Basically, *Softdisk* was an Apple II "magazine on disk" or a "monthly software collection." So we'd write 8–10 little utilities, games, applications a month, often just sprucing up submitted programs. We worked like hell to blast out that much content every month.

The product was on one 5.25-inch disk, eventually two, then at last, a 3.5-inch disk. Eventually, I became Editor of the Disk and the Apple IIgs disk, *Softdisk* GS. They both still kept going beyond when we left for a while, probably the last things professionally written for the Apple II and IIgs.

I remember awesomely spiffing up a game called *The Seven Keys* soon after I got there—basically a kind of *Monopoly* game. I made it pretty snazzy. *Anagram Challenge*, an anagram game, and *Magic Boxes*, which was kinda like *Sudoku*, come to think of it.

I also spruced up a game I'd made for my first semi-real programming gig. I had made a game called *Changemaker* for a teacher-friend's class of learning-disabled kids. It had a kid named Eddie and his piggy bank. Eddie's arm could stretch all the way up to the top of the screen, where there were the different coins: penny, nickel, dime, quarter. You had to move Eddie left and right, then press space to get coins to add up to the goal amount, to teach the kids how to make change. I spiffed up a number of [user-submitted] games as well, which was good training for *Softdisk* later.

Craddock:	What was the Special Projects division at *Softdisk*? What type of software did its developers create?
Tom Hall:	Our competitor, UpTime, went out of business, so we hired good folks from there. Jay Wilbur came over, and a coder named John Romero, who'd done a number of cool games for them. He said he'd come over if he could work on the IBM PC because he wanted to learn it. Special Projects, if I recall correctly,

did one-off disks, like a business app, a game collection, or something like that. I didn't work on it.

Craddock: How and when did you meet John Romero?

Tom Hall: When he came to work [at *Softdisk*], we kind of bonded over Apple games. We were both avid fans of all the classic games. He had Coke-bottle glasses, and liked hair metal [a mix of heavy metal and hard rock] and classic music. I did the *Softdisk* newsletter for a while, and took his photo for it holding a Great White CD and a classical CD.

Craddock: How did you meet John Carmack?

Tom Hall: He was a submitter to *Softdisk*. He did a cool tennis game. After about three great little games (ones we didn't have to clean up like others' games), we said, hey, maybe we should hire this guy.

Craddock: How did the magazine's gaming disk, *Gamer's Edge*, get started?

Tom Hall: Romero pitched it with Carmack, I believe. We got in a room to name it with the senior staff. I came up with a bunch of names; everyone liked that one the best. It was supposed to be two games a month; eventually it became one game [every two months]. I was buds with Romero and a bit with Carmack, and they were doing the fun project at *Softdisk*. [I became involved with *Gamer's Edge*] soon after it started.

Craddock: What was the schedule like, working on *Gamer's Edge* on top of your other magazine duties?

Tom Hall: I snuck in at night after working all day, offered to do levels, graphics, and sounds. I was excited to work on games, so I worked sort of a second job on that product at night. It was fun. Carmack said, "You like doing the stuff we don't like to do." Romero was tools and game code, and Carmack was game engine code. I was design and some art. Eventually we got Adrian Carmack (no relation), and the art obviously got tons better!

Craddock: What were some of the projects you guys worked on for *Gamer's Edge*?

Tom Hall: John did a PC update to his *Dangerous Dave*, which is crazy popular because it runs on really old computers. Romero gets mails once in a while from [gamers in] developing countries who love the game. John did all the graphics for the VGA game. I had planned to do a port to the Apple IIgs, but that never got done.

The first games were *Dangerous Dave* and *Catacomb*, a 2D, action-RPG shooter. We did a sequel to that, and later a 3D version, as our second 3D title, the first with texture-mapped walls. We did two puzzle games, *Rescue Rover* and *Rescue Rover II*; a shoot-em-up called *Slordax*. *Shadow Knights*, which was a fantasy platformer; and *Hovertank One*, our first FPS. We were trying all kinds of games and getting loads of experience.

Craddock: Could you share some anecdotes from those days?

Tom Hall: This is way easier now, but we were getting to make games. We had salaries and could make games. That was just unimaginably cool.

We had a multi-disc CD player, so each person would get a turn to play their music. And we were all doing discretely separate tasks, so we could just go. We'd

ask for various things we needed, but we were just blazing on our own stuff, then playing, occasionally tossing about ideas. We all played games together on the NES and PC, and we all loved Apple II games, so we were always talking about what was cool. We watched Carmack finish *Sonic the Hedgehog* on the Genesis. I helped Romero get through the maze before the boss in *Super Mario World*. It was games, games, games.

In the science of happiness (one version at least), there are three things that make you happy. Pleasure-seeking is short-term. But experiencing flow, where you love what you are doing for work so much, you lose track of time and creating meaning for others, people enjoying games, are the things that make people happy long-term. And that's exactly where we were doing. The time working on games just flew by.

Craddock: You and Carmack famously whipped up a demo that recreated the first level of *Super Mario Bros 3*. That was a big deal because, at the time, sidescrollers were virtually non-existent on the PC. People believed the hardware was incapable of rendering scrolling graphics smoothly. What was your motivation to make that demo?

Tom Hall and John Carmack painstakingly recreated the first level of *Super Mario Bros. 3* using John Romero's *"Dangerous Dave"* character.

Tom Hall: Carmack had just finished the smooth-scrolling-tile trick and had a sample sprite of *Dangerous Dave* bouncing around over it—first time there was cool scrolling that we'd seen on a PC. That was like his first amazing hack I remember, one that let technology jump forward. Seeing that, I looked over in the corner to the NES, which had *Super Mario 3* on it. I smiled, and said, "What if we did the first level of *Super Mario 3*. TONIGHT?!?" Carmack smiled and said, "YEAH!"

So we got to it. I started/paused, started/paused the NES, copying all the tile graphics, then grabbing them with a tool, getting them in Romero's editor, setting tile attributes. Carmack and I agreed on what meant "solid," what meant "death," what meant "coin block," and so on. Carmack made the little

character behave [correctly]. So I painfully made the whole first level, did some sounds, did the coin graphics, made the title screen, animated the Dave character. I don't think we got any enemies in.

So we did that from the evening to about 3:00 a.m., finished it, put it on Romero's desk, crashed. It was made for fun as a joke, out of pure joy and love of games. We came in the next day. Romero closed the door and said, "I've been playing this all day. We're so out of here."

Craddock: That demo was your golden ticket. How did you plan to cash it in?

Tom Hall: Jay knew someone who knew someone at Nintendo. They said, "Make us a demo." We took two weeks to do it, I think, really doing the first level up right. It got all the way to the head table, but [Nintendo] decided they didn't want to enter the PC market.

So, like Homer from The Simpsons: if they didn't want it, we know someone that does.

Craddock: How did the *Super Mario Bros 3* demo become the foundation for the first *Commander Keen* trilogy?

Tom Hall: When we couldn't do *Super Mario*, we talked about what to do. I said, "I can do anything." Carmack said, "A kid that saves the galaxy or something." I was so there. I left for 15 minutes, wrote the paragraph you see in the game, read it to Carmack in a Walter Winchell '40s newscast voice, and Carmack applauded. That was it.

Craddock: Was your idea for the *Commander Keen* game entirely spur-of-the-moment?

Tom Hall: It was a spur of the moment culmination, but it was also sort of me as Walter Mitty. I had the red and black Converse [sneakers] when I was a kid. I had a Packers [helmet]. I dreamed of space. Keen was really me.

Keen just came to me. Ideas just come to me. They just seem to come out of the ether, but really, as I mentioned, all the ideas of all these different stories and visuals and heroic kids were all swirling around. Steve Jobs said "creativity is just connecting things." And with all those inputs and my dreams, he [Keen] just formed.

All of my characters seem to have two lives, two forms. One normal version and one extraordinary one. I seem to be focused on the different versions we present, or the people we want to be versus what we are.

Craddock: What were some of the influences that informed your creation of the *Commander Keen* character and his world?

Tom Hall: It was mostly Chuck Jones' Warner Bros. cartoons, like "Duck Dodgers in the 24th and 1/2 Century," "What's Opera, Doc," and so on. Plus *Mario*. Plus the old sci-fi serials.

Plus a little short story called "The Available Data on the Worp Reaction" that I read in a sci-fi anthology, where an autistic kid slowly collects a pile of junk from the junkyard next door, then assembles it, gets in it, and it hovers with anti-gravity for a bit, then he takes it apart piece by piece. Plus hero kid books like *Encyclopedia Brown*, *The Nose Knows*, and *The Mysterious Inventions of Alvin Fernald*.

Craddock: What was the appeal of casting a child as the protagonist instead of, say, a big burly action hero?

Tom Hall: It was me. It was my hero fantasy. It seems it was the hero fantasy of a lot of folks, too. I was a brainiac introvert as a kid and got picked on for it. I was so geeky, I got kicked out of a clubhouse by my blue-collar-type friends when I was a kid.

So this was me being the extrovert and being smart, plus having that clubhouse I lost. It was my hero fantasy and, in a way, my revenge against being picked on, excluded. In this universe I made up, I was the hero, and being smart was rewarded.

Craddock: Scott Miller, the founder of Apogee, was a big fan of *Gamer's Edge* and John Romero, and made contact with John by sending him fan letters under different names. He talked you all into publishing *Commander Keen* through his company, Apogee. Unless I'm mistaken, the *Gamer's Edge* crew was still under contract at *Softdisk* while developing *Commander Keen* for Apogee, correct? How'd you work around that little detail?

Tom Hall: We did *Commander Keen* by moonlighting at night and on weekends for two and half months. We were working ceaselessly. I don't remember if we actually had non-competes [non-competition clauses], but they weren't happy when it came out. We agreed to keep doing a year of games so they wouldn't sue us. I stayed there in transition for a few months to train a replacement, working at id at night and on weekends.

Craddock: What was your role on *Commander Keen*?

Tom Hall: First and foremost, I was the game designer. But I also did about 80 percent of the art. Adrian [Carmack] came on the team in the middle, and you can see the enemies in the last episode are clearly better than the first.

Craddock: *Mario 3* served as a fitting inspiration for *Commander Keen*. Not only was it powered by a sophisticated scrolling engine, but it was deeper than its predecessors. What other ways did *Super Mario* influence your design of *Commander Keen*?

Tom Hall: Oh, *Mario* was genius. Miyamoto's sense of the hidden; cute but menacing creatures; clever mechanics introduced over time; variety of levels—just brilliant. Most of the levels went from left to right. The ways tiles go together. The way you communicate danger. Collection. I mean, *Mario* games invented the language of platforming. I feel super fortunate I later got to kinda invent the language of first-person shooters.

Craddock: I love the names of people, places, and things in Keen's world, such as the Bean-with-Bacon MegaRocket. What were some of your favorite names?

Tom Hall: The MegaRocket was inspired by names from Warner Bros. cartoons and *Hitchhiker's Guide to the Galaxy*, and lots of jokey takes on cheesy TV products.

Bean-with-Bacon came from the ship that was supposed to be made from stuff around the house, so I remembered a George Carlin routine: If you run out of deodorant, go into the kitchen and put a bay leaf under each arm. It

doesn't stop you from perspiring, but you smell like soup! Keeps your friends alert, y'know. "Hey, who's wearing Chicken Vegetable?" "Not me, I have Bean-with-Bacon."

So I added that as a detail, just flowing out in that quick 15-minute origin story. Dopefish was my "Bugblatter Beast of Traal" from *Hitchhiker's [Guide to the Galaxy]*. It's described as the "Second dumbest creature in the universe," since the Bugblatter beast is number one. I love names that have double vowels. They make me laugh. Foob. Boobus Toober. Bloogs.

I dunno, I am weird.

Craddock: I found it interesting that you took some gameplay mechanics away in every new episode of Keen. For example, no pogo stick for Keen in *Keen Dreams*. What made you decide to remove that particular mechanic, and add new ones such as crouching?

Tom Hall: Well, new things were added, gotta keep stirring it up! And the pogo stick is really powerful for [ascending in levels]. Gotta use that sparingly or make huge levels. Plus *Keen Dreams* was in his nightmare, so he would feel less empowered and more in danger.

Craddock: Along the same lines, you swapped out the blaster for flower power in *Keen Dreams*. What was the motivation behind this change?

Tom Hall: That was a reaction to parents complaining about the violence in the first—which was intentional, to teach that there are repercussions to your actions. It [flower power] made it interesting in that things weren't out of commission forever; they came back. Always trying new ideas, seeing what is interesting.

Craddock: *Commander Keen* maintains a nice balance of humor and sobering realizations, such as enemy bodies sticking around to remind players of what they had to do to progress. Did you give thought to striking that balance, or did it just work itself out while you focused on making something fun?

Tom Hall: No, that was a conscious decision: your actions have consequences. That's good for a kid to learn. We later changed to a Neural Stunner and did stars around the monster's heads, because parents for some reason don't want any reality to be taught to their kids. I saw characters commit suicide in cartoons as a kid, and didn't think anything of it, because I was taught that that wasn't reality.

And having smart references that people may not get is fun too. Just gives depth for those that notice, like the Standard Galactic Alphabet.

Craddock: *Commander Keen* featured a fun, colorful, and deep universe, but the technology of the day wasn't exactly cut out for modern amenities like scripted events and cutscenes. How did you convey some of the messages you wanted to pass on to players through Keen, given the technology you had to work with?

Tom Hall: Well, framing with a bit of story, then showing the story through the levels instead of telling—that worked. In later Keens, we had a bit more framing text, back-and-forth dialogue for a sentence or two. That's enough to give you a sense of purpose.

Craddock: Many gamers prefer to just play games and ignore the story. Yet, they're bound to notice certain elements (colors, NPCs' reaction to the player's actions, and

so on). They absorb the world, characters, and story through osmosis, even when playing a game where story is virtually nonexistent. What steps did you take to pull in players who didn't care much for story?

Tom Hall: It was just a fanciful universe. You don't want to have too much story. Like in *Parasite Eve*, you see a long cinematic, get to walk up a red carpet, then see another long cinematic. Some game [designers] are frustrated movie makers with token gameplay in [their games].

Beyond that bit of framing story, you just want to create a consistent universe. If you create a fun-to-control character, and have the enemies act in a funny, consistent way, the joy is there even if you don't get into the pure context of it.

But I never put so much story in that you were just waiting to get into the game. Keen 1's story is just in the menu mostly. The end uses story as a rewarding finish. And Keen 1's is a cliffhanger to get you to want Keen 2 and 3!

Craddock: You went so far as to create your own alphabet for Keen's aliens. What was your motivation for that?

Tom Hall: My mom gave me a love of cryptography. I love secret codes, puzzles, and so on. My childhood was filled with puzzles, cyphers, and such. I love that, so I made a sign for the EXIT, but I wanted it to be in "alien language" but recognizable as an exit sign. So I drew those four characters, then thought, *It would be fun to have a whole alien alphabet on signs and stuff.* It grew from there. It is just another fun secret to discover.

Craddock: I'd like to talk more about your sense of humor, which finds its way into most of your games. Colleagues have described you as an energetic guy who loves to be funny, and who is likely to blurt out sounds and quotes at any moment. Where did those tendencies and quirks come from, do you think?

Tom Hall: I always made sounds effects and stuff as a kid, and my folks didn't stop me; they just let me be creative. They are amazing folks. I was lucky. Also, our family was always joking, telling puns, trying to say the next funny thing, so I just grew up with that sense of humor as a constant thing. I can't turn it off.

Craddock: Designing shareware episodes interests me. You have to give the players enough to whet their appetite for more, yet not so much that they skip the pay-to-play episodes because they feel they've seen enough. For example, episodes two and three of Doom presented new enemies, guns, and environments, which made me want to pull out my wallet (well, actually, my parents' wallet) and go beyond the free shareware episode. Did you think ahead to spreading out such elements when creating *Commander Keen*, or did you focus more on one episode at a time?

Tom Hall: Scott Miller had the idea of the trilogy, like *Star Wars*, but the first [episode] is free. It was a good sales idea. We made the games in sequence. Romero helped on the levels for episode three because we wanted to get the dang thing done.

We were just flowing, we knew what to do, how much to include. We'd made a bunch of games together, and they just came out. I just designed what I wanted. I think I asked Carmack how many enemies we could budget.

Craddock: What did you enjoy most about designing *Commander Keen*?

Tom Hall: It was really fun thinking of things that pretty quickly came to life. *Sonic the Hedgehog* came out and had a rotating spiky bar you run across. I surprised the guys with that by staying up and doing the graphics and setting up tile animations. Then we put it in, but with energy posts instead of spikes.

Craddock: What was the most difficult aspect of designing *Commander Keen*?

Tom Hall: Well, we did the original trilogy so fast. It was create and go. Coming up with new ideas was fun. Like having to turn out the lights to get past Vorticons. It was just a flow of ideas. The original trilogy was a joy.

The angle perspective of the next three games made them much more arduous to put together, a lot of fiddling with edges and stuff.

Craddock: How did you discover that *Commander Keen* was taking the shareware world by storm?

Tom Hall: We got our first check for $10,000. We looked each other and said, "We can live on this!" It was a revelation. We could have our own company making games and making a living. The brass ring had arrived. We had to reach for it!

Craddock: Is that level of success something you ever imagined? Do you recommend any budding developer shoot for that level of success, or should they keep their focus elsewhere?

Tom Hall: We were just excited to make the games we wanted to play. That should be your goal. Make yourself happy. Make meaning for others. Don't worry about the money. That's the short-term pleasure focus, and a mistake. Focus on what you absolutely love, and what would be meaningful to others. Then if the money comes or not, you made what will make you happy.

Craddock: What lessons did you learn from *Commander Keen*'s development?

Tom Hall: Trust your gut. Make what you love. Keep that childlike sense of wonder, exploration. Be open to what you could do, what would be cool, what would be different. Why do we need this game? What makes it new and fun and cool and its own thing?

Craddock: What do you hope gamers took away from *Commander Keen*?

Tom Hall: A sense of wonder, of childlike adventure, of laughing, of the smart geeky kid getting to be a hero.

Craddock: What are some of your fondest memories working on the *Commander Keen* episodes?

Tom Hall: Just the four of us working endlessly together, each in pure creation mode—tools, game, design. We were just flowing, a set of folks each doing their part to the best of their ability. No production. No design docs. Just flow.

4

Matt Householder
Epyx and California Games

Matt Householder is an elder statesman of video and PC games. Perhaps most well-known as a producer on *Diablo* and *Diablo II* at Blizzard North, Householder's career started years earlier. He worked on early hits like *Temple of Apshai* and a port of *Rogue*, the roguelike that started it all, for the Mac. Years ahead of the influx of casual games on social networks and smartphones, he played an integral role in coming up with titles such as *California Games*. Before that, he published games for Nintendo and was working as a producer for 3DO when he met Max and Erich Schaefer, then still making console games before co-founding Blizzard North with David Brevik.

Householder and I have spoken at length about his time at Blizzard North for *Stay Awhile and Listen*, my trilogy of books about the history of Blizzard Entertainment and Blizzard North. He was gracious enough to set aside yet more time to talk about his early experiences in the industry and his days at Epyx.

**

Craddock: What led to your interest in making games?
Matt Householder: I discovered computers in 1975 at Kent State University, when I took a Physics class about designing laboratory instruments, focused on using op-amp ICs [integrated circuits] to build analog computers. Luckily, it turned out the grad student instructor for the lab had just built a few of the new MITS Altair 8800 microcomputer kits. So, digital computers were added to the class. I learned (among other things) how to toggle in by hand a brief loader which loaded a longer loader from paper-tape, which then finally loaded a copy of Altair BASIC (aka Micro-Soft BASIC).

I remember in those long-ago days, when my wife, Candi Strecker, and I went to the laundromat, we took along a *Mastermind* game set to pass the time. While there was a *Pong* machine there and we had played it a few times—costing a quarter a play for a brief game (that wasn't much fun), it seemed like a waste of money to poverty-level, Pell-grant students like us. Basically, we preferred drier clothes over *Pong*. For a final project in my Physics class, a partner and I designed and programmed a single-player version of *Mastermind*, using a clattering teletype for I/O. My main contribution was the computer opponent AI.

At Kent State, I went through a number of majors, dropping out a couple times to earn some money and figure out my next academic move. I serial-majored in Chemistry and Math—and ultimately took a detour from hard sciences into Cultural Anthropology, ending up just a few credits short of a BA before quitting Kent for good to build my own home computer from a kit—a Poly 88 by Polymorphic Systems (an S-100 bus computer like the Altair). My biggest software project on the Poly 88 was to write in 8080 machine language (and hand-assemble) a program to display on its graphics card a version of "Life," the cellular automaton created by Roger Penrose. I still have the computer and it still works!

In one of those breaks from college, I took a job as an air-conditioning repairman. After several months, I was sent to a job on the roof of my former high school. I crouched down in front of a big rooftop compressor, removed the electrical panel, and reached in to check for 480-volt, three-phase power at the main breaker. Somehow, I took a huge jolt through my arms and legs, being launched backward (like one of Galvani's frogs) toward a knee-high parapet wall 20 feet away. I landed on my feet and skidded, surfing backward on the roof gravel. Finally, I ground to a halt at the parapet and looked straight down at the asphalt three stories below. I figured it was time to go back to college again.

After my experience building and programming the Poly 88, I figured that home computers were too difficult for average people to use and would never be a mass medium. So, I decided to become a computer engineer and applied to the University of Michigan in Ann Arbor. I'd already learned most of what I needed, I figured. I became a fan of coin-op video games after playing *Space Invaders* in 1978 in Ann Arbor, Michigan. After two years I finished my BSE (Comp E) at Michigan and took a job with Bell Labs in Naperville, Illinois, east of Chicago, where I hoped to find a job programming coin-op video games. Meanwhile, Bell Labs sent me to Northwestern University where I earned an MS in Computer Science.

Though Epyx was more famous for sports hits like *California Games*, it also published several RPGs, including the IBM PC DOS version of venerable roguelike *Rogue*.

Craddock: Could you tell me about PC culture at that time? Was it common to see PCs in home settings? What about offices?

Matt Householder: I'd built my first computer in 1976. It was mostly an educational device/hobby before I entered engineering school at the U of M. It was uncommon to see a home computer (in the mid-west, at least) until the Commodore 64 came out in 1982. Similarly, desktop office computers were rare until the IBM PC was released in 1981. I used an IBM PC to develop my first game, *KRULL*, at Gottlieb in 1982/1983. I bought my 2nd computer—a C64, 1541 disk drive, and Epson MX-80 printer—in fall of 1982.

My wife used it for her "zine" production and correspondence/mail art. I had a copy of *M.U.L.E* for the C64 and played it a few times. Mostly, I'd had my fill of programming all day on my PC at Gottlieb. For fun my wife and I videotaped wacky shows off cable TV or went to punk clubs and video game arcades in Chicago.

Craddock: How did you come to work for Epyx?

Matt Householder: In a computer graphics class at Northwestern in summer 1981 (in my final semester), I met the VP of Engineering for GDI (Gaming Devices, Inc.), a division of Seeburg, the Chicago jukebox maker. He offered me a job as a systems programmer on the 68000-based video poker/slot machine they were building. A year later, GDI had not progressed fast enough for me and I began to fear it might be years before video poker was approved by the Nevada Gaming Commission. So, I began looking for another game job.

Through a headhunter I applied for a job as a coin-op video game programmer at Gottlieb Amusement Games. Another programmer from GDI also applied and we were interviewed together and hired on the condition that we produce a game based on the Columbia Pictures movie script for *Krull*. We had a 9-month deadline—which we met. Our game was a financial success, selling about 3000 units (before the movie came out and flopped, dooming any sales synergy). As the coin-op video game business began to sink in 1983, I asked my headhunter to find a game programming job for me near San Francisco, where my wife and I had friends in "punk science fiction" fandom. He got me interviews with Atari and Lucasfilm Games. Atari offered me a job converting coin-op hits to the Colecovision with a big raise (from Chicago standards), a substantial cash bonus for finishing a game—and they moved me, my wife, our cats, and our growing collection of stuff.

In 1984 I finished the conversion of *Moon Patrol* to the ColecoVision (unreleased, but Google "Matt Patrol" and you'll find it now), survived the Jack Tramiel transition, where 90 percent of the staff was fired in one day, and coded the line/polygon graphics primitives in the Atari ST GEM operating system (aka TOS). I left Atari in 1985 when it became clear to me that I would not be working on games in the future there. I found a job at Epyx as a Project Manager (producer/designer) and began working on a number of their titles across various home computer platforms: C64, Apple II/IIgs, Radio Shack Coco, Amiga, Atari ST, PC clones, and [other platforms].

Craddock:	What were your responsibilities at Epyx?
Matt Householder:	As a Project Manager my job was to ensure that high-quality games were developed on schedule. I worked with external developers to review their latest builds, collect bug reports, make my own recommendations, and prioritize the work for the next builds—generally, communicating at first by fax and telephone, later by email. Occasionally, I visited developers in person to work with them during "crunch time" (to shortcut the feedback loop)—when an important deadline (like the start of the Xmas-selling season) loomed.

Since I had been a game programmer for several years, I could often help developers find bugs as well as devise time/cost-effective bug fixes or make improvements to the user experience and gameplay. I also knew if they were trying to bullshit me. On a typical day, I would play the latest builds of my assigned games, take notes, review bug reports, write feedback on the builds, and finally (maybe the next day) discuss my feedback with the developers. Over the years I reviewed hundreds of programmer resumes and interviewed scores of people, making recommendations on hiring to help Epyx grow rapidly. I worked directly with Epyx' internal teams of artists and programmers on *World Games* and *California Games*.

Craddock: How would you describe the office environment and culture of Epyx?

Matt Householder: Every morning around 10 am, the receptionist would announce "Code 99" on the PA—meaning that a snack truck had just pulled up in front of the building. Some of the programmers typically came in later, of course, and missed breakfast from the "roach coach."

Epyx was "vertically integrated" in that every department was physically located in the same building—executive, product (producers, programmers, artists, audio, QA), marketing, sales, manufacturing, and shipping. So, you could walk around and see the whole operation and talk with anyone at any time. One day in 1985 everybody—about 30 of us—at the Kiel Ct. Sunnyvale office were put to work on the assembly line filling a big, last-minute Xmas order. Epyx was run as a fairly tight ship (compared to Atari before the Tramiel takeover). The programmers had offices, typically two programmers sharing one, I think. After moving from Kiel Ct. in Sunnyvale to Galveston Dr. in Redwood City, the art staff shared one big "bull pen," I recall. Similarly, there was a big QA lab with lots of machines set up for testing game builds.

The office culture was tech oriented, fun loving, and friendly. One example I recall is: Kevin Furry goofing around with tele-presence by sticking a video camera on top of a remote-control miniature truck and then driving it around the hallways while he sat in his office watching on TV. Regardless, everyone felt pressure to make quarterly sales goals. The approach of the Xmas-selling season each fall was crucial to Epyx' continuing success in the following year. In hindsight, venture capitalists and other key stakeholders at the executive level must have been desperate to reap a big payday (10 times or 100 times on investment) by going public or being acquired by a public company. I figure VC pressure is what drove Epyx to develop the Lynx and to the bad deal with Atari to manufacture and sell it.

Craddock: What were Epyx' most profitable platforms when you joined?

Matt Householder: C64 and Apple II, but management favored the Color Computer because Radio Shack paid promptly and did not return software for credit. During the time I was there (1985–1988), the Apple II was very important [to Epyx], but became less so as other computers—PC clones, Amiga, Atari ST, etc.—took market share in the home—some at very low prices like the C64 and CoCo.

Craddock: What do you feel kept the Apple II competitive during the advent of more powerful PCs such as the Commodore 64 and Atari 800?

Matt Householder: The Apple II had plenty of third-party hardware and software developers. Apple was generally eager to support third parties—while Atari and Commodore were discouraging and proprietary about others making money on peripherals and software for their systems. Still, Apple was not especially supportive of game developers and publishers—because Apple felt that games worked against their marketing goal of convincing

average people (typically moms and dads) that buying a computer would be a sensible household investment and not just wasting money on an expensive toy.

Craddock: What prompted Epyx to develop games based on events held during the Summer and Winter Olympic Games?

Matt Householder: A number of other successful Olympic-inspired games had already been developed: most notably, *Olympic Decathlon* (1980, by Timothy Smith for Microsoft), *Track and Field* (1983, coin-op by Konami), and *Decathlon* (1983, by David Crane for Activision). The 1984 Summer Olympics were to be held in Los Angeles. So, Epyx' sales and marketing realized that riding the coat-tails of the LA Olympics advertising juggernaut was a "no-brainer"—but they needed a good game, of course.

Coincidentally, Starpath had already developed and published a multi-event, eye-hand simulation game: *Party Mix* (1983, by Dennis Caswell) and had been developing another one when Epyx acquired them: *Sweat: the Decathlon Game* (by Scott Nelson).

Craddock: *Summer Games* was incredibly successful for Epyx. What accounted for its success?

Matt Householder: The graphics, especially on the C64, animation, and control feel were outstanding. Epyx put a team of programmers on it—along with a dedicated artist/animator!—allowing each programmer/designer to work on a different event in parallel, thus achieving a high level of gameplay polish in a very short development time-frame and consequently enjoying the peak US and worldwide market interest in Olympic-style sport games during summer/fall of 1984.

The tremendous success of *Summer Games* immediately called for a sequel. And Epyx immediately rolled its internal staff into developing *Summer Games II* for release ASAP—the spring of 1985. But by that time, Epyx staff programmers and artists had been overworked and became burnt out on the "Games" series and could not/would not work on the next obvious sequel, *Winter Games*.

Thus, *Winter Games* was contracted out to Action Graphics, an Illinois game developer in the midst of some turmoil—in that it was failing to make payroll, while the founder, Bob Ogdon, was in the process of moving to Colorado, leaving most of the development staff behind. I was hired by Epyx in the summer of 1985 and soon handed the responsibility to manage (and rescue) *Winter Games*' development, making sure that it shipped in time for the fall Xmas-selling season. Luckily for me and Epyx, the designer/developers were dedicated to finishing the game, hoping for royalty payments later, which they never got.

Craddock: What did Epyx want to see *Winter Games* do that its predecessors had not? Or, what did they want it to do better?

Matt Householder: Well, cynic that I am: Epyx' management wanted *Winter Games* to further lighten the wallets of retailers and the fans of *Summer Games*

I and *II*. My responsibilities were the same for my other games: play-test and review builds, gather and write feedback, review feedback with the developers, make decisions that would deliver the best game using the available resources of time and effort, and to approve payments by Epyx to external developers upon meeting development milestones.

Craddock: How did you and the team choose which events to include in *Winter Games?*

Matt Householder: Epyx had asked the Action Graphics team to pitch *Winter Games* to them. It was a team effort of brainstorming by Richard Ditton, Bob Ogdon, Elaine Ditton, Lonnie Ropp, Carl Norgren, and Dave Thiel. Being drawn from the Winter Olympics, there were fewer events to consider than in the Summer Olympics. One programmer, one sound designer, two artists and six months didn't allow much time to experiment. So, Richard selected from the brainstorming list those events he was sure that he could program in the six months before the contractual ship date in August. Richard picked Biathlon because he thought it would be unique and fun. Bob insisted on Hot Dog Aerials. Bobsled had a 3D, first-person-removed perspective that was the hardest to program in the amount of time allotted.

The technical design document dated February 1985 that Richard Ditton recently sent me listed six events: Bobsled, Biathlon, Figure Skating, Freestyle Skating, Ski Jump, and Hot Dog Aerials. At the last minute (July 1985), Epyx twisted Action Graphics' arm to add a seventh event, Speed Skating (by offering a new contract with an advance payment along with source code from *Summer Games II* Cycling). I recall that the sales department insisted that six events was not enough—since *Summer Games* had seven and Summer II had eight.

Craddock: Were there any events the team wanted to include in *Winter Games*, but couldn't?

Matt Householder: I wondered why downhill Slalom Skiing was missing from *Winter Games*. It seemed iconic to me. But Richard knew that downhill skiing had already been done in other games at the time. He felt it would require 3D to look (and play) different than the others. However, the computers we were targeting would not have been capable of 3D.

Craddock: What was the process of researching the events included in *Winter Games?*

Matt Householder: Freestyle Skating was "Two birds with one stone": built on the same code as Figure Skating. The Action Graphics artists did the research on what moves to include for the skating events and how they should be animated. Richard researched Biathlon—uphill and downhill sections punctuated by target shooting where a simulated heartbeat interfered with your aim if you failed to squeeze the fire button right between pulses. Hot Dog Aerials was not a real Olympic event, but inspired by Ogdon's ski trips to Colorado.

Craddock: What are some of your favorite memories from working on *Winter Games*?

Matt Householder: My main memories are of intense pressure from Epyx to meet the deadline with a hit game. The sales expectations were off the charts. I do recall enjoying my visit with the developers in Illinois—Richard Ditton, Lonnie Ropp (who was porting Richard's work to the Apple II), and Dave Thiel (with whom I'd worked at Gottlieb on my first game, *Krull*). I spent a few long days with them finalizing a number of bugs and design issues.

I remember one particular design issue, though. I'd felt the Biathlon event needed more user interaction and challenge. It was just too easy to go bang-bang-bang and get three quick bulls-eyes in the target-shooting phases. As a kid back in Ohio I'd had a .22 "varmint rifle." So, I asked Richard to add bolt-action simulation, where the player ejects each spent shell and loads up a new one for the next shot. Richard coded it in a few minutes. It was so easy to do (high "bang for the buck") and added verisimilitude to the target shooting.

Craddock: How did Epyx transition from the *Winter Games* to a broader stage in *World Games*?

Matt Householder: *Winter Games* turned out to be an even bigger market success than *Summer Games I* and *II*. In another "no-brainer," Epyx management demanded yet another sequel in the Games series. Epyx' internal art team had been critical of the art quality in *Winter Games*, so they were eager to produce the art for the next Games title. Unfortunately, Epyx' internal programming team was occupied with other projects (and was still opposed to working on another Games project after the *Summer I/II* double crunch time).

In this climate, marketing chief Bob Botch held a brainstorming meeting that included some marketing and sales staff, some artists (including Mike Kosaka), some programmers, and my boss, Bob Lindsey and me. We quickly agreed that our goal should be to come up with events the Olympics forgot. Most of us were familiar with the ABC TV show: Wide World of Sports—"Spanning the globe to bring you the constant variety of sport! The thrill of victory. The agony of defeat." Using that as a model we came up with the name *World Games* and a dozen or so ideas for possible events. I also proposed that as the next event loaded, we show a globe turning and an airline logo as a product placement. Continental Airlines was later signed by marketing as the sponsor.

Epyx' art staff and the programmers at K-Byte in Troy, Michigan were truly the "boots on the ground" in implementing the events. I'd captured the brainstorming meeting in my notes, added my own ideas, and whittled the list of events down to eight that I liked. I also wrote descriptions of the events (screen and animation) including the user joystick interaction for the artists and programmers to refer to as the game design document for implementation. Later iteration on the art/animation, but especially gameplay, were under my direction.

Craddock:	*World Games'* array of events is arguably the most diverse, and suitably so, given the many cultures the game represented. Could you talk more about how you landed on them?
Matt Householder:	I chose events from around the world that I thought would have broad appeal in our Games series markets (US, Canada, UK, and northern Europe): Weightlifting (Russia), Slalom Skiing (France), Log Rolling (Canada), Cliff Diving (Mexico), Caber Toss (Scotland), Bullriding (US), Barrel Jumping (Germany), and Sumo Wrestling (Japan).
	Most of the events I'd chosen were stereotypically related to the host country—Bullriding, Caber Toss, Sumo, and Cliff Diving being prime examples. However, other events had more complicated associations. For example, Russian weightlifters had dominated the sport in the '80s—as rumors had it—due to steroid use. On the other hand, I really liked the idea of Barrel Jumping—I remembered watching it on Wide World of Sports in the early '60s—and I put it in Germany because it was an Olympic powerhouse and the athletes wearing speed-skates made me think of northern Europe (Denmark, Netherlands, etc. neighbors of Germany). Slalom Skiing was set in France because of Jean-Claude Killy (and, cryptically in-jokey, it reminded me of the early SNL skit involving French actress Claudine Longet). An obvious in-joke was my choice of the music accompanying the Log Rolling event. It was a classic Stephen Foster tune from the Monty Python sketch with Canadian Mounties—the one that goes: "I'm a lumberjack and I'm OK. I cut down trees, I skip and jump, I like to press wild flowers, I put on women's clothing, and hang around in bars."
Craddock:	Which events were the most challenging or interesting to design?
Matt Householder:	Cliffdiving and Caber Toss were the most difficult because of the multiple interaction phases and ways for the player to fail. Sumo had the Utchari move where one opponent could dramatically turn the tables to win at the last instant.
Craddock:	Previous titles published by Epyx, such as those in the Games series, featured vector-style graphics on their box art, whereas *World Games* emphasized illustrations. What led to this change?
Matt Householder:	Marketing decided on the style change. The new illustrations were more '80s, I suppose, and less of a nerdy, monochrome '70s look.
Craddock:	*Summer Games* and *Winter Games* benefitted from established events that you and the team could draw from when designing minigames. Where did the idea for a game based on sports popular in California, specifically, come from?
Matt Householder:	During the summer of 1986 the production of *World Games* was wrapping up and I was starting to think about what to do next. My wife, Candi, and I were walking to breakfast one weekend morning in the Excelsior, our hilly, working-class neighborhood of San Francisco, when we saw a kid carving down the middle of Lisbon Street on his skateboard. Candi looked at me and commented: "You should do a game with skateboarding in it." Immediately, I was struck with the epiphany that my new game should

include nothing but alternative, youth-oriented, non-commercial sports. Candi and I brainstormed as we walked two blocks to breakfast and I decided on half-pipe skateboarding, surfing, Frisbee, BMX, hacky-sack, and roller-skating (roller blades as yet unknown)—overall, vaguely Californian and reminiscent of the '60s and '70s, yet with a modern '80s edge.

When I got some free time at work the next week, I wrote up a brief design document outlining the game, calling it "Rad Sports." A few weeks later, I presented it at a company brainstorming meeting and it was overwhelmingly approved for full development—marketing, sales, programmers, artists, and management all got it immediately.

My most memorable career moment was conceiving the idea that became *California Games*. It was obvious to me from the very start that it would be a big hit. And it is always more fun to work on a hit.

Craddock: How difficult was the process of translating athletic actions to joystick buttons and keyboard keys?

Matt Householder: Generally easy, but the most challenging were Skateboard Halfpipe and Surfing. I chose Chuck Sommerville to program Halfpipe because he had actually been a skateboarder. Similarly, I chose Jon Leupp for Surfing because he was a surfer. I had to convince Jon to return to programming from his new producer position with Epyx. Last time I talked with Jon, he reminded me of that fact and thanked me for doing it!

Craddock: I remember gathering around my "IBM PC or 100% compatible" machine with friends and competing for high scores in *California Games 1* and *2*. What was the process of designing and writing a game that was fun and easy to pick up, yet also took considerable skill to master—much like the actual sports being simulated?

Matt Householder: There is really no secret recipe other than to visualize the game in your head, make good sketches, and write descriptions of the interaction from the player's perspective. Then, implement and iterate until good enough to ship.

Epyx' most popular title.

Craddock:	What were some of the design and/or technical challenges the team faced while working on *California Games*, and how did you/they overcome them?
Matt Householder:	The biggest technical challenge was modeling the wave in Surfing. In fact, Jon needed to write a special tool for Suzie Greene to use in animating the wave in its various states: building, steady state, advancing tube, and breaking. Beyond that, it was a huge management challenge due to the high stakes, time pressure, and sheer number of people working on it. I was managing development of the Apple II and IBM PC versions before the C64 original was done. Epyx had well over 20 people working on *California Games* at once.
Craddock:	What anecdotes can you share from your time working on *California Games*?
Matt Householder:	The programmers pulled an all-nighter to finish *California Games* for the C64. To celebrate I took them all to breakfast at Denny's that morning. However, the last thing we did before going to breakfast was to install an Easter egg title screen in the final master disk—"California PAINS" would appear if you took out Side 1 and flipped it over to Side 2 as the [computer] was looking for the real title screen.

There are a number of other Easter eggs in *California Games*. I don't recall how to trigger them all, but here's a partial list:

- Surfing—When you fall off the board sometimes a shark appears with sound effects that resemble Jaws' audio danger bassline— "Duh-DUH duh-DUH."
- Halfpipe—If you go high enough (way off the top of the screen), you will come down on the other side of the pipe, triggering an earthquake which knocks over an "L" in the Hollywood sign.
- Footbag—If you kick the bag high enough, it will knock a bird out of the sky.
- Flying Disk—If you wait too long before throwing, your catcher will be abducted (a la Defender) by a UFO in the long-range scanner.

Craddock:	*California Games* was one of Epyx' most successful games, and its most successful sports game. What accounted for its popularity?
Matt Householder:	Breaking the mold of the stodgy Olympic Games metaphor that had inspired it, *California Games* was perhaps the first computer game to effectively define itself as "cool" to a mass audience. It was the first computer game to license music—"Louie, Louie." It was the first with interactive product placement. It was the first computer game to be marketed in a sexy box. Its popularity likely led to the creation of *The X Games* by ESPN which tapped into the same alternative, rebellious, consumer/sports vein.
Craddock:	I'm researching a book about Apple II games. Besides titles you worked on, what were some of your favorite Apple II games, and what about them impressed you?
Matt Householder:	I never played games on the Apple II except as part of my job at Epyx. I played the C64 versions because Epyx' titles typically led on the C64

and were ported to Apple II a bit later. I recall being surprised that Apple II Barbie had digital speech—"Ken, this is Barbie. Plans have changed." Using pulse-width modulation the 1-bit speaker could simulate a 4-bit DAC [digital to analog]. However, I was really impressed with how well the Apple II version of *California Games* turned out, especially the BMX event scrolling effect. Kevin Norman had worked out an ingenious kind of delta-compression technique to give the illusion of horizontal scrolling by simply lengthening and shortening the vertical logs that made up the edges of the track.

Craddock: Apple released a number of different Apple II models, such as the IIe and IIgs. Some developers experienced compatibility issues: their game would work on one model, but not another. Did iterative hardware updates cause you any headaches on the Apple II or any other platform?

Matt Householder: It was a headache, but one that I didn't worry much about personally. We had a QA lab and staff to find such compatibility problems. Also, Epyx treated the Apple IIgs as a separate machine (and product SKU)—as different as the C64 and Apple II. Even though all three had a 6502-family CPU, the rest of the hardware differed radically. And if you wanted native-mode 65816 code on the IIgs, that would not port directly from the Apple II version, of course.

Craddock: Software piracy had a different reputation in the 1980s than it does today. How would you describe the piracy scene back then?

Matt Householder: I did not see software piracy as much of a threat. I figured that pirates were not going to buy games. Certainly, they could not afford to buy as many games as they copied and sent around to like-minded pirates. And maybe they actually helped publishers to some degree with a kind of guerrilla marketing that later morphed into the shareware distribution model. Retailers feared and hated piracy more than publishers did. Retailers put pressure on publishers (via the sales department) to continually respond to the tit-for-tat moves of the pirates and their latest cracking tools.

Craddock: Thanks for your time, Matt. We've talked plenty about your time at Blizzard North for my Stay Awhile and Listen series, but I wondered if you could bring me up to speed on what you're up to in the present.

Matt Householder: As CFO (Chief Fun Officer) at boutique studio Play On Games, I am designing "*Word Nerd*," a new word game, for Facebook and mobile devices. However, I am equally happy playing *Robotron: 2084*, restoring my vintage Computer Space coin-op, biking up San Bruno Mt, running three miles, or grafting heirloom apples on my backyard trees.

5

Milton Guasti and Steve Rothlisberger
AM2R

In June 2017, Nintendo announced that a remake of *Metroid II*: Return of Samus, released on Game Boy in 1991, was in development for its 3DS handheld and would be released later that same year. On the same day, the company revealed that *Metroid Prime 4* was in development for its Switch portable console, and targeting 2018 for release. Fans rejoiced. Aside from *Metroid Federation Force*, a multiplayer-focused 3DS game published in 2016, the double-whammy announcement was the first Nintendo had spoken of single-player *Metroid* titles since 2010s poorly received *Metroid: Other M* for Wii.

Lifelong *Metroid* fan Milton Guasti, known to fans by his online handle "DoctorM64," was not content to wait for Nintendo to reunite him with bounty hunter Samus Aran. Way back in 2006, four years before *Other M* had rendered *Metroid* taboo, he began writing *AM2R*—short for another *Metroid II* remake. Guasti aimed to recapture the ominous and mysterious atmosphere of the Game Boy title, but enhanced with more weapons, items, and terrain to explore.

Working from his studio in Argentina, Guasti recruited a passionate and remote team of volunteer artists and designers such as Steve Rothlisberger to make the game even better. More than 10 years later in August 2016, Guasti uploaded *AM2R* for free, only for Nintendo to squelch it. The game became taboo. Undeterred, fans mirrored *AM2R*, determined to share it. All's well that ends well, however. A year later, Guasti's design skills were recognized when he announced that Moon Studios had hired him as a level designer on platformer *Ori and the Will of the Wisps*.

Before Guasti got his happy ending, I spoke to him as well as Rothlisberger to write a profile shortly after the game's release.

Craddock:	What led to your interest in games?
Milton Guasti:	I started with Atari 2600; I was very young. Then I had a Commodore 64. Awesome computer; I still have one working at my friend's house. It actually didn't have any games. I was able to rent them from a video store. There was a video store on the corner, so I went there every day and tried out games all the time. It was a nice experience. The only one I did

buy, because I was playing it very often and getting very frustrated, was Battletoads. I got really good at the Turbo Tunnel.

Growing up in the '80s, you were interested in video games by default. Arcades. I had a friend with an NES, and some other friends with a Mega Drive. You're pretty much always going to be exposed to some sort of awesome video game at some point in your life. I happened to like them. I grew up playing what would be the Famicom, here. We didn't have the NES, the VCR-shaped console. We had the Famicom and some chipped ROMs that came from China. There were many games that were not available here on that system. One of those was actually the original *Metroid*, for some strange reason. I never got to play the original *Metroid* or any of those original Famicom carts, but I did enjoy *Super Mario 1, 2, and 3*, Contra, and many old games.

I also had a Commodore Amiga. Awesome computer. Very impressive. The graphics and sound were revolutionary. After that, SNES. Eventually my brother bought a PlayStation. I couldn't enjoy the N64 or the GameCube because they were very, very expensive. PlayStation games were dirt cheap. They were just bootleg copies of CDs and were extremely common. So we could buy a system that held extremely expensive cartridges, and you wouldn't know much about the games because the Internet was pretty young at that time, so they were a gamble; or you could buy this PlayStation thing that had very cheap games that were also awesome. I kind of gravitated towards that end of the spectrum.

Craddock: What were some of the other major differences that separated gaming in Argentina from the United States?

Milton Guasti: We had the two biggest game companies, Sega and Nintendo, so in that way it was like the US. You actually had access to all the awesome games on the Sega that were classics. For the NES, there were games that either I was unlikely to stumble upon them, or were not available for some strange reason. The *Zelda* games, I never got to play them when I was young. The original *Metroid*, Kid Icarus—I never got to play them. There were other classics like *Duck Hunt* and *Super Mario*.

It was strange. When I saw *The Wizard* [film], I was seeing games I didn't know of. Those cartridges were so big; it was pretty confusing for a 12-year-old. Most of the games we had here were in Japanese. It was a nice experience to enjoy the game without needing to worry about text or story or whatever, simply because I couldn't figure out what the kanji said. It was also nice to reverse-engineer the *Captain Tsubasa* games, the ones that are soccer themed, pretty much RPGs. Figuring out which abilities did what on the interface was pretty fun; I actually enjoyed those games even though I couldn't tell what was going on in the story.

From the Super Nintendo and onward, it was pretty much all the same: we got to enjoy all the classics, but games were extremely expensive. You had the option to buy bootlegs for half of the price, so most of the games were Japanese or Chinese rip-offs, but they were options. I was able

to enjoy classics like *A Link to the Past*, *Star Fox*, and *Super Mario World*, of course.

Craddock:	When did you become interested in the *Metroid* series?
Milton Guasti:	At some point, I had a Super Nintendo. I was very happy to enjoy many awesome games. I discovered *Super Metroid* after [that]. When emulation was a big thing, I wanted to know what the big fuss was about this awesome title that was 24 megabits big. I thought to myself, *Could this be as awesome as they say?* I was quite surprised, and I kind of regretted not buying a cart. I played completely out of context, starting the game at a friend's house. It was nice, but it didn't pull me in right away. It was something you needed to play by yourself, at a pace the game wants you to play. I gave the game another chance all by myself and fell in love with it.
Craddock:	Did you play *Metroid II* as a kid?
Milton Guasti:	I didn't mention the Game Boy at all as part of my gaming life. I did have the old white brick. I remember playing a lot of *Wario Land* [*Super Mario Land 3*]. My interest in *Metroid I* started when I finished *Zero Mission*. I said, "Let's see what the next chapter in the series is. How bad can it be?" *Metroid II* was dated, to say it politely.
	I was able to find a Super Game Boy very cheap and played the entire game with a printed map in one hand and a controller in the other. It was so easy to get lost in that game. It wasn't what I expected. I had already played *Super Metroid*, so [playing *Metroid II*] felt strange. I knew that eventually Nintendo would be remaking *Metroid II*, but in the meantime it felt like a good excuse to learn programming: to imagine *Metroid II* [with better graphics and controls]. My mindset was, whatever I do, it'll be better than an old black-and-white game.
Craddock:	How did you transition from just playing games to making them as well?
Milton Guasti:	I'm pretty curious about how things are made, and I did start some development with Multimedia Fusion, a software suite used to do multimedia presentations; it was also very good for making simple games. Eventually I started making characters for the M.U.G.E.N. engine, a fighting-game engine that lets you customize characters from any franchise you can imagine.
	When I discovered GameMaker, the interface seemed very simple to actually learn how to do game logic. It was an interesting process. I experimented with making some basic games, small prototypes that never went anywhere. By 2006, I believe, I was feeling confident to actually learn some proper programming. I picked up a platformer engine that another programmer made. It was supposed to be a base for *Mario*-type games. I started messing with it, replacing the *Mario* sprite with a Samus sprite from *Zero Mission*, and was [modifying] a platformer engine that would have these awesome power-ups and features. It was a very slow learning process, but I managed to get some sort of *Metroid-y* feel out of it.
Craddock:	Was that the start of *AM2R*?
Milton Guasti:	It was the year of 2006. I was 26 years old; I had a lot more hair than I have now, and about 25 kilos less in weight. I was young. I was naive.

I had just finished assembling a recording studio with a partner. I had established my career in sound engineering. When we were just starting out, there weren't a lot of customers, so there was a lot of dead time: just me, watching the monitor, doing backups, and cleaning up.

Eventually I installed GameMaker and experimented with stuff. One of those was a *Metroid* engine. I had a lot of free time during the week, so I was able to attempt to refine this engine. I had open the GameMaker window, and beside it, I was running an emulator with *Zero Mission*. I was comparing the behaviors in real-time. I also examined TAS [tool-assisted speedrun] videos, and tried to replicate the tricks shown. I was able to actually compare some behaviors frame by frame by analyzing the videos and applying them to my engine.

If I had to do that right now, I would be a lot more impatient. I had the ability to rip sprites, something that I got from the M.U.G.E.N. scene: you actually had to rip character sprites from other video games. It was a very solid foundation. It took me a couple of months to add shooting because I had to make the running, jumping, and all the physics feel very accurate, before moving on to add new stuff. [I played *Metroid* games on emulators] just for a one-to-one comparison [as I worked].

I was able to get a [prototype] up and running, and it was a nice foundation, something that was very uncommon back then. I tried other fan games, based on *Metroid* and *Mario*. It was understandable that fan games do have that fame of being unpolished games that people make in their basements, but in some cases, they can work. I wanted to do something that fared a little bit better.

The first screen of *AM2R*, an almost pixel-for-pixel tribute to the Game Boy original.

Craddock:	There are huge differences between *AM2R* and *Metroid II* on Game Boy, two of the most obvious being that your game is in color, and you offer much higher screen resolutions. Could you talk about those and other technical changes, and how they affected *AM2R*'s gameplay?
Milton Guasti:	I had to start making changes. I had made decisions that were [impacting] the way things would proceed. The resolution, for example. I wanted to make a proper standard resolution of 320×240. Samus was looking very small compared to how she looks in the Game Boy Advance resolution. To compensate, I made her run faster, so she couldn't traverse the same amount of screens as in the Game Boy Advance. I ended up making some custom changes, including the jump distance and jump height, so it wouldn't feel limited, but instead feel more natural in the higher resolution.
Craddock:	*Metroid II*'s gated progress offered Nintendo's programmers a readymade way to partition off portions of the world so the game didn't have to load the whole map at once. Did you pinpoint gated progression as one of the game's staples that you wanted to carry over to *AM2R*?
Milton Guasti:	It was a nice way of getting things under control because it had very distinct areas. They were not interconnected, and it was not a huge maze that needed to be balanced as a whole. Just focusing on that idea was something that I valued: all the players would be experiencing it in many ways.
Craddock:	*Metroid* has traditionally been Nintendo's most adult franchise. With few exceptions, *Mario* and *Zelda* games are appropriate for players of all ages, while *Metroid*'s atmosphere tends to be tense and its themes more mature. *Metroid II*, while technically simplistic, did a good job of building on the original NES game. Did you consider that type of atmosphere to be a touchstone for *AM2R*? It seems fully intact from what I've played.
Milton Guasti:	To a certain extent, but not all the time. I wasn't aware of the atmosphere [in *Metroid II*]. I tried to deconstruct why I was feeling uneasy, and determine which elements were contributing to that feeling. I did try another *Metroid II* remake—not mine; another one. There was a game that tried to remake *Metroid II*; it was being developed by a group of people, some of them very talented. The game engine was a bit rough around the edges; it was still an early alpha. You had access [to the game world] from the first landing site to the first alpha *Metroid*. The moment that you stuck your foot into the first cave, it was already feeling claustrophobic. A couple of screens later, it was pretty much pitch black with some lighting, just enemies and some plants around Samus casting dim light effects.
	It was appropriate to show the tone of your intended game by releasing a small demo, just to show how advanced your [technology] is going to be. That's fair. I did enjoy their demo, but playing the entire game in blackness got tiresome. I decided to leave that [claustrophobic] tone for specific moments later in the game and do something a little more cheerful and upbeat in the first couple of areas. I do play with that contrast. We're going to kick ass on this alien planet, so we start with upbeat music.

Once you start fighting *Metroids* and realize how dangerous they are, things start to get a little grittier in tone and atmosphere. By the mid-game, it becomes [bleaker and more difficult]; you should be more alert as you explore caves.

What took me the most [time] was the actual *Metroids*. The way that some of those fights are planned out in the original game is nice. I was in a dark room with my CRT television in front of me, with the Super Game Boy in my Super Nintendo, and I knew where the *Metroids* were going to be. I had a map, after all. But with that tiny screen, and trying to interpret which room I was in—it felt like an adventure. You felt that uncertainty that a *Metroid* could pop up at any minute. Even though I knew what was going to be in each room, I still felt uneasy. I found it interesting.

Craddock: Tracking down dead scientists was a nice touch. It reminded me of the chills I experienced—and still experience—watching the opening of *Super Metroid.*

Milton Guasti: Once you find the first couple of scientists dead, you realize you were too late. You weren't able to save these people. The entire tone of the game changes. It's not as upbeat and optimistic. You're ready to assume the worst for the rest of the game. If you decide to go back to the surface, you'll find the entire surface is now bathed in sunset. That kind of com-plements the musical tones. It adds some maturity to the whole concept. The perception of the mission must have changed for Samus, and changes to the environment accompany that feeling.

That inspiration comes from different places during development. During years when I wasn't able to work on the project—I had stuff going on in my life—and just thinking about stuff, being exposed to new things, gives you a lot more material to integrate into the project, many of which were those small details.

Craddock: You took great pains to modernize *Metroid II*, but I wonder what techni-cal limitations you set on yourself. Were those limitations defined by your experience as you worked on the game, or what lines you felt you should not cross in order to preserve a certain level of *Metroid II*'s look and feel?

Milton Guasti: I was able to determine what my limitations were. My first game with the GameMaker [toolkit] was *Breakout* with Amiga-style graphics. I was able to draw that pixel art; it's not that difficult. But if I was going to make something more complex, I [knew I would] need to keep the scope of my ambitions realistic.

I knew that I was able to rip tiles and graphics from Game Boy Advance games. I knew there were many enemies in *Metroid Fusion* that were from the same planet where *Metroid II* takes place. Remaking the game seemed feasible. I started out with small ideas, simplifying the game. I wasn't sure what I was going to be doing with the actual *Metroid* because there were no 16-bit versions of those sprites. I was going to recolor the black-and-white versions into something that resembled 16-bits, and that would

suffice. It wouldn't be a masterpiece of animation; it just needed to look like the Game Boy version, but in color.

That was enough for me. It was just an excuse to make a game and learn from it. Things changed when I made the project public.

Craddock: I understand you had to shut down your recording studio just as work on *AM2R* was really getting underway. What happened, and what impact did closing down the studio have on you, and the game?

Milton Guasti: It was tough. I spent about six or seven months preparing the place. It was an old house that was almost abandoned. We rented the place and turned it into a recording studio. We did some of the construction work also, because handiwork is very expensive here. The recording studio was going nicely, but then my partner had a personal issue in his life. His divorce was taking up most of his time and money. I started working myself, alone in the studio, but still sharing earnings.

Eventually we had to split up and close the studio. Doing so after four years of awesome stories and being a successful engineer, with plenty of satisfied customers, all the effort and investment—it was very depressing.

Craddock: How did you decide to go public?

Milton Guasti: I wanted to know what the *Metroid* community thought about my idea and how my engine was, so I did a small trailer with some of the ideas I'd done. I started to make some test rooms and put together a small demo. One thing I didn't want to do is usually, whenever you download a demo for a *Metroid* fan game, it's one room with all the power-ups in it: all the beams, all the missiles, whatever. In this case, I expanded my test rooms to give them continuity; scattered around some of the power-ups; and I improvised a boss fight that was very cheap, kind of embarrassing, but something different to end the demo.

It was something different, and people liked it. Then it became pretty popular. I remember reading one comment that said something like, "Dude, you got featured on Destructoid and Kotaku, and you're on the front page of GameTrailers! Here are the links!" It was a nice surprise, because that wasn't the point of my project. I didn't intend to be someone who became famous or be considered the one remaking *Metroid II* instead of Nintendo. No; I was very convinced that *Metroid II* was something Nintendo would be remaking, so it was just an excuse for me to learn programming. It was a personal project, and then people liked it. It was nice.

Craddock: Besides positive feedback, what other events occurred due to announcing *AM2R*?

Milton Guasti: I got offers from artists, musicians, very talented people who wanted to contribute because they liked what they had seen of the project. The first artist that showed up was Ramiro, who's also from Argentina. He did all the *Metroid* evolution sprites. He's a very talented young man. He was able to make each evolution a lot more unique. Having help changed

the scope of the game: now I had the power to make original assets. The *Metroids* became more interesting, and I changed mechanics to take advantage of the extended mobility that Samus has. Areas became bigger. Things became much more detailed, and I tried out new mechanics just because I wanted to have more control of Samus.

More people started to show up. They started contributing with enemy sprites, the ship that you get to see in the intro sequence, etc. Before I knew it, the whole thing was starting to be a team. It was really nice because it was a completely different way of working. It wasn't just me. I learned how to communicate what was needed and make examples. It was a very interesting process.

Craddock: This seems about the point where you got involved, Steve.

Steve Rothlisberger: Before any of the demos were released, DoctorM64 was originally releasing tech demos for *AM2R* in the form of *Metroid* Confrontation. He made one release that had all the game files open to the public so people were able to change the sprites, the textures, and whatnot. I noticed that one fan had put together a suit that looked like a version of Samus from Super *Metroid* except it was scaled down. It looked really good, but I thought to myself, *I bet I can do better.*

I decided to make a follow-up to it and made my own version of the Varia suit. From there on, I created a re-colored [version] of the Gravity suit, and it ended up being really popular, so some people requested I redo the Power suit. That one was a little more difficult because the shape of the suit was different. I did the Power suit sprites from scratch as opposed to doing more of a retexturing. Those ones had a lot of love put into them.

As soon as I finished all those up, DoctorM64 contacted me and asked if I would be willing to let him use those sprite sets as the official sprites for Samus in *AM2R*. I said yes, absolutely. I told him that if he needed any other sprites, or if I could help out in any other way, to let me know. Not even a few weeks later, I ended up getting another email from him asking me for my assistance with some more sprites. Most notably with the tile set; that was how I got my start.

I actually have the very first thing that I did specifically for him on hand. I can check dates on it. The very first thing I did was there was a broken bridge in the second area, when you go past the temple. It's just destroyed. There was an earthquake and some rubble fell on top of it. He sent that to me in 2011. That was when I started working directly with Doc.

Craddock: How would you describe the state of *AM2R* when you joined?

Steve Rothlisberger: When I started on it, it was pretty basic. It looked like the original screenshots you've seen from way back when; Doc was more focused on getting the engine smooth and comfortable before making it pretty. Samus still had her *Zero Mission* sprites, and there were a lot of textures and art that were reused from previous games. To an extent, there still kind of is, but

it's all been modified to be its own thing. But when I started it was all very basic. It still felt like it was in the beginning stages compared to where it's at now.

Craddock: What were some of the side effects of bringing on outside help?

Steve Rothlisberger: We've had artists come in and do different art for the project. The first area we all worked on together was the Area 2 Hydro Plant, with the water and a green facility. It turned out really well, so we started working on the next one. It kind of paled in comparison to the previous area, so we ended up redoing the whole interior: all the sprites were custom [made]. The next area was like that too: it paled in comparison to the one before it, and we knew we needed to do better.

By the time we got to some of the later areas, we would look back at the first ones and realize that we could see how much better we'd gotten at what we do.

I think what happened was some of the help that he ended up getting for the game raised the bar so much more dramatically than he had anticipated. In doing so, it gained a lot more publicity than he intended for it to get. When he started it, it was just a way for him to learn how to program. He started with something to teach him the fundamentals, and eventually it got more complicated from this small thing he could do and release to people later on. People had been wanting a *Zero Mission* version of *Metroid II*, because *Metroid II* is the only one we haven't seen an [official] remake of yet.

Craddock: What were some of your interactions with the Doc, given that you all worked with him remotely?

Steve Rothlisberger: When I started working with him, he was very professional. He would send an email with a write-up describing something he needed from me. Basic stuff, saying, "I have a sketch for you; this is what I want. It's supposed to be a transition from this area to this one, and it needs to have this kind of feeling to it. If we could make it look like this is what happened, that would be great; try to make sure it maintains the style of the area around it so we can maintain aesthetic because that's important."

The more I worked with him, the more I realized that he had a very good idea of what actually makes a game pop out. There's millions of games out there, but only a select few stand out from the crowd. He knew what was important in order to find that. In working with him, I found a great deal of respect for his professionalism. I started to look up to him because at the age he was at, he was everything I wanted to be. I wanted to make my own games like this; I wanted to be able to have that big following by creating something that absolutely everyone loves and adores.

Craddock: How often were you able to contribute to *AM2R*? Did you set a schedule?

Steve Rothlisberger: It's more of a voluntary schedule. I tried to dedicate between 15 minutes to an hour after every work night that I could. There were a few times when I took vacation time from my day job so I could sit down and work

on it; so we could function like a legitimate dev team. I have to admit: those were some of my favorite days that we worked on stuff, and some of the best stuff got finished during those days.

One prime example being, in the brand-new area of the game, the fifth (Power Distribution Center), where it's got metal interior above the water, there's moss and foliage all over the place. That was one area we'd worked on during a day that I had asked off. Generally those days were incredibly productive. In the time I've worked on *AM2R*, I've held a few different jobs. When I started, I was actually working a graveyard shift. I was working 12-hour days, but I'd get two to three days off at a time. That made it a little bit easier to spend time just working on *AM2R*.

Craddock: Do you specialize in certain types of art?

Steve Rothlisberger: I was definitely a Jack of all trades. We would have something in place in the game that we really needed art for, like a specific sprite. For example, when I first started he had me doing environments. I started with that broken bridge, and then I moved up to the turbines and fans in area two that push water around. From there, he had me work on some of the spike plants that you see in the breeding grounds.

After that, it kind of blew up into a few different things. There are three different versions of the area-three temple on the inside: one that's nice and pristine; one that's kind of beat up; and then one that's just trashed. I went through and cleaned all those up, did all those. The very first enemy you see in the game, not even a week before release, I ended up completely redoing that one. I wanted to make him a little less threatening. He's the first enemy you see in the game. I figure: it's a frog; it shouldn't be angry, but it jumps around and spits stuff, so it's still dangerous, but it shouldn't look threatening.

There were a few other things I did. For example, the Samus model that is on the item menu sub-screen. I did most of that; it was actually collaborative with another person who was on our forums. I ended up creating this whole big thing, but it didn't really look traditional. He threw in some elements that were from *Metroid: Other M* that ended up looking a lot better than mine. We ended up building on that; we created Samus's design based off of that screen. She's mostly built from *Metroid II*'s Samus, but she has elements from *Other M* and a little bit of Smash Bros, such as the gaps in her armor. People can say what they want: I thought the gaps were super cool and I wanted to integrate them.

Craddock: How much input did DoctorM64 have in your work?

Steve Rothlisberger: He would give me a sketch to work off of and tell me the general look or feel he was going for. I would make something that would become sort of detailed. I'd have a canvas and would make a really basic shape and form for what I had in mind, and I would send it to him. He would make suggestions based on what looked good and what didn't. Sometimes I would send it to him and he'd say, "That looks great. Keep doing that." Then

sometimes I'd send something to him and he'd say something along the lines of, "Well, we're not really looking for something quite like that. Try changing a few of these things." I would do that and send him a new copy. From there we'd keep going back and forth, trying to hit on the right feel.

Most of the stuff I did was a collaborative effort with Doc. We've used Skype since the beginning. He'd give me a task, and depending on our schedules—he lives in a different time zone—sometimes he'd hop on Skype and we'd work together. If we had a couple of days off, we'd have Skype open the whole time, talking to each other back and forth while we worked. There were other times when I was working later when I wasn't able to get hold of him a lot because he was on the polar opposite schedule as me. He'd leave me with a task that he wanted a detailed sketch, and I would plow through it in a couple of days and send it back to him.

There was one particular area however that I had almost complete creative control over, that being the hidden area of GFS Thoth [interior]. I was told that this was pretty much my playground and to do with it what I saw fit. I used this as an opportunity to really push the envelope, show what my idea of a spooky *Metroid* area could be. The aesthetic of the area turned out really well, and I'm grateful to have had help from "1Eni1" who worked on the Bridge.

Milton Guasti: Since I was part of a team, I had to be a team player. That was a nice experience that was very useful for me. It taught me a lot of project management skills, and that changed a lot of how *AM2R* was being developed. Before, it was just a mess of collaboration. When something was ready, I would use it; if it wasn't done, it didn't matter. I wasn't relying on other people's work because they were doing stuff in their free time. I got into a project manager mentality, and started organizing assets: what's needed where, what are priorities for production, what things do I need for the next demo, how should we focus our efforts, what are our deadlines.

That made the whole thing feel much more professional. The results became much more consistent. Being organized, and being able to not waste other people's time, making sure their work was in good hands and letting them see results come alive in the game, helps motivate people who are putting their free time and their talent into something that won't make them money. [Project management skills] didn't help me so much in my real job at first; I was used to coding alone. But being part of work-flow that includes many people, and having to interact with an entire team, having my work affect the stuff that other people were doing—that was something I wasn't used to. I was just a lonely person sitting in a recording studio, completely alone, doing things by myself and at my own pace. Having people around you changes things.

The entire project escalated in scope slowly. As more people came in, the areas became more complex. There were new gimmicks, new

Craddock:	mechanics, new stuff, and making things more interesting instead of just tunnels, walls, and enemies. That's more or less what happened.

Craddock: Steve, what are some of your favorite characters, items, and stages you've made for *AM2R*?

Steve Rothlisberger: It's tough to say. I've made a lot; it's kind of hard to pick a favorite. If I had to choose, I think it would be an environment. One of my favorite environments that I did was in area four. There's a power switch that I created that, when you activate it, it lights up the whole area. You see these green lights pulsing through all the tiles. That was an idea that I'd had that I wanted to relay to [Doc]. It ended up taking a lot of time, and it was a huge pain in the butt, but it was totally worth it because it looked so cool. That was one of the areas that kind of raised the bar for the ones around it. You'd go to that one and say, "Wow, that had a lot of love put into it." Then you'd go to one of the previous areas and it suddenly wouldn't look quite as good. There's definitely a little bit of inconsistency in some places, and I eventually do want to fix that.

As we were working on this, we were all getting so much better at what we were doing. If it was something we'd been able to work on full-time, all together, in the same office space, this thing would have been done a long time ago. I think it would be more consistent because we'd have had more time to get back to each other and work on little things that needed to be fixed before [release]. Trying to schedule a handful of people's free time so they could collaborate and make something consistent was one of the more difficult aspects.

Craddock: DoctorM64 and I talked extensively about themes and atmosphere in *Metroid* games. What has been your take on those elements across the franchise, and did you manifest theme in the work you created?

Steve Rothlisberger: I'm proud of the aesthetic. We tried to emulate the mood in the original [*Metroid II*], which was kind of a dark loneliness. It was easily one of the spookier *Metroid* games out there, and still is. We wanted to recreate that atmosphere the best we could with modern assets. We're not going to make just a plain black background with [the same music track]. That's boring; it's got to have some feeling to it.

I think out of all our areas, the ones that we succeeded the most with [creating that] atmosphere was the GFS Thoth. That place is beautiful; I absolutely love it. Area three, the breeding grounds underneath the temple. I love the cave before the *Metroid* nest, the final area. It's just this big, beautiful, underground lake that's putting off a glow. There's the blue lights bouncing off the atmosphere, and bouncing off the temple. It's just gorgeous. Then you get inside and it's so creepy; it looks like something out of *Castlevania*: ancient, old, decrepit. There's a Chozo statue that's been mutilated. We don't know what it held before. In the original game, it was the Ice Beam, but that's not where the Ice Beam is anymore. From then on, you move up through the

crust, and there's a *Metroid* lab where these *Metroids* were created. I'm pretty sure that's what it was in the original game. The *Metroids* were created by the Chozo to fight a parasite we didn't know about at this point in the timeline, which is why there's never going to be X parasites in the game.

That cave area was just a nice calm before the storm. It was very easy to look at; it was nice to listen to; it was quiet, aside from the background music, but still kind of spooky. It was a very calm, serene moment before you got into the final thick of things. I think that's one of the things I'm most proud of. For the record, I did not do that background; I am incredibly jealous of the artist who did. I did do the vast majority of the lab stuff, however. Anything with a blue glow on it, I did that, as well as nighttime sprites outside. Those were really cool, too.

Craddock: Milton, a lot of people might not realize that you worked on *AM2R* over 10 years. A lot can happen over a decade. We've discussed closing your studio. What were some other major life events that accelerated or impeded on *AM2R*'s progress?

Milton Guasti: At one point, I had to close my recording studio and open up some rehearsal studios closer to where I lived. I kept working on the game; more people were showing up. About six years later, after continuous work [2011–2012], things changed quite suddenly: I found out I was going to be a father. At that sort of moment in your life, you have to start really considering what the future is going to be like. It affected how things developed.

I was working on my studio, and coming home at 1:00 a.m. If I were to have a proper family life, if I was going to be there for my child, I would have to change my working habits. Eventually I got into learning how to program in C#. A friend of mine recommended me to a software [company], and I started working officially as a developer. At one point, for about an entire year, I was maintaining my recording studio, working a day job, and being a father for a brief period of time before I fell asleep. It was exhausting. And in the middle of all that, besides working for customers, I was also working on *AM2R*. I won't do that again. I usually work at night, but that period was very tiresome. It nearly destroyed me.

By the time I knew I was going to be a father, I immediately had a job as a programmer. The first year I was staying late and was extremely tired. My little girl pretty much didn't recognize me. I was just some guy that showed up and spent some time with her before she fell asleep, and helped with the household chores.

Craddock: I'd like to dig more into the dichotomy of changes and similarities between *AM2R* and the original *Metroid II*. For example, the original game's map was large for a Game Boy title, but I'd imagine technical changes sent ripples through the game design. Did you start by studying

the game's map and deciding where to add to or cut from it? And how did changes such as increased resolution affect the scale of rooms and areas in *AM2R*?

Milton Guasti: I actually worked backwards. I started with landmarks, the places that need to feel familiar. You need to see a screenshot and recognize it as a place from the original. That was my starting point. Some things had to be scaled because the resolution of the screen was way bigger, but some places are actually on a similar scale. They had to feel about the same size as Samus in some places. Others were just completely changed. The entire map feels more horizontal because of the screen ratio. Every screen that you see in-game is actually one square on the minimap. If something was a square building in the original, in the original game the screen was actually square. So something that's square in the original is more rectangular in my remake. Compensations had to be made sometimes.

Overall, the main idea is to make the people feel like they're exploring some big place. Some of the rooms in *Metroid II* were bigger than the screen, so there was lots of scrolling. That amount of free space was respected. This also falls into my plan of, the closer to the surface you are, the more open areas you're going to be seeing; the closer you get to the bottom of the planet, the more claustrophobic the caves will be. There will be multiple passages for you to traverse and try to find your way into small labyrinths. It was subtle, but the style of the areas followed that plan. The first tunnel you see, you have huge corridors with many platforms; it's very easy to traverse, and there's not much danger besides weak enemies. Later areas start to be more functional and claustrophobic. That's kind of the whole idea.

Craddock: When we talked about *Metroid II*'s atmosphere, we also touched on how gating the map allowed the designers to pace the player's progression. Did you want to use gated progression and other techniques to set a similar pace for *AM2R*? Or did many areas have to be rebuilt to accommodate technical considerations?

Milton Guasti: The first area was very easy [to create] because I was following the original design, pretty much, but with better graphics. Later areas got trickier. I was a bit uncertain where things were going to be, and the player was more likely to get lost starting with the second area and onward. I was one of the most impatient testers of the game. I get bored very easily. If something fancy isn't happening, or if I don't have any clear objectives, I get bored and just play something else. I try to make sure that when the player gets to see the map, they have an idea of where they haven't gone yet. When you find a place that requires a power-up [to navigate], such as walls of spikes that require a high jump, it has to be distinct enough for players to remember. I made sure those kinds of

obstacles were memorable, and to let the player know where unexplored areas can be found.

There's no such thing as a dead-end. Every corridor, every way you try to explore, leads to something, even if it's just a missile expansion. There's no filler. That was my main philosophy: I'm not going to show the player a labyrinth and just have the player come to a wall. It's very likely there's something hidden around you. If there is a corridor or passage that goes somewhere, that somewhere is going to lead to a *Metroid*, or a miniboss, or some power-up.

Craddock: Speedrunners love to dissect *Metroid* maps and find the most efficient way through. Did you design *AM2R* with speedrunning in mind?

Milton Guasti: Everything is thought out so you can skip some parts, or you completely avoid some of the power-ups. In theory—and I do mean this in theory—you only need to pick up the bombs, the Ice Beam, the super missiles, screw attack, and the speed booster to beat the game. The entire game is beatable with only those items. If you can bomb-jump and you don't get killed, you could, in theory, complete the entire game with that. It would be insane, and I doubt many people will be able to do it.

Craddock: Did you consider minibosses such as the various *Metroids* players fight as they push deeper into the planet a sort of landmark?

Milton Guasti: Those appeared quite late in the process. Between the beginning of [development] and the [release of] the first demo that showed actual game content, there was a release called *Metroid* Confrontation. It was just an extension of the small demo I'd released in the first couple of weeks. By the time I actually focused on a proper demo that showed the actual levels, there were artists working on enemy sprites and a writer giving a hand with what would eventually become the logbook. There was a beta tester who was insanely effective; he found stuff that was very obscure and did help make the entire game feel more solid.

There was some sort of team going on. Since I had more resources, I tried messing around with the idea of bosses. The only planned boss I had was Arachnus, just because he was in the original and I already had the *Metroid Fusion* sprites for it. Making the first Chozo guardian was a matter of repainting and editing an existing statue and animating it. It was a nice way of repurposing existing sprites. I thought that was a nice experience, having Arachnus for the second area. What can we do for the third area? I kind of like the Torizo from *Super Metroid*. He's one of the first bosses, and then he appears again and is extremely difficult. He seemed to be iconic enough, so people would be fighting something familiar. Then again, he adds a little bit of a twist.

Craddock: I was impressed to learn that you also composed *AM2R*'s score in addition to doing design, programming, and art. Boasting such an array of skills harkens back to the days when one or two people built entire games on their own.

Discovering a room in *AM2R*.

Milton Guasti: Writing the music was a little bit different [than writing code]. There were a couple of songs that I was certain would be in the game. You start the game, you see the ship, and the theme music will be playing. It will be an arrangement of that classic *Metroid II* song. You go to the first area of the game. We remember that there was a strange song in the original; we can do an arrangement of that. After that, it's uncertain, because the original didn't have that much music to it.

One of the reasons why I left the soundtrack for later was at one point, I was going to do a combination of digital audio and the XM format. Depending on the situation, I was going to have four instrument channels playing at the same time (two stereo tracks), and you would be able to cross-fade within those tracks depending on the situation. So if you're going into the place with all the green plants, the XM track would cross-fading between two pairs of channels. You'd have two versions of the same song playing in parallel.

Technically speaking, that was possible. I had experience with that, making loops inside of those XM files and playing them with an extension for GameMaker. The experiment was successful, but it was a pain in the ass to actually produce. To actually loop the tracks and make the entire soundtrack like that was possible, but impractical. I decided it would be better to just have normal music looping, and that did change how I would be producing the soundtrack. It was going to be loop based, and it was just going to be a single song at a time.

One thing I made sure about was I needed to know how an area would feel gameplay-wise and aesthetically. I needed to know what the sequence was going to be, and how some places would look. The soundtrack was done in service to the aesthetics of each place instead of the other way

around. That also helped me to decide which tracks from existing *Metroid* music to remix. For example, I was playing through the second area, and I inserted as a placeholder some *Super Metroid* music. I thought, *This is nice; I like how the music combines with this particular place. I could do a remix of this.* Most of the musical choices had to wait until I saw how the area turned out, and how the gameplay feels.

Craddock:
You ended up releasing *AM2R* near the 30th anniversary of the original *Metroid* in August 2016. I know the game took over 10 years to make, but was there a point when you started eyeing the 30th anniversary and thought, *You know, that seems like a good date to target?*

Milton Guasti:
The scope kept changing. The contents of the game were very simple in the beginning. They were just the level data, the *Metroids*, some areas, and the suit. Then it started to grow a little bit, and I started to add more stuff. Eventually, it was going to be a month or two that I was going to dedicate to improving some asset or something in a level; I ended up dedicating that to expanding controller support.

I was able to purchase a license for Game Maker Studio. Suddenly the idea of multiple platforms actually justified the entire port from the old Game Maker version to the new studio version. That was about two and a half months that was writing and rewriting stuff that was obsolete or just didn't work in the new Game Maker. I was actually adding stuff, and things were getting more complex. I'm pretty sure I wrote many times in the blog, "The game might be finished this year."

Steve Rothlisberger:
I think we decided that maybe sometime between last November and December [2015]. We were just finishing out the fifth area, and we realized that that was the biggest area that needed to be finished up. Everything else just needed minor tweaks here and there. We realized that if we really hauled ass and pushed to get this thing done, we could make the August release date. We could make the 30th anniversary and give [the *Metroid* community] something that everybody's been craving.

We haven't gotten a traditional *Metroid* game since *Zero Mission*. That was 12 years ago. That's all I ever see anybody clamoring for: "When are we going to get a traditional *Metroid* game?" The closest thing that we've gotten is Axiom Verge. Just from the small amount I've played, Thomas Happ and his team know what goes into the *Metroid* formula and what gives the game its feeling. That's important. During development, we try to emulate the same thing. When I was doing artwork, I would think to myself, *If I was working in a big office, if I was working for Nintendo, what would they tell me to do and how would I do it?*

Milton Guasti:
By the time I started on the 1.3 demo, when I got to the organizational stuff, I opened up a Freedcamp account. It's an online project management tool that lets you break projects into tasks that can be assigned to different users. We had the tools to collaborate. Organizing things, setting deadlines, and being able to reach them—that went a long way

toward planning: how much time and effort will something take? For example, demo 1.3 showed the factory. By that time, we were getting serious about it and we set a deadline. The outline of the entire place was done, a lot of mechanics and bosses, but the entire pitch-black area wasn't done. I hadn't even made a lighting engine. I knew the place was going to be dark, but I didn't have the technology to make it dark yet.

Using that [management system] was a way of measuring how productive we as a team could be, and let you separate how much time you'd need to work on an area to actually be able to show it and make it work. It showed all of the bugs that appeared in that area. We repeated that process. I was actually going to be developing most of the content myself, and then the testing phase started. I had a rough idea of when the entire place would be functional enough to appear in the demo. By the time we finished demo 1.4 and people loved it, I was able to plan how much time we'd need for the rest of the game. The new area was something that got many changes; it was redone from scratch two times. Then the later parts, the Omega Nest and the Queen's Lair were already done; they just needed their respective *Metroid* fights. And music, and sound effects, and backgrounds, and special events... you get the idea.

All in all, the planning went pretty well. I did take a lot of time to make the new area, making changes along the way to a couple of new items. Once that area was roughly done—just having the collision data and the power-ups in place—I knew more or less that we'd be able to finish the game this year [2016]. I was aiming for December at first, until I found out the date of the 30th anniversary of *Metroid*.

Craddock: What thoughts and emotions ran through your head after releasing *AM2R*?

Milton Guasti: It was a little bit of panic. Many fans were waiting for the game, so I was compiling and uploading things as fast as I could, making sure the build was the correct one, trying to minimize the amount of things that could go wrong. A lot of people tried to contact me on Skype, asking me how the release was going. Many things were happening at the same time. It was not easy, to say the least.

Seeing the game out there, seeing people have fun and just waiting for people to finish it, was very cool. Very satisfying. I was joining people on Twitch as they played for the first time, and it was nice to see how they reacted to the new changes and new areas. It was satisfying, you know?

Steve Rothlisberger: I was thinking, *What's left to do?* When it comes to me, what I'm doing needs time to be put into the game. So instead of doing any kind of art—we were past that by the last 24 hours; that all needed to be done beforehand—I thought to myself, *What can I do to help Doc with PR to make this go as smoothly as possible?* For the week beforehand, I made a Twitter account that was dedicated to *AM2R* and media related to it.

Every day I released a screenshot of something people hadn't seen and talked about it and its development process.

Twelve hours later I would upload unreleased assets that weren't used in the game so we could share them, and talk about what it was originally supposed to be for or why it didn't make the cut. Everybody wants to know about the development process; I'm not different. I love seeing stuff that was on the cutting-room floor. I think that's really cool, and I feel like it generated a good amount of interest.

Milton Guasti: One of the testers sent me a Discord message about half an hour before release saying he found a bug. I had uploaded everything; I'd had a blog post ready to go. So I had to fix the thing, test it, make sure it works properly, recompile it, package it, upload it again to all the hosts. I think the game was ready maybe 10 minutes before the countdown hit zero. I didn't want to disappoint gamers. If they were going to wait, I wanted to be able to get it to them.

Steve Rothlisberger: It was really cool to see: something we'd worked on so hard and diligently, to get such positive feedback, it just. I don't know. I don't know how to describe that feeling. Immense joy. A little bit of pride. On August 6, I actually held a release party at my home with some family and close friends. We played through the game a little bit and talked about it. They were all happy.

I spent the rest of the day shuffling through people's screenshots, watching streams, looking at reactions, answering questions, just interacting with the community. When I answer questions, I try to answer them in a way that doesn't tell them precisely what to do; it just pushes them in the right direction. But generally, that doesn't become as popular as the [answer] that just tells them what to do.

Craddock: Almost immediately after pushing *AM2R* out for release, Nintendo dropped a DMCA warning. Did you see that coming?

Milton Guasti: One of the long-time fans was Mr. Ryan Barrett from *Metroid* Database. It's one of the biggest *Metroid* communities in the world, and they have plenty of material from every game. He's very professional, and a very nice guy. Before I was going to release the game, he asked, "Do you want me to host the game for people to download?" I said okay, and I sent him the game. He was able to host it. A few hours later, he messaged me and said he'd received a DMCA notice due to the hosting, and he asked me to remove the link, if possible. I had to do so.

After that, the MediaFire link was unavailable. Another link went down a couple of minutes after. Luckily I was distributing the game via torrent, also. The actual torrent file was hosted on my Google Drive, and that was taken down the day after.

Steve Rothlisberger: I didn't hear about that until it happened. I saw the tweet that *Metroid* Database had uploaded, about how their link had been taken down. I started looking into it, thinking, *Is this legitimate?* There had been an

influx [of fake DMCA notices] in the past for fan games being taken down. It was someone posing as former Nintendo employee Jason Allen who was getting these games taken down with false DMCA claims. For the ones that had false claims, things ended up turning out rather well, as far as I'm aware.

Milton Guasti: I was keeping an eye on all my email accounts to see if I'd get word from Nintendo, and to see if I'd actually get in trouble. The silence made everything uncertain. You get one message saying that this is illegal; people shouldn't be able to download it. But we didn't get one that said, "Stop doing what you're doing." That's all I know. I'm pretty sure that if I upload the game somewhere, it will be taken down eventually. Apparently, in the eyes of someone representing Nintendo, I'm a pirate, and I'm being treated pretty much the same as someone who had created a ROM hack or stole resources.

I'm not sure if this is some sort of automated process, or just a company that offers services to protect companies like Nintendo. No idea. So far I haven't heard from Nintendo themselves. I really don't know how I'm going to face this at the moment. I got a DMCA notification from blogger.com. Evidently they did revert some of the pages and posts to drafts so I can delete them and make them comply to the notice. Then again, there was the risk that they still see something that was copyrighted. I made a blog post explaining the situation to people regarding the future of the game.

But then again, I'm not sure if Nintendo is responsible. I don't know who's behind this. This could be something that's automatic; a bot that detects high traffic on certain Google searches involving key words. I don't know.

Steve Rothlisberger: What's important to me is that from the very beginning, we didn't want to step on Nintendo's toes. That's absolutely the last thing we wanted. If anything we were trying to pay them respect. The thing is, it's their legal obligation: they have to protect their IP. Now, we weren't expecting [AM2R] to be so popular. I think that's the biggest thing. If it hadn't blown up the way it did, I don't think they'd pay any attention to us. But the fact that it was being reported on major news sites made it a big deal, and they noticed.

I think their legal team was worried that it was going to do some damage. If anything, we wanted to do the opposite: we wanted to bring more attention to the series and get it popular again. We wanted to show people that most everybody wants [*Metroid*] to go back to its roots. We want traditional *Metroid* games again. They even announced that new Prey game, where it's a giant Metroidvania inside of a skyscraper in space. Man, that sounds awesome to me. The last thing we wanted was for them to feel like we were threatening them. The fact of the matter is, it's out

Craddock: there. We're going to be respectful about it; we're continuing to work on it in private. It's supposed to be a love letter and not a contest.

Craddock: Looking back on *AM2R*, what is your proudest accomplishment?

Milton Guasti: Being able to make the game in an orderly fashion, being able to motivate people to achieve this. All the contributors have jobs; they have issues, problems, families. They have their dramas, their life stuff. Even then, they feel responsibility to jump on board this passion project made by some dude who's nobody and lives in some other country. They believe in this project. Over the years, I was able to demonstrate that I could achieve milestones in a timely manner, with actual quality. Having people believe in the project, giving me a hand—that's something I'm very proud of.

Steve Rothlisberger: For me, one of my childhood dreams was working on a *Metroid* game. I always wanted to go to school and learn game design so I could get hired by Nintendo and make a *Metroid* that kicked all the other ones out of the water because that was hands-down my favorite game as a kid. I've played through all of them more times than I can count and did everything I could to learn how they would guide the player, how they designed their aesthetics. When it came to *AM2R*, I tried to emulate that the best I could with the art I put into it.

Case in point: Genesis inside of the GFS Thoth. That was one of the later things that we did. That area had been in development for a couple of years, on and off. It went through three or four different designs until we finalized the one that we have. Genesis was supposed to be the culmination of that area. Right now he's kind of a pushover, but he was one of the most original things that I created. Originally I had created it from my own [design], but I realized it looked like a creature that was already in *Metroid Fusion*. So I decided to switch it up and change it around so we could use it in *AM2R* as an original boss. It ended up turning out really well as far as animation goes. That whole area came together so well. That's probably hands-down my favorite area.

Milton Guasti: Hearing praise for our work is awesome. *Metroid* fans, and people that never played *Metroid II* are now enjoying this important chapter in the saga. Things may not have turned out exactly how I wanted, but knowing that people are enjoying a faithful *Metroid* experience fills me with joy. It makes every hour of dev time worth it.

6

John Romero
Apple II, id Software, and First-Person Shooters

Over 10 years before John Romero and his cohorts at id Software created *Wolfenstein 3-D*, *Doom*, and *Quake* on IBM PCs, Romero wrote and sold his first commercial games on Apple's pioneering machine, the Apple II. And even though Apple ceased production of the Apple II family of computers all the way back in 1993, he's still active in the scene today. He gave the keynote address at the 2012 Kansasfest, an Apple II-centric convention, and as of this writing, he's hosted three reunion parties where trailblazers from the halcyon days of green screens and dual Disk II drives come face to face and compare notes—often for the first time.

Over the course of two interviews, Romero talked to me about his earliest experiences as a programmer, the magazines he submitted early games to, and why so many of his peers owe their careers to the Apple II.

**

Craddock: How did you become interested in video games?

John Romero: I used to go to the pinball arcade in Tucson, Arizona, called Spanky's. It was full of pinball machines on one side, and a snack bar on the other side. After I did that for a while, they started to replace some of the pinball machines with electromechanical games like *Dune Buggy*. This was around 1974, 1975, around there.

After that, they brought in *Pong* and *Targ*, and they got rid of electromechanical once everything was black-and-white video games, like *Gun Fight* and stuff. That was yellow, but still. [laughs]

I was very excited about video games, and in 1976 I moved up to northern California from Tucson. Around '79, I saw *Space Invaders, Tail Gunner, Asteroids*, and then in 1980 came *Pac-Man*. *Pac-Man* was the one that got me super excited about video games, even though I was already playing them a lot back then. I started programming games in 1979, and in 1980, I decided it was something I had to do [as a career].

Craddock: What was the first computer you learned how to program?

John Romero: The first computer I ever used was a terminal connected to an HP9000 main-frame located at Sierra College in Rockwell, California. My friend and my brother came to the house and said, "Oh my god, you won't believe this. We can play video games for free up at the college." I went, "What?!" and I jumped on my bike and we rode our bikes all the way there. This was in the summer of '79.

We got to the college, and it was summer, so there weren't many students there. We went into the computer science building, which was about 60 degrees. There were some students on computers in there, these black-and-white terminals, and I saw they were doing some programming stuff. My friend had access to an account from another friend who lived down the street, so he logged in to that account, and that account had a bunch of games of the time, like *Poison Cookie* and *Hunt the Wumpus*.

We were playing those games, and they were very different than video games. That was another interesting thing. Then on a Saturday, we got up there early because one of the seniors got access to *[Colossal Cave] Adventure*. I got to see *Colossal Cave Adventure* being played, and that was way more exciting than any of the other [computer] games I was playing, and really wanted to code at that point. I started asking students in the lab questions: "What are the words you type in?" and they started telling me how to do stuff. I started making my first adventure game that summer.

Craddock: How did programming on those old terminals differ from writing code on the PCs that came later, like the Apple II?

John Romero: It was HP BASIC, so the language was BASIC. Our friend told us not to save anything into his account because he didn't want to get into trouble, so to save a game I was making, I used punch cards. I had to type the whole thing in one card at a time, per line. That was a hassle. It was nice when you came back to load it up, but you wanted to change your code in a way that didn't violate your original cards unless you want to type them up again, and keep track of which cards you're replacing.

It was a total nightmare, but I did it just so I could save my stuff.

Craddock: What is your earliest memory of the Apple II?

John Romero: I saw the Apple II in, I think, 1980. That was when Sierra College opened up another room close to the main room [computer lab] I was in. They put Apple II+s in that room, and as soon as I saw that those computers had color graphics and sound, I was done with the other room. Then I started asking the students in there, "What are some of the commands you use to program?"

I spent the next two years going to the college, going to computer stores, and, when I got to high school, going into the computer lab and doing what-ever I could [on the closest Apple II] in the time I had. I told my dad what I was learning and what I was doing. Eventually, in 1982, he got us an Apple II. That was pretty much the beginning of a ton of code.

Craddock: Nowadays, most people are familiar with the accessories they need to use their computer: keyboard, mouse, monitor. The Apple II was released at the dawn

of the PC age, and few people knew how to use it once they took it out of the box. Could you describe your Apple II setup? For example, did you hook it up to a TV screen?

John Romero: At the very beginning, I believe we had the green screen. I told my dad I really wanted to get a color monitor. "I want to program games in color, and I can't do that unless I get a color monitor." He went and got one. It was an NEC monitor, and it wasn't that good, so it wasn't long before the color started to flake out and I had to punch it on the side to fix it. [laughs] My dad would yell from the other room, "Stop beating on the monitor!"

So, yeah, I had a green screen for a short period, and after that I got a color monitor. Then I could play games in color.

When my dad got the computer, he kind of went all out. He got Microsoft Soft Card, which was a CPM card that went into slot four. He got a serial printer card for slot one, and he got a printer; it was a dot matrix, and an NEC model. He got disk drives, two of the Disk II drives. We had a Kensington power saver fan on the left side of the Apple II, so you could switch it on from the front and the fan would pull the hot air out. We had an eighty-column card, which was really nice. The CPM soft card used that, so it was 80×25.

That was a lot of stuff for back then. I then it came to around $6000. We didn't buy anything else for the computer after all that stuff in the beginning. I got an Apple IIe in 1985, and I got a Mockingboard C [sound hardware]; I got a mouse. I think those were the only two things I got for it. I also got an RGB monitor, but the Mockingboard was a big deal for me. And I needed a printer because I was writing newsletters.

Craddock: Was your newsletter your gateway into the larger Apple II community?

John Romero: The newsletter was just for my family. [laughs] What I did, though, was when I was in high school, I did a lot of emulating. When I saw a game, the author's name would be on the front cover of the game, and when you ran it, their name was right on the title screen. They went through a publishing company that put their game in a box or a Ziploc bag, and sold it in stores. So what I did was I came up with a company name, which was Capitol Ideas Software, and that was because I used to go to Capitol Computer Systems in Roosevelt, California. That was the store I went into and tried to get access to their Apple II.

When I made games, I would write, Developed by Capitol Ideas Software. I'd draw advertisements and covers for my games, and then I wrote up flyer advertisements and handed them out to members of the computer club at school. I was just trying to do the same thing [other programmers were doing]. I thought, *Well, when you make a game, a company publishes it, and you have advertisements, and covers, and packaging, and all that stuff.*

So I really wasn't part of an Apple II community. It was just family and people at school. I didn't have a modem, so I wasn't even online in that era. Not until '93, probably.

Lemonade Stand, one of the Apple II's formative games.

WEATHER REPORT: THUNDERSTORMS!!

Craddock:	What were some of your favorite Apple II games? Did any of them excite you the way _Pac-Man_ had?
John Romero:	There were so many of them; it was crazy. I played all the really big ones from back then, like _Lode Runner_ and _Choplifter_. I played Sirius Software's whole catalog of games. Nasir Gebelli's work was very important to me. Anything by Brøderbund, and also Sierra and Origin. I played _Ultima I_ all the way through _Ultima Online_, and beat _Ultima I_ through _V_. I loved the series so much that I went to work for Origin Systems in 1987.
	Sierra and Brøderbund were the companies I really looked up to because they had a really high quality bar, and Nasir Gebelli put out such great games in the beginning. Everyone was just amazed by him. Also, Bill Budge's work on _Pinball Construction Set_ and _Raster Blaster_.
Craddock:	Other developers I've spoken with described the piracy scene from back then as having a different vibe. It was less about stealing games and more about learning about software. How does that gel with what you remember?
John Romero:	Back then, everybody knew you were stealing when you copied games and gave them away, but most people didn't feel they were hurting anybody by doing that. It was like, "I wasn't going to buy it anyway," but if the game was really good, you'd buy it. I considered pirated games demo copies; if they were great, I'd buy the actual game. There were very few demos back then because disks were expensive.
	People would get together at user's group meetings and basically copy the shit out of everything. Most of the games I played were all copied like that. Then I started to get ones that were really great, and I wanted to have disks with the gold labels on them.
Craddock:	Your first published game, _Scout Search_, appeared in the June '84 issue of _Apple InCider_. How did you discover InCider?
John Romero:	Magazines were in computer stores back then. When I went to Capitol Computer Systems, they had a magazine rack, and they had _Nibble_ and some of the really early ones. They might have even had _Hardcore Computist. Softalk_

was the best one out of all of those, and that started in September of 1980. *Softalk* had covers that were way more interesting, and the articles had techy parts, but there were also accessible parts that anyone could read. It had a great mix and a really good vibe. *Softalk* and *Creative Computing*, in December of '82, were the first two magazines I got.

I saw those in the store, and not until I was in England—I went in 1983 for high school, graduated in '85, and then came back to the U.S.—but from '83 to '85, I got subscriptions to *Softalk* and *Creative Computing* since we were over there. The Apple section of *Creative Computing* was called Apple Cart written by David Lubar, a really great programmer. He was basically taking apart Mark Turmell's *Beer Run!*, drawing code just from what he could see on the screen, and had assembly language detailing what Mark must be doing in *Beer Run!* I saw that and was like, "Oh my god! He's talking about assembly language. I need a subscription to this magazine."

Then, that January, I found out that someone else had taken over Apple Cart, and David Lubar had left the magazine. Luckily, the guy who had taken it over was John Anderson, who was an author for *Adventure International*. He wrote *The Eliminator* and *Sea Dragon*, so he was still a good guy for the magazine.

When InCider came out, I started seeing magazines on the Air Force base [in Huntingdon, England] and I picked up some InCider issues and saw that they took submissions. I submitted my game to them from England, and they accepted it. They accepted some other games of mine as well.

Craddock: Your games made the cover of several magazines, such as a cover of *Nibble*.

John Romero: Actually, I made three *Nibble* covers: December 1987, '88, and '89. That was the fun issue; they put the type-in games into the Christmas issue, and I made the cover for those big issues three years in a row. That was really cool. The games were *City Centurian*, *Major Mayhem*, and *Twilight Treasures*. Those were some really cool, pretty long assembly language listings that had lots of combats. In fact, one of the guys from Raven who worked on *Heretic*, Chris Rhinehart, had learned how to program assembly language from one of those listings.

Craddock: During your first year of publishing, you won a programming contest conducted by *A+* magazine. How'd you learn about that contest?

John Romero: *A+* was another magazine that had come out in '84. I saw that at the base, read through it, and said, "Oh, they're having a programming contest. I hope it's not too late to enter." I learned of it around June or May. I decided to make a new game and submit it. I made a game called *Cavern Crusader* and submitted it [to *A+* magazine]. It took forever, but I think I won in December, the last month they were doing the contest. Then it was in the running for the big prize, a program called *VisiCalc*, and I won that. It also came with a $500 prize. It was a big thing. I got written up in the school newspaper for winning it.

Craddock: What made the Apple II so appealing as a programming platform?

John Romero: It came with what was called a monitor that was built in. That meant you could go look at memory directly. You could type a command, hit Return, and how

you have a different prompt. Instead of a BASIC prompt, you had an asterisk; that meant you were in the monitor.

There was a whole different list of commands. It was basically saying, "Let me look at the contents of memory." You could dump the contents to the screen, and you could see machine language and assembly language together; you could look at memory dumps to see what the values were in memory, and it was all in hexadecimal. You could type in new values to change memory; you could run programs from there; you could move memory [contents] around. You could just do a ton of stuff with it.

That was not available on the Atari [computers] or Commodore 64 unless you bought or somehow downloaded a monitor program on a cartridge that was plugged in. So the Apple II was already accessible at that level. The Apple II Reference Manual that came with every Apple II had the hardware schematics in the back, so you could unfold these giant pages in the back that would show you the wiring and hardware layout for the computer, all these different chips. The computer had slots, but the Atari and Commodore computers didn't, so you couldn't expand them except for cartridge plug-ins.

The Apple II was just a great hobbyist machine that had low-level access. It had a nice keyboard, which is very, very important. The Commodore and Atari 800 keyboards were not as good as the Apple II keyboard. The Atari 400 keyboard was membrane, and that was awful for typing. The Commodore 64 keyboard was also awful for typing in code compared to an Apple II keyboard. So it really had a lot going for it.

What the Apple II didn't have going for it was any kind of hardware to do graphics or sound. Those other two computers [Atari 800 and Commodore 64] had excellent hardware to do sprites and really nice sound. On the Apple II, you had to program even harder to make that work. You had to learn how to generate square wave in code, in assembly language, to make sound, and you had to know that that takes processing time, which means it takes time away from your game. You had to write a lot of code to interweave your sound card with other card to draw graphics on the screen manually, by putting values in memory, to draw things on the screen and animate it.

It was way more complex to make things happen on the screen, and to make the sound decent. To do that, you had to be a better programmer. In doing it that way, every programmer on the Apple II made games that looked different than everyone else's games because the way they put graphics on the screen was up to however they decided to do it, which could be completely different from everyone else. It was great for artistic expression. It was like a blank canvas, and you could paint however you want. It was great for that, compared to Atari or Commodore; when you used their graphics API, you were going through their hardware, and the graphics would be restricted by their technical limitations, and the games could look very similar. On the Apple II, there was no API; you created whatever you wanted.

Craddock: You've hosted several Apple II reunion parties. How did the first party originate?

John Romero: The first party happened on August 8, 1998. I figured that I had this really great company, Ion Storm, and had amazing office space. It was 1998, so it had been more than a decade past the heyday of the Apple II. I thought, *You know, I could probably put an Apple II party together, and I bet you lots of people would show up, especially if I got some of the most revered people there and listed them on the invite.* I wanted to get Woz, Steve Wozniak; Bill Budge, and Nasir Gebelli, maybe Jordan Mechner. I thought if I could get those guys to agree to come, I could put them on the invite and hopefully get everybody else.

That's what I did, and I got so many people. There were at least, minimum, 40 Apple II [game developers] who were massively influential. They made some of the most popular stuff on the platform. I think I had more than that, probably 50. Then I got people from the games industry in Dallas coming in so they could meet these Apple II developers. It was a huge event, professionally videotaped, great photos.

When the Apple II programmers got there, they all knew who they were, but had never met each other; only a few had actually met because they were spread all over the U.S. back then. They were blown away by getting to meet these people who they'd thought were amazing. So it wasn't like everybody was crowded around Woz; they wanted to meet Bill Budge and Nasir Gebelli as well. I had Steve Kent, who's been covering the gaming industry for a long time; he was there to do interviews. I had Greg Kasavin [then-executive editor of Gamespot.com] and some other Internet writers and journalists there. It was a really amazing event. It was awesome.

I had another one in 2004, at John Garcia's house in Malibu. Woz showed up for that one as well. Then we had one not that long ago here at our house near Santa Cruz, and that one went really well also. If I have another one, I'll always try to invite more people, like the people who run Kansas Fest as well, so people can meet each other as soon as possible. People are getting older. Bob Bishop passed away a whole year ago, and he was at the first reunion I had in 1998.

Craddock: I'd love to have been a fly on the wall at that party. What were some of the conversations that stood out to you?

John Romero: It was really amazing when people were getting interviewed, and there was one interview—I can't remember if I was doing the interview, or if it was Steve Kent—it was with Mark Turmell. He was at Sirius Software in Sacramento, California, and there was one programmer who made games for them; his name was Larry Miller. He made a couple games there, one was called *Epoch*. These were 3D games. I found out that the way he made these games was he wrote them down on yellow legal pads, he wrote his assembly on these things, and had tons and tons of them. Then he had his secretary type his code into the computer. But she only typed it in one time: when she was finished.

So Mark and some other people who worked at Sirius were at the office when Larry Miller came in one time with his secretary, and she had this massive stack of probably 20 of these notepads, full of his assembly language for

his latest game. It was going to get typed in at the publisher, and run on the computer. They sat there talking the whole time, like, "I can't believe this is happening. You normally come in with a disk to show the publisher, but this guy did it all in his head."

It got all typed in, they ran it, and it worked almost perfectly. There was a bug with the score, but all the graphics, all the game logic worked, right off those legal pads. It was one of those crazy-genius stories.

I remember when I was working at *Softdisk* magazine, there was a Commodore 64 department. Loadstar was the name of that disk. They had somebody who had submitted code to them. It was a game, I believe, and they liked it and wanted to publish it, but there were a couple of bugs in it. The author lived nearby, and they had him come in to fix the code right there. The guy came in, and I was there, and they listed his program. His program was basically a loop that ran through data statements written in decimal. It was: data, number, number, number, until the program was packed full of numbers.

All this stuff was getting read in from data statements and them POKE'd into memory. So instead of putting machine code into memory, he just had data statements that had operands and decimal values that got read in and POKE'd into memory. He went and edited those data statements directly, and he knew what the codes were and where to insert new ones. It was insane.

Craddock: The fact that so many Apple II developers, game programmers on contemporary games, and journalists converged on one place obviously speaks to the importance of the platform. Could you talk about what the Apple II meant to you?

John Romero: A lot of the game genres that we have today, originated on the Apple II. A lot of the reason is because it was one of the first computers that everybody started making games on, because it came out years before the Commodore 64 and the Atari. So it was the first PC that the earliest pioneers jumped on, like Dani Berry making *M.U.L.E.*, a great multiplayer game, and creating an interface for four players using four controllers with Wheeler Dealers in 1978. The earliest gaming pioneers just jumped on this machine and started pumping out games, and they were inventing genres.

The first game Will Wright made was *Raid on Bungling Bay*, and that came out on the Commodore 64, but Will was not a Commodore programmer. He was an Apple II assembly language programmer, and he cross-developed the game from the Apple II to the Commodore because the Commodore's keyboard sucked. He wrote his game on an Apple II, for the Commodore. All the graphics routines in his code would only work on the Commodore; he had to transfer it all over. He created the whole sim genre; it started with *Raid on Bungling Bay*. The things he did in that game with cities were more interesting him, and that led to him making *SimCity*, which then spawned *The Sims*.

SunDog was an early *Grand Theft Auto*. *Wizardry*, the first RPG on a computer. Economic simulation games? What Will Wright created [*Raid on Bungling Bay*] was something independent of economic city building sims. That genre started in 1962 on IBM mainframes. A woman in a university, her

economics department was paid by IBM to make a game to each people economics, so they made a very verbose game around that concept called Sumer. It then turned into this Sumerian game, which then turned into *Hamurabi*, and so on to an Apple II version. But it started in 1962 on an IBM mainframe, and a woman programmed it.

Several genres popped up on the Apple II, and they were also being furthered very quickly on the Apple II before other platforms were really out. Akalabeth came out in '80; the IBM PC came out in August of '81, before the Commodore 64 in '82. The IBM PC was just a copy of the Apple II, basically: it had CPM for DOS, and a similar slot configuration. So, the Apple II influenced the entire PC industry as we know it today with slots and all the hardware designs that came from copying the Apple II's layout.

Game-wise, so many different games appeared on the Apple II and turned into full genres later.

Craddock: You're even more well-known for your pioneering efforts in first-person-shooter games than you are your passion for the Apple II, a genre in which you innovated alongside fellow id Software co-founders John Carmack, Tom Hall, and Adrian Carmack. Could you trace the team's interest in first-person perspective to a specific game or moment in time?

John Romero: *Hovertank 3D* was the very first [FPS by the id Software team]. I believe that was May of 1991. Actually the very first 3D thing that John wrote was a spinning cube in January of 1991. We finished making *Commander Keen* on December 4th of 1990, and we took Christmas vacations, and when we got back, we were still working at *Softdisk* at that time. We started work on *Quake*. It was called *Quake: The Fight For Justice*. It was a top-down RPG. We spent about two weeks working on it and decided, "You know, *Quake* should be so much better than this. It doesn't look good. It's not going to be *Quake*. Let's just wait until we have the tech."

So we canned it, but during that time, John wrote some code to make a spinning cube appear on the screen. That was his first 3D thing. That was like, okay, he's excited about this 3D thing; maybe that will turn into something later. He thought about it more, and finally, around April of '91, we were making games every few months. February and March was *Dangerous Dave* and the Haunted Mansion. In April, we took two months to make another game, and John decided, "Hey, I think I want to try to make a 3D game."

He started working on *Hovertank*. That was solid-filled polygonal walls, ceilings, and floors. That was his first real 3D code, and it was the only time he felt real stress while making a game because it was hard to do. In fact, he didn't get the game done until the two months. It was just grinding constantly, trying to get 3D working, getting rid of problems like the fish-eye lens—it was his first really, really hard [project]. He got it done under deadline, but that was really, like—and it was all him. He wrote all that code.

In October of '91, we needed to make another game. We decided we were going to work on texture mapping, which I'd heard about from Paul Neurath,

who was making *Ultima Underworld*. I'd heard about texture mapping a whole year earlier in October of 1990, but we didn't do anything about it. I talked to Paul on the phone, and he said, "We're making a game. I can't tell you what it is, but it uses a technique called texture mapping that takes a graphic and maps it onto a polygon." I was like, oh, wow, that's interesting. John Carmack said he could do it, but it wasn't until a year later that we could make a game that could use that concept.

So in October we started making a game called *Catacomb 3-D*. It took two months and was much less painful than doing *Hovertank*. It was in EGA [graphics mode], which was actually the painful part of it because EGA is a total pain to write for. VGA mode, 256-color mode, was so easy to write code for, but EGA was a nightmare. Anyway he got C3D written, which used texture mapping in a 3D game. We finished it in November of '91, and in January we started working on *Wolfenstein*.

Quake was conceived as more of an adventure game. When development stalled, id Software reworked it into an action-heavy FPS like Doom.

Craddock:	You've said in conversations with me and in other interviews that *Quake*'s development was the most tumultuous during your time at id. Did the crunch schedule you all worked result in many ideas left on the cutting-room floor?
John Romero:	Really, only for *Quake*. For *Wolfenstein* and *Doom*, there was stuff we came up with, and we put it in and then took it out because it wasn't true to the essence of the game: run and gun, basically. When we were doing *Quake*, we actually had a totally different design for it that was more like a medieval world. It wasn't even a shooter in the beginning. It was first-person, but not a shooter, and we were going to use other weapons. But it took so long to make the

engine work at a good framerate, and the company was just too tired to inno-vate on the design and see if it would work. No one had the stamina to try and push through this possible new gameplay, so we went with the *Doom*-style shooter and finished it in seven months.

But we did have an idea for the game that was really different. Your main char-acter would have had a big hammer, kind of like Thor, because this was going to be *Quake*. You were going to play as *Quake*, like we wanted to make in 1991. *Quake* was almost like Thor, but he had a thing called the Hellgate Cube which was a companion that had its own personality. It would orbit you, and whenever you were fighting it would help suck the souls out of the enemies you were beat-ing on. If you didn't kill stuff fast enough, or kill enough enemies, it would get upset and just leave, and you'd have to find it somewhere and get it back. That would have been an experiment to see how cool it would have been, and to see what kind of world we could have made around those types of combat concepts.

One thing we thought of for multiplayer was you were going to be standing on top of a cliff somewhere, and someone could come up behind you and hit you on the back of your head with a hammer, and you would tumble forward. You'd be looking at the ground, then the sky, like you're tumbling down a hill. I don't think I'd seen that in a shooter, and it would have been a really different point of view.

Another thing I wished we'd put in there were view triggers. If a view trigger was in your field of view, it would trigger just because you looked at it. Let's say you're going down a path through the woods. There's a cave off to your right. You look over and see red eyes peering out of the cave. Suddenly you hear growling, and the creature starts to come out of the cave just because you looked at it. That could have happened at any point, or it could never have happened because you never looked over there, or there could have been a second view trigger and walking through it would have triggered [the first].

It would have been cool to have view triggers back in 1996. I think some shooters have used it, but not in a major way; just in a visual-effect sort of way.

Craddock: *Wolfenstein 3-D*, *Doom*, and *Quake* paved the way for every FPS that followed. If you had to pick one favorite innovation you and the team at id made, what would it be?

John Romero: That's tough, but I think one of the first ones [that comes to mind] was the design of maps in *Doom*, the abstract design style. Before then, everything was just 90-degree walls—cubes, basically, from *Wolfenstein*. When we started *Doom*, we were just replicating that design aesthetic, and it was just boring and garbage for probably five months.

One day I finally just said, "I'm going to solve this level problem." I spent a few hours going nuts with the *Doom* tech, trying to do stuff we hadn't done before. I made a really neat room that ended up being in E1M2. When you go into the level, you go through the red door on your left, move down the hall that curves around to your right, go up the stairs, and there's a room that has slime in it. Go over the slime and walk onto the elevator. The elevator lowers

into a really tall room that's dark but has some lights on ledges with monsters on it. That's the room that I made.

I brought the artists and Tom [Hall] into the room and said, "This is what we should be doing with our levels." And they said, "Holy shit. That's exactly it. Right there."

Basically, everything made from that point on, in shooters made during the '90s, sprang from that day. Everything before that was [modeled after] *Wolfenstein*-style levels. All of the games—*Ken's Labyrinth*, *Isle of the Dead*, any of the numerous Wolf clones—were all simple copies of *Wolfenstein*. But *Doom* was the first engine that was capable of a more interesting world, but we were still replicating that stupid design until I decided I was going to do as much as I could with the engine. We did even more later on, but that was the very beginning of, "We need to stretch."

Craddock: On my social media feed, I frequently see pictures of you grinning after having just thrashed all comers in *Doom* deathmatch sessions. You were one of the chief architects of the game, of course, so that gives you an advantage. But many pros in eSports say their reflexes start to fail them by their mid-20s. What's your secret to remaining the king of *Doom* mountain?

John Romero: It's probably because I am *Doom*. [laughs]. I made *Doom*; *Doom* is me. It was made for me. I made it. The design of everything worked so perfectly, the way I wanted it. It was all about friction, acceleration, and speed. I tweaked all those values until it felt perfect to me. So when I play the game, it's exactly what I want to be playing. To me it's optimal.

Quake was way slower than I like to play; *Doom* was super high speed. People who are used to playing *Quake* are used to going at half the speed. Unless they're amazing *Doom* players who have been playing for years, I can usually win.

Craddock: What are your favorite levels from the *Doom* and *Quake* games?

John Romero: In *Doom II*, level 26, The Abandoned Mine—I really liked that level a lot because of the verticality of the design. It's very pleasant, in a vertical way, the very first room you start in, but you don't know [it's vertical]. You can look out the windows at other areas lower than where you're at, and there are monsters that will start shooting at you.

So you're stuck at this little room, and you know you're going to flip the switch and bad things will probably happen. But when you're in that room, you have no idea that there are two other rooms connected to that room, and you can't see them because vertically, one of them is not uncovered and the other one is below you. You need to go somewhere else to get to that main room. It's a really interesting design, but very simple. There's a center to the map that has four different paths from it. It seems simple that you have four ways out of the one center area, but each one of those ways leads to a very strategic way of playing in each of the four areas.

Playing deathmatch on that map was really, really fun. It really rewards the person that knows the map well. For *Doom II*, that's the level.

For *Doom*, E1M7 is probably my favorite. It's a pretty complex, big map, and one of the best maps I made in the original *Doom*.

In *Quake*, probably E2M5, *The Wizard's* Manse. I was really happy with that map. That was a fun one. We submerged the player underwater for probably a minute. [laughs] Something like that. That's the first time I drowned the player, and it was terrifying for them when they played. There was also a room in that map that had three levels to it, and you could see up to the other levels. This was before [people knew] about rocket jumping, so it was like, "Oh, wow, I can't wait until I get up there" instead of just [blasting yourself upward].

Craddock: One of my favorite anecdotes of yours is that no one at id foresaw rocket jumping in *Quake*. Thinking back to *Wolfenstein*, *Doom*, and *Quake*, what other techniques did you learn about after the fact?

John Romero: Probably grenade-jumping. [laughs] I held a speed-run contest in 1996, and I used E2M5 in *Quake* as the challenge to beat my time. My time back then was 1:05. We put the contest up on the website. Basically, "*Quake* E2M5 speed-run! Send in your demo files! Beat 1:05 or don't bother." People started sending in all these files, and I was like, oh, man. People were doing little optimizations here and there, really perfect moves.

One person submitted one with a time of 40 seconds. I was like, "40 seconds?!" I checked out his demo, and of course, I learned something. He got to the very top of E2M5—I think he was rocket-jumping—but when he got up there, he got in the elevator that submerges you, and he went to press the button and rocketed himself off the button. So the button [triggered]. There was a door behind you that slammed shut in one frame, but he rocketed himself into the door as it was shutting because you couldn't go faster than the door. He took damage for about 10 seconds until the door let up, but that meant he basically could go anywhere on the level from that point because he'd bypassed the level. He went straight to the exit and got out. Instead of losing one minute underwater, he only lost 10 seconds.

Craddock: The '90s is my favorite era for FPS games. Even though countless *Doom* clones cropped up, there were so many games that just borrowed a few ideas and seeded them in unique designs. Two of id's biggest competitors from that time were 3D Realms with *Duke Nukem 3D*, and Epic Games with *Unreal* and *Unreal Tournament*. Did you ever play those games and think, *Wow, this is cool, I wish we'd thought of this?*

John Romero: I didn't ever think that anything in Duke was something we should have done; I just thought *Duke Nukem 3D* was amazing. I love that game so much. I listened to the soundtrack to that game every day for years. And the game itself, I was just crazy nuts over it. I played through the whole thing multiple times. The humor was so funny, and the interactive environments and music worked so well together. Some of those sounds were so scary. I mean, the Octo-brain sound? You don't ever want to hear that sound. It's [terrifying]. The boss of the shareware episode? Holy crap. You don't ever want to hear that guy because that sound means you're going to die.

It was one of my favorite games. All of the funny references in there—maybe I wish we would have done something like that in *Doom*. But the references were great.

Unreal Tournament was really amazing with the variety of levels they had. Playing deathmatch while floating through space and jumping onto a space-ship? That was nuts! I loved it. It was great. I loved the weapons that they had; alternate-firing weapons, which we didn't do in our games. Maybe I wish alternate fire is something we would have done. *Heretic* did that before anything else did, then [*Star Wars*] *Dark Forces* did it. But I had a lot of fun playing *Unreal Tournament*.

Craddock: *Half-Life* is viewed as the game that broke the *Doom* and *Quake* mold of "find keys and kill everything." How would you quantify *Half-Life*'s and Valve's impact on FPS design?

John Romero: When you're designing an FPS and you want an FPS to scare somebody, what can you do to make a monster scare the hell out of the player? Make the monster appear where they wouldn't expect. The story of *Half-Life* supported aliens teleporting right in front of your face. That's one of the scariest things ever: when something just appears in front of you.

They used the *Quake* engine to make that game, and they did a great job with the programming. Really smooth animations, great AI, and stuff that made the player wonder what it was and how it worked. The way they told a story cinematically, never taking control away from the player.

And just the variety of places you could go. I know some people didn't like it that much, but I loved going to Xen. I thought that was one of the best parts of the whole game, because the way the level design opened up completely was unexpected. Some of the later levels on Xen were linear and [standard], but that first level was just really different. Jumping down from the platforms all the way down to the bottom area where you're exploring and looking at plants, and the plants pull into themselves when you get too close.

What a great game. Great variety, great use of color, great sound effects. They just did everything perfectly. It was a great game. And *Half-Life 2* was also incredible; easily one of the best FPSes ever made.

Craddock: I'd say the last huge paradigm shift in FPS design came in 2007 when Infinity Ward released *Call of Duty 4: Modern Warfare*. Why did that game make such a big impact relative to other games in between it and *Half-Life*?

John Romero: I think because it's military [in theme], and not going back to World War II. People were glad to get past that [setting in video games]. I had the original *Call of Duty*. I believe that was also written off of the *Quake* engine. I wasn't really excited about the original one; the only interesting thing they did there was make these objective points you had to get past. It was like "What else can we have people do in a shooter level?" It was a way to progress a level: have an encounter until you beat it, then go to the next objective.

But [*Call of Duty 4*] *Modern Warfare*, which is similar in that respect, modernized the weapons and scenarios. I think people were ready for that. That

was the first *Call of Duty* that I [understood]; like, "I would rather play this than the World War II stuff." I really loved *Modern Warfare*. It was a really great game. I loved the scenarios where you were trying to go through the building with a sniper rifle, and the Ferris wheel and bumper car area in the abandoned carnival, trying to figure out how to kill everything and in what order you should do it in. It just had a lot of great stuff in it.

I think *Modern Warfare* was just the right design at the right time for that genre.

Craddock: Another facet of FPS design I miss is built-in modding. *Doom* and *Quake*, especially *Quake*, were so inviting to amateur game developers. In contrast, AAA games are closed off. Some of the most popular and profitable games of the modern era came about from mods: *Team Fortress 2, DOTA 2*, and *Counter-Strike*, just to name a few. Do you think the tendency of publishers to build walled gardens has stunted game design?

John Romero: Yeah. I think there's a middle ground. With poor tools, makes it harder for people to mod the game. But closing the game off, and not allowing people to run their own servers, kills the potential for the game to live for a long time. In the middle ground, you could support modding and release really nice tools for your game, kind of like the way *Pinball Construction Set* worked. Everybody could make pinball tables on it, and they could come on their own disks, and you don't have to know anything about programming, or format a disk, or anything.

I think with modding games, you should be able to release tools that are easy to use and that keep people away from the low-level details they don't need to know, but still give them the ability to modify config files if you know how those work, and let players run their own servers. As long as it's not for commerce. Look at *Minecraft*. That's a perfect example of how to open up your server, but a terrible example of how to let people mod your game. *Minecraft* is probably one of the worst games to try and mod.

Craddock: These days, AAA publishers want FPS games in the vein of *Call of Duty 4* and *Battlefield*. I don't want to take anything away from those games or their ilk, but I don't see nearly as much variety in FPS gameplay, color palettes, or weapons as I did during the 1990s. What are your thoughts on the state of FPS?

John Romero: More experimentation would be great. The reason those games are stuck in that design style is because of the amount of money it costs to make one. Publishers say, "I don't want to take a risk. I'm not putting that much money into something [unknown]." They're going to do what's expected, and people will buy it, so why would you not do that?

Experimentation is still going to happen, but in smaller-budget FPS games. I think people making more of those, with different themes and ideas, something is going to click the way that *Half-Life* clicked. It's just that people need to do more experimentation.

7

Brian Fargo
Founder of Interplay Entertainment and InXile Entertainment

In October of 2013, I released the first eBook in my *Stay Awhile and Listen* series, which documents the history of Blizzard North and Blizzard Entertainment. One of my goals in writing Stay Awhile and Listen was to craft a digital monument that celebrated the era, people, and games of Blizzard Entertainment and Blizzard North—hence the name of the e-publishing company I co-founded with my wife: Digital Monument Press. To that end, I conducted extensive interviews with dozens of former Blizzard developers as well as developers who played a part in the history of Blizzard Entertainment and/or North. One such individual was Brian Fargo, founder of Interplay Productions (later renamed Interplay Entertainment).

During our interviews, Brian and I covered history leading up to and beyond Interplay's founding, and I did not want to scrap all that information just because it did not directly relate to Blizzard or *Diablo*. This chapter collects the rest of that interview and explores Brian's exposure to game programming, the guerrilla marketing tactics he used to get his early games on store shelves, and much more.

**

Craddock: What led to your interest in making video games?

Brian Fargo: When I was in junior high school, they had a mainframe computer. People talk about the cloud now, but everything was in "The cloud" back then. You just had a dumb terminal talking to a mainframe. I was fascinated by computers even though there wasn't much in terms of games. The coin-op business had just gotten to the point where games like *Pong* and *Space Invaders* were emerging, and it was those games that first got me interested.

Then my parents got me an Apple II in high school, and that really opened my eyes to how you can make games, how I could go beyond just playing them. I played a lot of the older titles. I remember there were some old strategy

titles where you would make a move and the computer would take two to three hours to process its turn. You'd go crazy when a game crashed halfway through because that meant you just lost three days of playing.

So I really discovered games through those means. I always had a background in reading a lot of fiction: comics, *Heavy Metal* magazine. Playing *Dungeons & Dragons* was a big part of high school for me. But the thing that I think led me to create games—which I think most people would give the same answer to—was, I looked at what was out there and thought, *You know, I could do better.* That's what sent me down my course.

Craddock: What was the first game you made?

Brian Fargo: One of my high school buddies was Michael Cranford. His parents wouldn't get him a computer, so he used to borrow mine. We made this little adventure game. I'd give him the computer over the weekend, he'd write code for a section, then he'd give it back and I'd try to finish his section and do my part, then he'd go through mine. We'd go back and forth. We did this all summer.

We made this little game called the *Labyrinth of Martagon*. We actually put it in some baggies and probably sold five copies. That would be a very obscure, technically speaking, first game. But one that really got into distribution would be *The Demon's Forge* [released in 1981].

Craddock: Before Interplay, you created Saber Software to release *The Demon's Forge*, an adventure game in the vein of games like *King's Quest* where players typed in commands to interact with the game. What made you want to create an adventure game, and how did you attract attention in Demon's Forge as a small, one-man studio?

Brian Fargo: I was a big fan of adventure games. I loved all the [adventure games developed by] Scott Adams, all the Sierra adventures. I also liked *Ultima* and *Wizardry*, but from a coding perspective I wasn't strong enough to do that stuff, but I thought I could do an adventure game. It was a category I liked, and I liked medieval settings.

As far as attracting attention, I had a budget of $5000 for everything. My one ad in *Softalk* [magazine] cost me about 2500 bucks, so 50 percent of my money went into a single ad. One of the things I did was I would call retailers on a different phone and say, "Hey, I'm trying to find this game called Demon's Forge. Do you guys have a copy?" They said, "No," and I said, "Oh, I just saw it in *Softalk*. It looks good." They said, "We'll look into it."

A few minutes later my other line would ring and the retailer would place an order. That was my guerrilla marketing. I was selling to individual chains of stores. There were two distributors at the time that would help you get into the mom-and-pop places. It was a store-by-store, shelf-by-shelf fight.

From a magazine perspective, there was really only *Softalk*. There was another one at the time, but *Softalk* generated the most business, so it was all about getting their coverage. In a way, they were like the iTunes of the day. You had to have their support.

Before *Fallout* and other RPGs, Brian Fargo was known for text-driven adventure games such as *Mindshadow*.

Craddock: It sounds like Saber Software got off on the right foot. What led to your transition from Saber to Interplay Productions?

Brian Fargo: There were some Stanford graduates who wanted to get into the video game industry, and they bought my company. They paid off my debt and I made a few bucks, nothing much to brag about. They made me the vice president and I started doing work for them. It became one of those things where there were too many chiefs and not enough Indians, and I was doing all the work. I was with them for about a year when I quit and started Interplay in order to do things my way. I'd gotten used to running development, so that seemed like the next natural step.

With Interplay, I wanted to take [development] beyond one- or two-man teams. That sounds like an obvious idea now, but to hire an artist to do the art, a musician to do the music, a writer to do the writing, all opposed as just the one-man show doing everything, was novel. Even with Demon's Forge, I had my buddy Michael do all the art, but I had to trace it all in and put it in the computer, and that lost a certain something. And because I didn't know a musician or sound guy, it had no music or sound. I did the writing, but I don't think that's my strong point. So really, [Interplay was] set up to say, "Let's take a team approach and bring in specialists."

Craddock: *Mindshadow* was Interplay's first game. What do you feel set *Mindshadow* apart from other text-input adventure games of the time?

Brian Fargo: I think most other adventure games were about good versus evil or trying to survive in a hostile environment, that kind of thing. *Mindshadow* was about remembering who you were. It was loosely based on the original Bourne Identity. That made it a very unique approach. You would discover clues, and if somebody said, "I ran into a David Craddock," you'd say, "Think David

Craddock," and if that toggled something in your mind, a memory would come rushing back.

It was all about discovering who you were after waking up on an island with amnesia. That, and I got a pretty decent artist to work on it, a guy named Dave Lowery, who eventually went on to work at Skywalker Ranch and do *Willow*. We didn't give him the greatest tools, but he did great work with what he had.

As a funny adjunct, I found the source code for *Mindshadow* about a month ago. I was searching through all my records, and the programming was done by [Allen] Adham, one of the founders of Blizzard. When he was still in high school, I had him doing contract coding for me on adventure games.

Craddock: Text-input adventure games were a very special genre to a lot of developers and gamers. I always felt like I was reading an interactive book as I played, even when the genre started to combine graphics and text input in games like *King's Quest* and *Mindshadow*.

Brian Fargo: I remember Infocom was the big text adventure king at the time. They used to run ads talking about how graphics weren't necessary. I used to get a kick out of that. I can appreciate the cerebral nature of it all, to say that graphics weren't important. They ran ads saying something like, "We don't need graphics because the best graphics come from your brain." That certainly gives one perspective of that era.

Craddock: In addition to *Mindshadow* being Interplay's first game, I believe it also marked your first opportunity to partner with a big publisher, Activision. How did that partnership come about? What was it like working with Activision?

Brian Fargo: That's a good question. I think because of the work I did at the other company—it was called Boone Corporation, the one right before Interplay—we had some awareness. Somehow we hit Activision's radar. They contacted me and liked what we were doing. They were moving from being an Atari VCS company to being a publisher for the computer, the Apple II in this case. I think we made the first floppy disk product Activision ever shipped in *Mindshadow*.

They liked it. They liked the plot line and what made it novel. We ended up doing a multi-product relationship with them.

[Author's Note: Boone Corporation was owned by Stanford University graduate Mike Boone. Boone Corporation acquired Saber Software and re-released *The Demon's Forge* under the Boone Corporation label.]

Craddock: Arguably Interplay's most popular game during the early 1980s was *The Bard's Tale* [*Tales of the Unknown: Volume I*]. The game also marked a transition from adventure games to proper role-playing games for Interplay. How did *Bard's Tale* come together?

Brian Fargo: I had a lot of diverse friends. I was big into *track and field*, I played football, so I had those friends, then I had friends from the chess club, the programming club, and a *Dungeons & Dragons* club. Michael [Cranford] was from that side. I always thought he was a pretty bright guy and one of the better dungeon masters.

We played a lot of D&D. We always tried to focus on setting up dungeons that would test people's character as opposed to just making them fight bigger and [tougher] monsters. We'd do things like separate the party and have one half just getting slaughtered by a bunch of vampires and see who would jump in to help them. But it wasn't really happening. It was all an illusion, but we'd test them.

I always got a kick out of the more mental side of things, and Michael was a pretty decent artist, a pretty good writer. He was my D&D buddy, but then he went off to Berkeley, and I started [Interplay]. He did a product for Human Engineering Software, but then I said, "Hey, let's do a *Dungeons & Dragons*-style title together. Wouldn't that be great?"

That's really how the game came about. He moved back down to Southern California, and I think we actually started when he was still up north. But then we worked on *Bard's Tale* together, kind of bringing back the D&D experiences we both enjoyed in high school.

I found the original design document for *Bard's Tale*, and it wasn't even called *Bard's Tale*. It was called Shadow Snare. The direction wasn't different, but maybe the bard ended up getting tuned up a bit. One of the people there who has gone on to great success, Bing Gordon, was our marketing guy on that. He very much jumped on the bard [character] aspect of it.

Craddock: Putting a bard in a starring role was the most interesting aspect of *Bard's Tale* for me, plot-wise. That protagonist slot is usually reserved for meatheads and wizards.

Brian Fargo: At the time, the gold standard was *Wizardry* for that type of game. There was *Ultima*, but that was a different experience, a top-down view, and not really as party based. Sir-Tech was kind of saying, "Who needs color? Who needs music? Who needs sound effects?" But my attitude was, "We want to find a way to use all those things. What better than to have a main character who uses music as part of who he is?"

Craddock: Electronic Arts published *Bard's Tale*, not Activision. What drew you to EA instead of sticking with Activision?

Brian Fargo: EA was more gamer-focused as a company. Activision's executive management was more the big business, CEO and CFO types, whereas EA, starting right up with Trip Hawkins and all his guys, they were gamers. When we would try to explain *Bard's Tale* to Activision, they didn't really get it. Whereas when I would take it to EA, they got it—boom. Just like that. You want to be with somebody who gets it, and they clearly got it and were excited about it, so we moved fast with them.

One of the big things at the time was, they hated each other, Activision and EA. Just hated each other. We were maybe the only developer doing work for both companies at the same time and they would just grill me whenever they had the chance. Whenever there was any kind of leak, they'd say, "Did you say anything?" I was right in the middle, there. I always made sure to keep my mouth shut about everything.

FIGURE 7.2
InXile's remake of *The Bard's Tale* (2004).

bullocks you'll get struck. Oh, it's bad luck to be
you. Now, Ogan came young from the farm and

Craddock: While we're on the subject of *Bard's Tale*, I'd like to know more about the
 remake your post-Interplay company, inXile, put out in 2004. That one was
 dramatically different in tone; it was much more humorous than the original
 from '85. What brought about that change in theme and direction?

Brian Fargo: I'll give you my mindset at the time. I took some time off after Interplay. I'd
 been working for almost two decades straight. So you take some time off.
 Great. But you start getting an itch after two or three months. I spent that time
 playing everybody's games, especially the role-playing games, and they'd always
 start off sending me into the cellar to kill rats and just doing this super generic
 stuff.

 I thought, *Oh my God. I've been [making RPGs] for so many years, and it's all
 still the same thing.* So I thought—this was kind of like a comedian deciding
 he wants to do a drama—I just wanted to do something different. The player
 would play a main character who felt how I felt about the same old dialogue
 and the lack of creativity.

 If you want to design a role-playing game, I can sit down and bang out a
 design in an hour as long as it's, "Okay, here's a dragon, here's two trolls guard-
 ing a dungeon entrance." We can all sit down and do that in an hour. But if you
 want to do stuff nobody's heard of before or seen before, that's creativity. That
 takes a while. I wanted to do something that was just totally different and sort
 of poked fun at the RPG.

 The *Bard's Tale* [released in 2004] is nothing like the original. For people
 who were dying to recapture that experience, that wouldn't be what they
 wanted. But for people who just took it at face value, they got it and loved it.

The real testament to that was we released it on [iPhone and iPad] in December 2011. It was the number one RPG on iPad and a top-10 game. We were up there with *Angry Birds* and *Words with Friends*. It got all five-star, 90-percent reviews just because of all the humor in that game.

That crowd took the game for what it was. They didn't try to compare it to the original. And I understand some people were hoping for that, but it was a console game, right? Not to mention I couldn't have gotten a PC RPG funded at that point, anyway.

Craddock: That makes me curious as to your thoughts on the MMORPG genre. Now there's a category of games in need of a different direction.

Brian Fargo: I haven't gotten into them [MMORPGs] as much, probably because I like more of a narrative structure. To me, whether it be *Wasteland* or *Fallout* where you have these morally ambiguous situations—my favorite movies are like that. I love the Guy Ritchie films where there's an edge to the story. You're making it through and hearing really witty dialogue. I love that.

Whereas MMOs are more about interacting with other human beings and not so much about story structure. I appreciate MMOs, but they are more of a grind and more formulaic. They're just a very different experience.

Part II

Ad Hoc

8

John Hancock
Game Collector

John Hancock has collected about 10,000 video games. His garage-turned-game-room bursts at the seams with cartridges, discs, boxes, cases, instruction booklets, bookcases, posters, cardboard boxes resembling treasure chests that hold odds and ends. All eras are represented, as are the complete libraries for over 24 game consoles. *Pong* machines, those earliest of consoles, dominate an entire bookcase. Nintendo and Sega cartridges take up entire walls. Opposite walls. John wouldn't want *Mario* and Sonic trading fisticuffs when he isn't looking.

But games are not truly what John collects. Cartridges, CDs, and DVDs—these are merely the manifestation of his true treasures. He has cleaned out mom-and-pop shops, plumbed yard sales, scavenged the remains of video rental stores, and traveled far and wide to conventions, "nerd binder" in tow. From each destination, he returns with a game (usually more than one). More importantly to John, he returns with a story. Not the story of how a game came to be, but the story of how the game made its way to him.

In this interview, John opened up about his early experiences collecting games, why he drained his savings account only one year into his marriage, and how he hopes to preserve his collection of games and stories for future generations.

**

Craddock: When did you become interested in playing games?
John Hancock: I've been playing games since I was a kid. I think my first experience with games was a TV scoreboard, Radio Shack *Pong* clone. I was pretty young, probably five or six. I was also exposed to many arcades in the area, so I'd say I was four or five when I was exposed. I used to sit on bar stools to play [arcade] games because I was so small.

That evolved from *Pong* and arcades to home consoles: an Atari 2600 down at my cousin's house. I was bad at playing games. They'd always beat me in *Combat*. But that was one of my first experiences.

Craddock: How did an interest in playing games lead you to devote so much time, energy, and money to collecting them?

John Hancock: That's a little more complicated. Starting out, I would sell comic books. I got them from my barber. They were used; a lot of them had the covers ripped off. I would read them, and I tried giving them back, but he said, "Oh, no, go ahead and try to sell those. If you get enough money, you can buy more comic books."

So I'd take these old comic books, and there were some that were really old and probably worth something. I'd make a little money, and I used the money to buy comic books and baseball cards. I got really into baseball cards and started collecting those. I got tired of it, and moved on to action figures. By the early '90s, I was done with action figures. I'd amassed a pretty decent collection.

Around that time, I started getting the [video] games I had growing up. That restarted my game collection. I'd been collecting games since high school, but I'd sold my collection to get through college. So I restarted collecting games in the mid-'90s, starting with loose [NES] cartridges, Odyssey 2, Atari [2600], and Sega [Genesis].

It blossomed from there. I was going after stuff that nobody else was going for. I had a lot of friends who were into Atari, and they would trade me their extras. At Funcoland, which was awesome back in the day, I had my own hold drawer. I would give them my Keppler's rarity guide books, and they would go through and try to find all the games they could from other stores. With my extra money, I'd get games from them. I used them to complete my NES set.

Craddock: You own an extensive collection of *Pong* machines. Did your early experiences with *Pong* draw you to collect those units?

John Hancock: You know, I don't know. I've always been drawn to forgotten games. I'm just an average guy, an average salary man with a very non-average hobby. When I first got into the hobby [of collecting video games], I was driven to collecting oddball [pieces]. One of my first systems was the Odyssey 2, and part of the reason is because nobody cared about it.

Pong systems have continued to be underrated. They were fun, and like many things, they were made in overabundance and went away suddenly. To me, the aesthetics of them is really appealing. The crazy 1970s and early '80s box art—I just like collecting stuff like that. You can find lots of older [forgotten] stuff, and it's affordable too. It is quite hard to find stuff that works 100 percent, but it's just something I've done on a budget. It's just a lot of fun for me to collect.

Craddock: You told me over email that you recently adopted a little girl, which is awesome. How has your hobby changed from the time you started until now? I imagine Younger John had more money for games than Responsible, Older John.

John Hancock: Yeah, Older John is more responsible with his money. Younger John drove hundreds of miles [to find collectibles]. I drove hundreds of miles to complete my first set, but I don't do that as much anymore. I have a friend with a game store in town. He sets aside quite a bit, and I do many trades with him. He's there every day, so that takes the burden off of me to have to hunt on the side.

I would say things have gotten really valuable. When I started collecting, I was collecting just for fun. Everything was affordable. Now, it's still fun, but

I don't collect doubles of things unless it's, say, an older console [in case the original stops working] because everything has gotten so expensive. I've had to change what I pursue because of money.

That's always going to happen. Back in the day, different things were expensive. Now, more and more people are collecting games, so you find less and less. Having such an extensive collection makes it difficult to find stuff in the wild. I don't do a lot of eBay hunting. I tend to sit and wait on something, leaving it open to, "Well, if I find this today, then I'll pursue that."

A good example is, right now, Nintendo is hot. Everybody's collecting Nintendo, so Nintendo items are through the roof. I tend to stay away from that. I still collect Nintendo, but it's not a priority because it's so expensive.

I'm not a big eBay seller. I use eBay to sell my late-90s to early-2000s [items], and I used that money to find stuff locally to add to my collection.

Craddock: Which Nintendo systems and games do you find are the most expensive or hardest to find?

John Hancock: What's super-hot right now is N64 and Super NES. I'm about 35 games away from completing my Super Nintendo [collection], but some of the games cost hundreds of dollars. I could spend all my game money and get one game, or I could pursue [clusters of less-expensive games]. I usually wait for conventions. If I generate money at a convention, I'll have money to buy other games.

Super Nintendo and N64 [games] are not rare, but when you find the sought-after stuff, it's always expensive. I have a lot of the rare games, but I'm still 35 games away. One of the games I'm missing is *Wild Guns*. I have the box and manual, but I don't have the game. A loose game [without box and instructions] runs around $150. That's a lot of money.

You rarely find Neo Geo stuff, and when you do, it's really expensive. I've been lucky and have found a couple of systems, and at conventions, I found some good stuff too.

Craddock: Is it easier to collect forgotten systems and games because no one cares about them?

John Hancock: No, you can't go off of age. You have to go off of popularity. Odyssey 2 is a good example. For most Odyssey 2 stuff, people wanted to collect an older system that nobody cares about. It's known as the Videopac overseas.

I would say there are many great systems out there that don't break the bank. Like, the Atari 2600: if you don't go for the rare stuff, you can find games for a dollar apiece, usually. Intellivision is the same way. I prefer the 2600 over the Intellivision just because there are more games, and there's a robust homebrew library. Odyssey 2's another console that has a lot of people still pumping out homebrew games for it. I just got some last year and the system is well over 30 years old.

Craddock: How many games do you have in your collection today?

John Hancock: I've done loose counts, and it's tough because I do count computer games. I don't have a lot, but I do have 500–700 games for Commodore Amiga, Atari, TI-99, tons of floppies. It's about 10,000 [games total], but I haven't done a count recently.

I can honestly say that my mass collecting has slowed down. I'm working on box upgrades and condition upgrades. If I have a loose cart, I try to upgrade it. I'm down to less than 100 boxes needed for a [complete] NES set.

Craddock: You have over 24 complete sets. Do you have any interesting stories behind how you acquired some of those?

John Hancock: Yeah, there's a funny story behind how I got my complete, loose Game Gear set. I used to lurk on Cheap Ass Gamer a long time ago, maybe six or seven years ago. Game Crazy was clearing out their Game Gear games for a song. Back in the day, I had a friend [on Cheap Ass Gamer] who would tell me, "Hey, this deal is going on." He was really nice, and he told me about this Game Crazy in Oregon City.

I went to a local Game Crazy, and they told me, "It looks like they [the store in Oregon City] have 250 Game Gear games." I said, "Oh, wow. This might be a great opportunity to score a lot of games for cheap." I go down there, and it's about an hour away. I walk in and say, "I'm here to see what Game Gear games you have." They look at me dumbfounded: "What is that?"

The youngest employee, couldn't have been a day older than 18, said, "Oh, I know what those are. The old manager said these games were stored back here." He goes into this cabinet, pulls out two garbage sacks, and pours them onto the counter. So I make this enormous pile. I have my nerd binder [to track what games I need], and the guy said, "Are you going to get all of those? Did you bring a lot of money?" I said, "Start ringing them up."

He started ringing them up, and they all rang up as $1. I knew that whatever I didn't get, someone else would snag. I said, "I'm probably going to get everything," but I made sure to only get one of everything. There were a good 150 games right there, one shot, that I was able to add. I got some extras [of games I already owned] that I knew I could trade for other games. That's how I completed my Game Gear set.

One of John Hancock's first complete collections was the library of titles for Sega Game Gear.

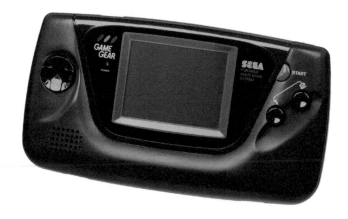

Craddock:	Have you ever acquired a console and its complete set of games in one fell swoop?
John Hancock:	Yes, the InterActiVision. That was at a convention. It was just one of those things. The InterActiVision was just this stupid, VHS-driven game system that no one cared about. The guy said, "You can take it all for 100 bucks."
Craddock:	As your hobby ramped up, was your goal to complete sets, or were you more interested in following your passions? For example, you're a big Sega fan. Did you want to complete a Sega collection because you were a fan, or because you wanted a complete set?
John Hancock:	You know, it's funny: I didn't start out wanting to complete anything because I didn't think it was possible. I was just having fun. I started off as a Sega [Genesis] collector, and part of the reason I pursued Sega was because it was a third of the price [compared to NES and Super NES]. Everybody wanted Nintendo, and Sega, for some reason, was kind of like Intellivision: it was the black sheep. It's gaining more popularity because Super Nintendo is so expensive.

In the era of declining mom-and-pop video stores, I hit every video store up and down the west coast in Northern California and Oregon. They would clearance-out their Sega games, and I'd buy them all up. Even when I moved up to Washington nine years ago, I only had half a Sega Genesis collection. I thought, *Man, it's going to be a struggle to get everything.* I just focused on it. It was just the right time. I was getting games for five bucks apiece.

I had a lot of loose games. During my final days in California, a friend scored me about 300 game manuals, and the artwork on the spine of game boxes. So I piecemealed a lot of my Sega Genesis stuff.

Craddock:	So you were on the Sega side of playground arguments?
John Hancock:	That's tough. I was one of the first kids on the block with a Sega Genesis. It was the first system I [purchased] with my own money. I was 12 or 13, and I showed my dad the Sears wish book. I opened it to the Sega, and said, "Dad, this looks awesome." He looked at me and said, "You know how you're gonna get that?" He pointed to the front yard: "Start mowing."

I busted my hump, washed and waxed cars. I think I saved $249 and got my own Sega Genesis. It was a Model 1. I eventually got a Sega CD and a 32X. Late in high school, I jumped into Super Nintendo. But predominantly, I was a Sega Genesis fan. My friends were really into *Mortal Kombat* and RPGs, and so we played a lot of Sega. Super Nintendo was, for me, all about The *Legend of Zelda*, *Super Mario World*, and *Super Metroid*. I played those games over and over again.

I had a Nintendo [NES] before a Genesis. I played my Super Nintendo almost as much as my Genesis, but I probably played my Nintendo more than both [the SNES and Genesis]. But I really did pursue Sega just because it was more readily available. Nintendo was just so much more expensive. It still proved to be fun to collect. I got a couple of lucky breaks, like finding

ma-and-pa stores with large amounts of Nintendo games. That let me knock out a bunch in one shot; I didn't have to piecemeal as much.

Craddock: You've got me reminiscing. Xbox One and PS4 are pretty much interchangeable, aside from the odd exclusive. I miss the days when consoles released in the same hardware generation felt different. There were reasons to own a Genesis and a SNES.

John Hancock: There's something to be said about that era. We saw such radical changes. I remember saying, "Oh my gosh, the graphics can't get better. This is it." The good thing is, almost any console can pull off so many different things, whether it's sprite-based or 3D. But we've kind of lost that evolution. With the PS4 and Xbox One, a lot of people commented that their games don't look that much better [compared to games released late in the lifecycle of PS3/Xbox 360]. It's the law of diminishing returns. You can only push the envelope so much.

At the end of the day, it really comes down to gameplay. Is a game fun to play? Some games are all graphics, and those games get forgotten. But if a game is challenging, or if it has a good story, that's one of the games that people remember.

Craddock: Do you pursue modern systems as well?

John Hancock: I do. I got my son a Wii U, and I do collect 3DS. I don't collect it like I collect the old stuff just because it's still expensive. I have a pretty robust PSP collection, and when I say robust, I mean a couple hundred games. I have PS[1], I have about 100 Wii games and Xbox 360 games. I have about 70 titles for PS3.

I pursue newer games, but it's different. I pursue stuff I'm going to play on those systems. If I ever do have a museum—which I think is the end goal I want to pursue; a place to [peruse] gaming from different eras—my collection is primarily from 1972 through 2010. My most modern complete set is Sega Dreamcast. I have very fond memories of being a manager at GameStop for the launch of that system.

Sega went out with a great system. It's unfortunate that [Dreamcast] was their last system, especially considering where Sega is now. But at least they went out on a great system.

Craddock: I always felt one of Sega's problems was they would introduce a really cool technology, but then they abandoned it quickly to chase the next new thing.

John Hancock: Yeah, they would put all their eggs in one basket. Obviously, Sonic was the most successful game they made. But they made so many Sonics, and not all of them were great. Some of the 3D Sonics were good, but there's so much more to Sega that they never pursued. They're so Japanese sometimes, and that kind of got lost in translation.

Craddock: What research do you do before buying games? Do you set out with a mission, or do you just like to try your luck?

John Hancock: It's definitely more try-your-luck, but I do keep up my nerd binder. To this day, I know there are databases and checklists out there, but there's not really a

database or checklist for me unless I create it myself. I have two binders of lists of stuff I'm looking for. Currently, I just finished a *PlayStation Greatest Hits* set. I am now looking to pursue *Xbox Platinum Hits*.

It's been a lot of fun. The cool thing about collecting Greatest Hits that is you're getting the cream of the crop of a system's collection. I wouldn't say it's affordable, but it's more affordable.

So I do have checklists, but more than once, I've gone to a game con[ference], saw something, and said, "I'm going to get that."

Craddock: In reading up on you for this interview, I noticed you like to collect game-related items as well as consoles and games. Which type of game-related items do you like to pursue? For example, do you have complete runs of any magazines?

John Hancock: I probably have more accessories that most people, but I'm just out of space. I like posters and find those at game conventions. I have a bunch of those on my ceiling, gotten from conventions I've been to or hosted. I have weird stuff, stuff my son made, just stuff that means something to me. I have an early Halo standee.

So, the accessories are cool. The problem is they're easily destroyed unless you get them framed. Which is great, but expensive. I wish I had wall space, but I'd rather have a wall of spined-out games than a bunch of accessories.

Craddock: How did you organize your room? It seems like you have as much fun showing off and talking about your collection as you do building it up.

John Hancock: The first thing to know is that I didn't do it to myself. I would have been overwhelmed, and I'm not the biggest builder guy, even though I look like the guy from Tim the Toolman Taylor's show [Al Borland character on Home Improvement]. I have a single-car garage, and when we bought the house, it was just a mess. Paint on the floor, the walls were uneven drywall, and the garage had one electrical outlet.

With the help of my father-in-law, I added a bunch of outlets and carpeted the floor over about a year and a half. I just took plywood, cut it into strips, and used five-inch brackets and a stud finder to measure out how many shelves I would need, especially if I wanted to expand. I put Nintendo on one side, Sega on another, and Atari on another.

Within the last nine years, I've outgrown it. I outgrew it about four years ago. There's stuff in boxes. I have it organized as nicely as I can, but I could easily fill a much bigger room. I think about, *What if I had a thousand square feet? What if I could dedicate an entire wall to Atari systems?* The 5200, the 2600, the computers, the Jaguar—just one entire wall. I think that would be awesome.

One of these days, that's how I'll organize it. There'll be the Atari mega-wall, and Sega will have its own mega wall, and Nintendo will have one. Hopefully, one day this will all be in a museum. I think there are collectors out there who are super specialized. They have prototypes, or shoot for, like, all the Super

Nintendo [models]. I want to have the ultimate comprehensive collection. Something that covers the basics as best as possible.

Craddock: How much thought have you given to the museum idea? Would you like to sell the collection to a museum, or open a small place of your own?

John Hancock: I've had a couple of people show interest, but I have put a lot of time and effort into this. It's all willed to my son and my daughter. I would like to have control over that in a museum to make sure it gets the appropriate [level of care].

Actually, I'd like to be the curator of my own museum someday. I've had a couple of people contact me about doing something, but it just wasn't a good fit. That's the nicest way to say it. They wanted to use my collection for a museum, and I wasn't really sold on what they were going to do with it. I think the collection is more valuable kept together. When I get old and crotchety, I'm not going to want to move around a lot. I want to put it in a place where the public can come and see all of it.

I consider myself a retro-gaming historian or specialist, and I'd like to continue to advocate for the hobby, and make sure that it can be remembered. Whether the ROMs in the games continue to work or not, the packaging is just as fun for me to collect.

Craddock: What is the single most valuable item in your collection, and what's the story behind how you got it?

John Hancock: It's easy to say *Stadium Events* [for NES]. I have some other interesting stuff, though. I have a loose *Outback Joey* in a plastic case. It's much rarer than *Stadium Events*. It came with the Heartbeat Personal Trainer, which is the same [hardware] as the Sega Genesis. You can stick the [*Outback Joey*] cart into a Genesis, but you can't play it.

But my *Stadium Events* game is probably my most valuable item. It's worth around $6000 now. I got mine for a hundred bucks. The story behind that is, the Classic Gaming Expo from about a decade ago started their Question-Mark-Box mystery auctions. All the money went to the Special Olympics. You donated money and didn't know what you were going to get. People weren't really excited about it. The previous auction ended up being an [Atari] 7800. Some guy spent around $130 and didn't get anything good.

What Classic Gaming Expo did was piecemealed a *Magic Card* 2600 game together from an original, nonworking product. *Magic Card* is super rare, sought after. At the time, I wasn't really pursuing Atari 2600. I came to the auction late, I had 100 bucks to my name, I won, and immediately I got people wanting to deal with me.

At the time, 10 years ago, I was only missing one game from my NES set, and that was *Stadium Events*. I put a bid out: "I'll trade this for *Stadium Events*." A guy halfway across the United States said, "Not only will I buy *Stadium Events* off of eBay for you, I'll throw in a sealed *Cheetahmen II*, *Rainbow Island*, and some other stuff, boxed, for your collection." I already had a sealed *Cheetahmen*

II, which I immediately sold, and used that money to work on the Sega Genesis collection.

So I got *Stadium Events* and a bunch of other games for negative money, considering their worth.

Craddock: Setting monetary value aside, what are some of your personal favorite items in your collection?

John Hancock: That's easy. I have a white Astrocade. That's my pride and joy. I've got four; I gave one to a friend, I had a nonworking one that I gave to another friend, and I have one somewhere in my attic. It's kind of touchy, though. Astrocades are really touchy.

I bought a boxed Speedway IV. Those are tough to get. I scored that over the past year; it's fully operational. I have some *Pong* units. My Sears Tele-Games Motocross Sports Center. It's funky, one of those late *Pong* units that had non-*Pong* games as well as *Pong*. If you remember *Stunt Racer* by Atari, Tele-Games made the same console, but they threw a *Pong* game into it. It came with four paddles. That's my pride and joy in terms of *Pong* stuff.

I have some homebrew stuff that's super rare. My wife had a cancer scare, so for one of our early shows, we did a limited run of 2600 homebrew games, and all proceeds went to the American Cancer Society. It was special that we were able to do that. She ended up not having cancer, but it was scary.

Show [conference] exclusives are fun because there are only 20 or 30 copies and then they're gone. War of the Robots, which was an early exclusive for Classic Gaming Expo 2004, for *Vectrex*, kind of plays like *Battlezone*. There were only 50 copies or so of that.

I could go on and on. My boxed *Robotron*—that's my favorite game.

Craddock: Every gamer has a favorite game. How did *Robotron* become yours?

John Hancock: *Robotron* was an arcade game, but my favorite is the Atari 7800 version because that was one of the first games when I set about re-amassing a games collection. I enjoyed it so much that I made a custom controller for it. I took two Tach-2 controllers and zip-tied them. It's like the ultimate *Robotron* controller. I tried some different things with dials and glue, but it just didn't work. So I got two Tach-2 controllers, and my score doubled.

Robotron, to me, is the best way of understanding someone with ADHD. If someone would say, "What's it like to have ADHD?"—look at *Robotron* and how chaotic it is. Everything is coming at you all at the same time. I just love that. I like the pressure. I like knowing that you're never going to beat the game. The game is going to beat you. It's just a matter of time. It has a neat control style.

It's just a really good game, and it's on [practically every system]. I try to get every version that I can, but I think the 7800 version is the best. But *Robotron* is what I call an evergreen game, a game that can stand the test of time. It's constantly on every system. *Robotron* is one of those. *Midway Origins* for Xbox 360 and PS3 has *Robotron* on it.

Robotron: 2084, one of legendary designer Eugene Jarvis's most iconic titles.

Craddock: A collection the size of yours has so much great trivia behind it. What is some of your favorite trivia pertaining to your favorite games?

John Hancock: There's a ton of lore out there. I like Easter eggs, or stuff that programmers have said about making their games. Eugene Jarvis was the one who made *Robotron*. The story about him coming up with the control scheme was that he broke his hand. He came up with the game's control style because he was immobile. I thought that was an interesting bit of history.

Craddock: What other stories do you have about acquiring hard-to-find systems and complete sets?

John Hancock: I can tell you my boxed-NES story. I'd been married a year, which meant I didn't have that much money. We were doing our anniversary trip along the California coast. Our anniversary trip had been a disappointment. We stayed in a Victorian-style bed-and-breakfast that just wasn't what we expected. My wife gave me permission to go check out this flea market, and I go to the most sad, pathetic flea market I'd ever seen. There was an old man with a dog and a handkerchief, playing a banjo for money. It was really depressing.

It didn't look like I'd find anything great. Then I see this old couple. They looked like grandparents. They were selling the leftovers of what must have been a video store. They had curtains hung, and I saw they were using them to hide products. I asked, "Do you have any video game stuff?" They said yes, and they opened the curtain, and it was like the gates of heaven opening up: nothing but boxed NES games.

I was star struck. I was looking at *Exterminator*, at *Power Blade 1* and *2*, at all the third-party stuff. All the stuff that's really hard to get, and it's boxed up. I was looking at a wall of 350, maybe 400 games. I said, "Let's make a deal."

I walked away and drained our savings. The only reason I got away with that was because I got [duplicate] games I could sell quickly. That let me pay back our savings and score about 250 boxed NES games. That was probably one of my best scores. That was around 2002, 2003. There's no way I could have done something like that now.

Craddock: I read in another interview that you got a Coleco Adam console through a transaction that took two years or so to wrap up. What's the story there?

John Hancock: Oh, yeah. That's a good one. That one puts a smile on my face. So, I have a good friend, one of my best, named Jon Rose. We'd been friends a long time. He was on the organizational board for Portland Retro Gaming Expo. He worked with a guy that said, "Hey, you're into this gaming stuff. I've got a boxed Adam computer." That's all he said. Jon said, "Cool. I don't know if I'm interested, but my buddy John would definitely be interested."

I came to find out that it was the rare Coleco Expansion Module #3, the Adam computer add-on. The box is a little beat-up, but the guy said, "I want 80 bucks for it." We went back and forth, back and forth, sending 20–25 emails over two years. Finally, he said, "Tell you what. I don't want to mail this because it's super expensive. I've got a daughter near you. I'll drive it to you."

That's exactly what he did. Another three or four months passed, and I got a call from him saying, "I'm coming up." I actually had to make a shelf that fit it because it's huge. The Adam computer box is huge. It's way bigger than a 360 box. It's big. It was a little damaged, but still in pretty good shape. It's the expansion module 3; it's really hard to get. For 80 bucks, it was a steal.

The guy saw my collection and said, "I'm really glad I did this." What happened was, [the Adam] had belonged to his dad. His dad died, and the Adam had been rotting away in an attic.

Craddock: Suppose a genie popped out of a lamp and said, "I'll conjure up any one game you need for your collection." What would it be?

John Hancock: I'll cheat and say a *Robotron* arcade cabinet. But if it has to be a console game, I'll say *Magical Chase*. It's the last card I need for my TurboGrafx collection.

Craddock: If you had the space and the money, would you expand your collection to include arcade games?

John Hancock: There are pros and cons. One thing I'm noticing is that hardware is failing. It's a nightmare when arcade hardware goes off. You have to fiddle with it and move it, and I don't have the greatest back. I'd love to represent arcade games, but I'm also aware that it takes a lot of technical expertise to maintain them. Consoles are a lot easier.

But if I had the space, yeah, probably. If I'm going to have a museum, I need to represent arcade games, even if they're just ports or a MAME machine. I had an arcade game in my collection that was a reproduction of Williams arcade games. I bought it cheap from a good friend, and I decided to put it up and donate to a show in an auction. This kid bought one ticket and won. He called his dad and was super excited. He wanted me to sign it and everything. That

was the first time anyone asked me for my autograph. The kid was in tears he was so happy. It was neat.

Craddock: What about boxes and manuals? How difficult are those to find?

John Hancock: My friend Jon Rose knew I was going crazy over Sega Genesis stuff. He went to a video game wholesale clearance center, and it was buying out all of the rental stores in California and selling excess inventory all in one shot.

On the way out, he goes, "By the way, do you have any leftover manuals or artwork from video games?" The guy said, "Yeah, I've got all this Sega crap. I don't know what to do with it, so you can just have it." He pulled out a box full of manuals and [game box] artwork.

I absolutely love manuals. I understand why they went away, but there was something great about them, especially the NES and Sega Genesis manuals. The cheesy artwork, the stories, the listings for how you play, and they would always put a "?" over the final boss because they don't want to reveal it.

One thing I do is if there's a rental store sticker showing the name and address of the store, I don't remove it from anything I buy. Knowing that those rental stores are gone, those stickers could be the last thing left of that store. I have stuff from my original hometown that I got just for that reason: it's a sticker from a video store that I went to as a kid.

Craddock: When you get a complete-in-box game, do you like to keep it closed, or do you like to open it up and play it?

John Hancock: I've unsealed a couple of games. For one, I was testing some product for a video game company, and I had to unseal my *Action 52* for Sega Genesis. I've done that. I'm not a sealed collector and never have been. Part of the reason for that is money. To each his or her own, but for me, I want to play stuff. I want to showcase it. The prices for some of that stuff is ridiculous. For that amount of money, I could get 20, 40, 50 games off my list.

Craddock: Digital gaming has become ubiquitous. PC games are rarely put out on disc. I can go on the Wii U Virtual Console and get rare SNES games for less than 10 bucks. As a collector of physical media, what are your thoughts on digital games? Do you think they affect the value of collections like yours?

John Hancock: I definitely think we're in a bubble. I don't believe in the theory of things going up and up. I think rare stuff will remain rare and be sought after, but I also know that an entire generation of kids are growing up without physical media. Media fails. I collect modern games. I have a Steam account. I don't have a lot of Steam games, but I like the service. It's a good service. I have Xbox Live, and I download the free games every month.

But there's something missing [from digital games]. There's no box. The manuals [are sparse]. For me, it doesn't feel like a complete game if it's digital. For a lot of people, that's all they know. I guess it's kind of like vinyl. We moved from that to a CD and lost something in translation. That's how I feel about physical versus digital media: digital isn't the same.

But at the end of the day, I'm coming from the perspective of growing up in an era where people felt like they owned games. Now, it's more of, "Well, you

have permission to play our game. You can borrow it. You have access to it." That's just not what I grew up with. I grew up owning games, borrowing games from friends. You can do the same thing with Steam, but it's just different.

As far as value: it's hard to tell, but I didn't get into the hobby for money. When the warning signs appear, when game values start dropping off, I think that's when a lot of people will cash out. And that's okay. I'm not in it for money. I'll be in it for the long haul. I just don't want that to happen because I have a lot of friends who rely on [collecting and trading games] as their main income.

We'll see. I look at myself as being like those guys at railroad stations who are really excited about trains. They've got their little conductor hats on, and they're just happy to talk your ear off about trains. I see myself like that.

9

"Infidelity"
NES ROM Hacks

Video game emulation dawned in the 1990s and exploded during the 2000s. Players can find and download image files that contain game data from cartridges and play them using emulators, software that emulates console hardware such as the NES and PlayStation. Those image files are known as ROMs, short for "read-only memory." Publishers stress that ROMs are illegal; you are, after all, downloading old games for free rather than paying for them through active digital services such as Nintendo's Virtual Console.

ROM hacks are a different beast. Anyone with knowledge of certain programming languages can download a ROM, crack it wide open using special editing software, and delete, add, and modify lines of code, resulting in a brand new experience that looks and feels like a classic game—and, indeed, are often packaged and sold in cartridges able to run on their original console hardware.

The creators of ROM hacks are Dr. Frankenstein, and the hacks that remix and conflate pieces of old games are their monsters. Time and experience have resulted in ROM hacks that are more complex—and arguably better-designed—than their originals. I spoke with one such ROM auteur, who goes by the online handle infidelity, about how he got started in the hacking space, the tools he uses in his work, and the particulars of his most popular game, *Mega Man Ultra*, a total makeover of Capcom's *Mega Man 2*.

**

Craddock: What led to your interest in ROM hacking?

Infidelity: Back in 2003, I stumbled onto a ROM hack of *Mega Man 2* called *Rockman Exile*. It had a lot of cool features at the time, like altered enemy AI, new level construction via tiles and palettes, and it even had different music. *Rockman Exile* was my inspiration for getting into ROM hacking.

Craddock: You seem particularly interested in hacking Nintendo Entertainment System games. What about the NES and its games appeals to you?

Infidelity: The system itself, back in the 1980s, was the sleekest, coolest looking, of all the video game machines of that time. The cartridges had an amazing shape, the artwork design on the boxes/manuals/cartridges, the controllers and the zapper—it all grabbed my attention as a child. I'm also a devoted musician, and if you owned a Nintendo as a child in that period, there is no doubt that you can hum a bunch of the amazing songs created back then to this date.

Craddock: What were some of your earliest ROM-hacking experiments?

Infidelity: When I discovered *Rockman Exile*, I also discovered various *Super Mario Bros.* ROM hacks. I found a level editor for the game, and made these ridiculously difficult level layouts, that you pretty much had to know by heart, in order to advance through them. They were pretty awful. Enemies placed in odd spots, massive jumps required to reach certain areas. It was a lot of fun making them, but not a lot of fun playing them.

Craddock: What language are most NES ROMs written in?

Infidelity: All NES ROMs are written in what is called 6502 assembly. It's a primitive language, and one of the hardest to decipher for newcomers. It's not for the faint of heart. I was very fortunate to have been around the ROM hacking scene in the mid-2000s, with some very experienced and smart coders, who took time out of their busy lives to show me the ropes to allow myself to get my feet wet, and program on my own.

Craddock: What sorts of skills would someone interested in hacking ROMs need? Can anyone do it?

Infidelity: Can anyone do it? Absolutely. It all depends on that person's determination and dedication to 6502. This is not something that anyone with zero experience can just jump into and expect amazing results. There are a lot of boring and tedious things that go along with hacking a ROM. But the end result always pays off when you accomplish what you set out to do.

Skills needed would be at least a little knowledge of 6502: how to do simple commands like load a value and store it, compare that value to a specific value, if it matches then have it branch to another piece of code, if it doesn't match, to have that code just continue on to whatever else is going on.

Now for me personally, I hack using the FCEUX hex editor; meaning, I code using hexadecimal. That is how I learned to hack/code 6502. This is heavily frowned upon in serious NES ROM hacking communities. Still to this day I get lectured on my method, and how bad it is, and how I shouldn't code like that. But hey, it may be frowned upon, but my end results speak for themselves. I'm not trying to advocate only using hex to code 6502. It's just what I was surrounded with. You are also able to code within the 6502 language by using text, much like C++, but obviously 6502 and C++ are [quite different], just using C++ as an example.

FCEUX, the editor "Infidelity" used to hack *Mega Man 2*.

Craddock: Could you give us a general overview of the process of hacking a ROM? How do you crack the game ROM open and decipher what all the code means?

Infidelity: A general overview can be taken in many different directions. It all depends on what the person who is hacking the ROM, wants to do within the ROM. Some may just want to see their name on the screen, instead of *MARIO* or LUIGI. Some may just want to edit the dialog within the game, to make it read something different/funny/silly/etc. Some may just want to change how a character looks within the game.

Certain games, like *Super Mario Bros.* or *Mega Man 2*, have dedicated level editors that allow you to take an unmodified original ROM of those games, open them up within the editor, and view all of the game's layouts, such as level construction, palettes, sprites, and whatever other various functions the editor allows you to modify/change.

However, even with level editors, they don't always contain everything you wish to edit. Those other things are usually the following: enemy/boss AI, enemy/boss movements or actions, music, screen scrolls. Those require you to know how to program [using] the NES language.

There is an emulator that I live by, and have for 10 years. It's called FCEUX for Windows. It is the absolute best emulator to use if you want to hack an NES ROM. Within that emulator, you can edit whatever ROM you want to your heart's content—within the NES's limitations and your programming skills, of course.

Craddock: Suppose I'm interested in learning how to hack ROMs. What are some of the easiest changes I could make to a game ROM, just for the sake of experimenting and seeing a change I made show up in a game?

Infidelity: The easiest change, I would say, is altering dialog within a game. Doesn't require 6502 knowledge. Most of the time, the dialog is clearly visible within the FCEUX hex editor. You simply overwrite it, staying within the already set parameters for the text you are overwriting, save the change, reload the ROM, and you should see the results appear on screen.

Craddock: Your *Mega Man Ultra* game is a brilliant hack of *Mega Man 2*. What made you decide to hack *Mega Man 2* specifically?

Infidelity: Thank you for that kind remark! I am a *Mega Man* fanatic. I've loved the *Mega Man* franchise since I first played *Mega Man 2* in 1989. What made me decide to hack *Mega Man 2* was my discovery of *Rockman Exile*. When I saw that ROM hack of *Mega Man 2*, I wanted to outdo what was done in that game: music, levels, enemies, graphics—you name it, I wanted to create something as cool as *Rockman Exile* was. That was my foundation, my template, to start learning 6502.

Craddock: *Wood Man's* stage features graphics from *Super Mario Bros.*, such as question blocks and giant goombas as seen in *Super Mario Bros 3*. What was the process of importing assets from one game into your homebrew game?

Infidelity: My thinking process was, "Okay, what has not been done in a *Mega Man* ROM hack so far?" This has always been my driving point in ROM hacking since then: a "what hasn't been done yet?" attitude. I was still fresh in 6502; I only knew how to do simple stuff, like alter how many lives *Mega Man* has, or how fast his plasma cannon shoots.

 My music hacking was just as fresh too; you can clearly hear it in the SMB theme song [laughs]. All songs are written differently within each game, so I had to literally listen to each individual note, hum it out loud, and match it within the *Mega Man 2* sound engine to get the desired sound.

Craddock: How did you create the remixed music tracks in *Mega Man Ultra*?

Infidelity: It was all done within the FCEUX hex editor. I had to code in each individual note, for all four tracks for each individual song. The tracks are called, "Square 1, Square 2, Triangle(bass), and Noise(drums)" There were no special editors for editing music in NES ROMs back then. I don't even think there any today. Music hacking in an NES ROM back then was extremely rare, which is yet another reason why I believe *Mega Man Ultra* was such a massive hit with *Mega Man* lovers. Just the music alone in that game was such a gratifying feeling of accomplishment for me, aside from everything else I did in that game.

Craddock: One reason your *Mega Man Ultra* game grabbed my attention was because it looked and felt like the genuine article—like a *Mega Man* game that Keiji Inafune [ex-Capcom lead artist on *Mega Man*] would have made. For *Mega Man Ultra*, how closely did you attempt to model the flow of your levels and the revamped boss battles so that they hewed close to Capcom's design blueprints?

Infidelity: Wow, to be even mentioned in the same paragraph as the great Keiji Inafune! I'm extremely humbled by that remark, thank you! For me, I always pay homage to what has come before, to what has been solidified as legend, classic, great, you name it. When you hear the name *Mega Man*, gamers will *always* think of *Mega Man 2*. Even if their favorite is another *Mega Man* game, there is no way that *Mega Man 2* does not pop up. I try to always stay true to what has worked in the past, and most importantly, what I've always liked from those games.

The one level I'm still so proud I pulled off was Quickman's level using the rooftop from the *Mega Man 2* title screen, with the city and mountains in the distance. I knew in my heart that people were going to like that right off the bat, because it was never done before, and it's something that gamers already know of, but now see it being used in a new light, [it gives] that rooftop a whole new fresh experience and perspective.

As for the bosses, this shows how little I knew of 6502 at the time. In 2005 and earlier, a decent portion of *Mega Man 2*'s boss AIs were discovered and made public. I was able to use those notes and change specific actions of the bosses to make them faster in movement themselves, or their projectiles. Today in 2014, the 6502 knowledge I now possess, I could literally make those bosses do whatever I'd want at will. I'm still proud at how they came to be, but I always wished I could've made them better.

Craddock: What are some of the restrictions and limitations you face when hacking an NES ROM? For example, I noticed that the enemies you added, such as the giant goombas and koopas in *Wood Man's* stage, are re-skinned versions of *Mega Man 2* enemies such as the bird that drops egg bombs, the rabbit, and the robot bats. Were you able to create new enemies, or were you forced to repurpose existing code, AI, and animations?

Infidelity: I wasn't able to insert new enemies because the CHaracteR RAM (CHR-RAM) for that level and that specific scroll were full. What I did was reuse the physical property of the sprite, and just gave it a different appearance. But obviously, you can tell what it is via the sprites AI. My inexperience then didn't allow me to be able to expand the ROM so I could insert additional sprite images, and even insert additional PRoGram ROM (PRG-ROM) so I could create new enemy AI.

Craddock: Even though you're hacking an NES ROM, are you tied down to the limitations and capabilities of the NES hardware? Were you able to wring a few extra drops of performance out of the hardware?

Infidelity: Yeah, the NES is very limited. There are plenty of things I hate about the NES. Like how you can't have more than eight sprites horizontally on the screen at once or there will be sprite flickering. With palettes, you can't assign an 8×8 tile a palette; it has to be for a 16×16 block (that can be changed by using the MMC5 mapper, like *Castlevania III* uses).

Craddock: I've seen *Mega Man Ultra* cartridges floating around eBay and collector sites. What is the process of packaging a ROM as a cartridge that works on its original hardware?

Infidelity: I was fortunate enough to receive *Mega Man Ultra* in a completely sealed package, and currently have it displayed in my living room. I can't explain all of the process that goes into it. It's done by people who are devoted to the NES, who are devoted to homebrew games, hacked games, and want to bring continued life to the NES console. To make my game work on a real NES, you need to inject my ROM onto an MMC1 mapper NES cartridge.

Shots from *Mega Man Ultra*, "Infidelity's" popular hack.

Craddock: Of all your ROM hacks, which is your favorite and why?

Infidelity: That's like asking "which child is your favorite?" [laughs] Each of my ROM hacks have their own unique story to them. Each one stamps milestones in whatever progression I made in my 6502 experience. But to answer your question truthfully, it has to be *Mega Man Ultra*. It solidified me as a legit ROM hacker, [and] it's one of the top most popular influential *Mega Man* ROM hacks to date.

It makes me incredibly humble when fellow hackers compliment *Mega Man Ultra*, and tell me that my work inspired them to ROM hack. That's an incredible feeling: to impact someone with something you created, and inspire them to do the same or better than what you put out there.

Craddock: What other consoles have you hacked, and how does the process of hacking those systems compare to hacking NES hardware?

Infidelity: I haven't learned a new language yet. If I continue to ROM hack down the road, the system I'd really like to learn is Super Nintendo. The reason why I haven't yet is that I don't like the debuggers that are out there within some of the emulators. The NES debugger in FCEUX is so user friendly, so easy to use, so easy to understand, so easy to find what you're looking for within an NES ROM. There is no one out there that is willing to code a similar style debugger for the SNES, like the NES has.

I can guarantee you this, and to anyone who reads this: the SNES ROM hacking scene would definitely explode if such a debugger was created. I've been dying to do a ROM hack of *Mega Man X*! I would be all over that!

Craddock: What ROM hacks are you working on now?

Infidelity: I have been working on a major project for almost three years. It's a ROM hack of the original *Legend of Zelda*. It is called *Zelda: The Legend of Link*. I have made it so the original game has items like the hookshot, the ocarina, the hammer, the shovel, the Pegasus shoes, and the flippers. The first ever beta version will be released either late June or within the month of July. This is my first major ROM hack since *Mega Man Ultra* was released.

Flashback Entertainment, at shopflashback.com, will be releasing my new *Zelda* project on an actual NES cartridge. I am extremely excited over the hard work and dedication that [my] team has devoted to [the] work. I encourage anyone that is interested to check them out. I can't wait to see and obtain the final product myself!

10

Scott Coleman and Jay Cotton
Kali

My first experience with multiplayer gaming on the PC was a disaster. Over three hours, I struggled and failed to dial into a friend's computer for a round of deathmatch in *Doom II*. From our separate zip codes, we followed the game's command-line-driven instructions, crossed our fingers as our modems screeched at each other. and then dropped out, leaving us blinking at blank monitors instead of racing down corridors and firing rockets.

In 1995, programmer Scott Coleman and fellow *Doom* fanatic Jay Cotton solved my and legions of other PC gamers' problems when they released *Kali*, a program that tricked computers into thinking they were plugged into a local network but instead whisked them into an Internet arena to face opponents from all around the world. Today, online gaming is considered a given on PCs and consoles alike. Back in the mid-'90s, it was a novelty.

Kali's ability to connect friends and complete strangers ushered in a wave of online gaming services that included Blizzard Entertainment's Battle.net. As a bonus interview included with 2013's *Stay Awhile and Listen: Book I*, I caught up with Scott and Jay to learn the origin of *Kali*, how the program works its magic, as well as *iDOOM*, *Kali's* predecessor.

Craddock: How did you discover games and programming?

Jay Cotton: For me, videogaming started with an ancient *Pong* game my great uncle had back in the '70s. I don't recall which make it was (Magnavox or Atari), but I was instantly hooked and over the years, with very little access to any console gaming device, I realized the primary purpose of home PCs was gaming, even if many others justified their purchases for other reasons. The VIC-20 and Commodore 64 were amazing machines and exactly what I needed to start experimenting during college.

Arcade games, especially *Pac-Man*, inspired me to learn programming as a means to understanding how these games worked. I've never really written any games myself except for a text-graphics version of *Pac-Man* on an old

135

Commodore Pet computer during high school (yes, that's all we had to work with). Armed with the "PEEK" and "POKE" commands, I soon learned how easy it was to crash a PC and also how to make it do more than just output text.

Scott Coleman: Like most kids, I was addicted to playing computer games, dating back to the Magnavox Odyssey video game that you hooked up to your TV. Once I learned programming in high school, I got a computer of my own (an Ohio Scientific Challenger 1P) and wrote my first game: the player would drive around in a little tank and attempt to shoot a buffalo, which would randomly appear and disappear on the screen. Later, I moved on to a TRS-80 and an Atari 400, which was an awesome game machine for its day.

During those days, I spent far more time playing games than writing them, however. While my interest in writing software was probably due in part to my interest in games, there was more to it than that. Programming itself held (and continues to hold) its own fascination for me. It was only later, after *Doom* was released and I had been playing it a while, that I started writing game-related software again.

Browsing games compatible to play on *Kali*.

Craddock: Before *Kali*, I discovered in my research that you first teamed up to write a program called *iDOOM* that allowed players to take *Doom* online. How did you discover *Doom*?

Jay Cotton: I discovered *Doom* as a result of a memo sent around by campus networking personnel at work [University of Georgia] regarding problems with *Doom*

and its all-broadcast networking code. The entire UGA campus was "flat" (no sub-nets, and no internal routing or even switching) and just a few people playing *Doom* were bringing down the entire campus network. I was working at UGA's vet school at the time doing some programming and network setup.

When I downloaded the game to investigate, I had found that the problem was already resolved. An update to the game fixed the code to use unicast IPX [network protocol that transmits data between computers connected to a network] instead of broadcast. However, it was too late. I was already setup to test it and managed to get "help" with my testing from co-workers. It was around this time we set up a packet sniffer, and I became fascinated by how the networking code worked and what exactly was changed to fix the problem.

Scott Coleman: I have always loved the idea of multiplayer, multi-machine games, but they were a rarity when I was growing up. Those that did exist were usually turn-based games like chess, not fast action "Twitch" games. I had also played modem games like *Knights of the Sky* and *Modem Wars*, but these were limited by the bandwidth available on a modem and were not very engaging for me.

Then I read about *Doom* on USENET in the fall/winter of 1993, just before the first beta came out. *Doom* with its IPX network multiplayer mode promised to be a quantum leap forward; I couldn't wait to play it! I downloaded it and was fragging my officemates on the day of its release.

Craddock: Can you share some anecdotes from your early days playing *Doom*?

Jay Cotton: I remember reading about "circle-strafing" and the need for a custom keyboard-mouse configuration. Re-learning the game using the mouse and keyboard was quite a challenge at the beginning, but paid off handsomely. Strafe-running and wall-running were tricks to outrun opponents. After playing against a keyboard-only opponent, and being accused of cheating many times, I always ended up teaching these techniques to other players, so they would provide a better challenge the next time we played.

It [multiplayer *Doom* sessions] was all LAN-playing at work initially. However, there weren't many people willing to play and no one enthusiastic enough to provide any real competition.

Scott Coleman: I started out as a "keyboard" *Doom* player, using the arrow keys on the keyboard to turn left and right. One of the guys in my office was a big *Wolfenstein 3-D* player, and he used a mouse to play; he encouraged me to play *Doom* using the mouse. That was a major turning point (pun intended) for me. I was a pretty good player before that, but once I got the hang of using the mouse, I became unbeatable. It got to the point where none of my officemates would play against me anymore. I was the biggest fish in my little office pond.

My favorite kind of map is one that is designed specifically for a fast-action deathmatch with continuous fragging. What might be interesting

for a single-player game is probably the last thing you want for deathmatch. Who wants a huge, sprawling map where you spend 20 minutes just trying to find somebody to kill? You also want to situate the respawn points such that other players cannot simply camp out near the respawn points and wait for players to respawn; nothing sucks more to have a rocket explode in your face before you've even fully materialized.

And the exit switch should require cooperation from at least two players in order to activate, so that no one can accidentally end the level early. Once level-editing tools like DEU [Doom Editing Utility] became available, people came up with some really fantastic deathmatch WADs [maps]. A couple I particularly remember were called "NIN" and "Danzig."

The office where I worked held an annual programming contest. My entry for 1994 was a deathmatch WAD laid out like my office area. I took photographs of the actual doors and walls and used them as wall textures; I recorded actual voices and sounds and used them as sound effects. The various monsters in the game became my co-workers. Although none of this was technically "programming," I won the contest anyway.

Craddock:	What was your first experience playing *Doom* online?
Jay Cotton:	There was a program called TCPSETUP written by Jake Page that replaced the original ipxsetup [program] from the game. Using this small program, and knowing the IP numbers of the other players, you could, theoretically, play *Doom* over the Internet. You had to find other players via IRC [Internet Relay Chat].
Scott Coleman:	I started hanging out in the #doom channel on IRC. Some of the guys there were using a program called TCPSETUP to play *Doom* over the Internet, so I gave it a try. The program was a great idea, but the implementation lacked polish and stability. My first few attempts at using it were very frustrating, but I kept at it and eventually figured out ways to actually play a complete game every now and then.
Craddock:	Did you two meet through playing *Doom*, then?
Scott Coleman:	I met Jay in the IRC #doom channel. He was another *Doom* addict like me, and he was the first person I'd ever met who could beat me consistently.
Jay Cotton:	Scott Coleman was one of the other *Doom* players trying to setup and play games using TCPSETUP. We both experienced the same problems and frustrations.
Craddock:	As the author of TCPSETUP, was Jake Page involved in writing *iDOOM*?
Scott Coleman:	Jake shared his source code for TCPSETUP with me. After using it awhile and identifying its limitations, I sent him a list of suggested improvements, but he never responded. So, using his source code as a guide, I wrote *iDOOM*. *iDOOM* was a ground-up, clean-sheet-of-paper design that incorporated all of the lessons we'd learned from our TCPSETUP experiences.
Craddock:	What areas of TCPSETUP did you feel needed improvement?
Scott Coleman:	For one thing, it was extremely delicate. If your timing was even just a bit off during the initial synchronization phase, the game would bomb out before it

even began. The command line required to run it was cumbersome, requiring you to determine and then type in by hand the IP addresses of up to three other players in a particular order; if one of the players in the game got the command line wrong, it wouldn't work.

It also required an external communication mechanism, such as IRC, to find other players and coordinate the games. To say that TCPSETUP was not user-friendly is a gross understatement.

Craddock: Was *iDOOM* meant to support games besides *Doom*? Could it?

Jay Cotton: We had no other plans for *iDOOM* other than to replace/enhance TCPSETUP and provide an easier means to play *Doom*. I just wanted to be able to turn on my PC at work and find an opponent easily and get started playing as quickly and painlessly as possible.

Scott Coleman: *iDOOM* uses the *Doom* network driver abstraction, so it can only work with games that use that mechanism. *Doom*, *Doom II*, and derivatives like *Heretic* and Hexen are the only games you can play using this type of driver. After the success of *Doom*, other multiplayer LAN games, such as Descent, started to come out, and we wanted to play them over the Internet also. That's why I started working on *Kali*.

Craddock: What was the process of testing *iDOOM*?

Jay Cotton: I had two DOS computers at my desk, as well as a packet sniffer so I was able to test launches of the game and see where the communications broke down when things failed. However, most of the testing was more along the lines of "Hey guys! Who wants to help test the new *iDOOM*?" via IRC.

Craddock: What was the most difficult feature to get working in *iDOOM*?

Scott Coleman: Getting the connectivity solid and stable took some doing, mostly because I knew nothing about network programming when I started and had to teach myself. Being able to see how TCPSETUP did it was a major kick-start.

Jay Cotton: Coordinating a launch was the most difficult aspect. Once *iDOOM* launched the game, you had to hope all of the other clients also launched successfully at the same time. If anything went wrong, the launching process would hang, and not knowing if this was caused by a slow computer or a failed launch would mean waiting a couple of minutes before quitting and trying again.

Craddock: What was the distribution of work between you both on *Kali*?

Jay Cotton: Having never written more than schoolwork code in C, Scott was responsible for all of the coding. I provided ideas and had a better test environment at my office so I was able to help debug problems.

Scott Coleman: For *iDOOM* and *iFrag* [an expanded version of *iDOOM* that supported other first-person shooters, released in advance of *Kali*], I wrote the code, and Jay helped me test and offered suggestions. For *Kali*, he contributed some code, as well. He liked coding in assembly language, and we incorporated some of his assembly language routines into *Kali*.

I've never actually met Jay face-to-face. Jay worked at the University of Georgia, and I worked at the University of Illinois. Our entire collaboration was done via the Internet. Back in those days cable modems didn't exist, and

	if you had Internet access at all it was via a dialup modem to a Unix shell account, or maybe via SLIP [Serial Line Internet/Interface Protocol] if you were a real power user. If it weren't for the fact that we both worked at major universities with great Internet connectivity, none of this would have ever happened. We were in the right place at the right time.
Craddock:	In my research, I came across a brief history of *Kali* that Jay wrote. He mentioned a project called MILK and said you both felt pressure to get your program done before MILK. What was MILK?
Scott Coleman:	MILK was something similar to *Kali* that another group had announced they were working on. Jay may have felt pressure to be first, but I wasn't really worried. I was pretty confident that *Kali* would blow away whatever anyone else came up with. I don't recall if the MILK project ever actually released anything.
Craddock:	Where did the name "*Kali*" come from?
Scott Coleman:	My girlfriend (now wife) suggested the name. She grew up in India and had been exposed to Hindu theology, which has dozens of gods and goddesses. The *Kali* avatar is usually depicted with swords in her hands and a necklace of skulls from those she has killed, which seemed appropriate for a Deathmatch game. Jay liked the name and we went with it.
Craddock:	What was *Kali*'s development schedule like?
Scott Coleman:	I had a full-time job, so I worked on *Kali* during the evenings and on weekends (in between *Doom* games, of course). *Kali* was straightforward to implement once I understood how an IPX network driver functioned. Using a book called Programmer's Guide to Netware by Charles Rose as a reference, along with a "Spy" program to determine empirically which IPX functions were being used, I laid out the skeleton for *Kali* in a day or so.

Most of the rest of the development time was spent doing exhaustive testing with games like Descent and *Duke Nukem 3D* to make sure *Kali* would emulate the real IPX driver correctly. |
| *Jay Cotton:* | *Kali*'s development went on for several years, non-stop. Although we may have released the first version rather quickly, it was a rather simplistic solution and would require months of further work before it became a success outside of the original *iFrag* community. I probably spent 12 hours a day working on *Kali* (or "Testing" *Kali* by playing games). I did this while still working a full-time job. This work-plus-play continued for years. My goal was always to get *Kali* working well enough to allow me to play more. Unfortunately, I was spending more time providing customer support than doing development or playing games.

Setting up an Internet connection was new for most of our players. We had to recommend ISPs and modems and provide support for every aspect of their Internet setup just to get them to the point where they could install and run *Kali*. |
| *Craddock:* | How did you decide to make *Kali* a commercial program rather than a freely distributed one like *iDOOM* and *iFrag*? |

Jay Cotton: I'm pretty sure it was Scott's suggestion to make money on *Kali*, but neither of us were sure it would actually work. I set up a P.O. Box, and with the help of my wife, set up a business, but before we even got started, Scott received a job offer and left me to it.

Scott Coleman: Commercialization was entirely Jay's idea. He wanted to capitalize on the boom in Internet gaming that was just around the corner, and I agreed. Left to myself, I probably would have released *Kali* for free, just as I did with *iFrag*, but I figured what the heck, maybe it will earn me a few extra bucks.

Blizzard Entertainment's *WarCraft II* was one of *Kali's* most popular games.

Craddock: I remember downloading *Kali*, playing through the time limit imposed by the demo, and then immediately shelling out the $20 for unlimited usage. How did you arrive at that particular model?

Jay Cotton: There were quite a few people balking at the idea of paying for something that had been free up until this time. However, a few *iFrag* users sent their money before we even released the first version of *Kali* stating that they felt they already owed us for the work we had done on *iDOOM* and *iFrag*. Setting the time limit would allow people to play short games for free, and hopefully they'd want to play more and be willing to pay.

Scott Coleman: Limiting the program in some way in order to encourage users to register was an established technique. *Doom* itself [included] only one set of levels in the shareware version; to get the other two, you had to pay the registration

fee. We figured putting in a time limit would enable people to verify that the program would work for them before they forked over their cash, and the $20 fee seemed like a reasonable price.

Craddock: Were you tempted to charge a subscription?

Jay Cotton: It was always my belief that *Kali* would continue to be successful as long as I never got greedy. I wanted everyone to be so happy with their purchase that they would never hesitate to recommend it to a friend and never charge more than what someone would be readily willing to pay. It also became a selling point that *Kali* only charged a one-time fee with free upgrades forever. People really liked this, and it prevented newcomers (TEN, Heat, MPlayer, etc.) from being able to charge enough to pay for their expensive overheads.

 Kali was able to compete with TEN, MPlayer and Heat because it already had a large established user base (more users equals more fun) and because it was much, much cheaper. These new services wanted to charge a subscription fee, but didn't provide enough added benefit to justify the added expense.

Craddock: How exactly does *Kali* fool my computer into thinking it's on a local network when I'm actually going online and gaming with people all over the world?

Jay Cotton: *Kali* was/is at its core, a local network emulator. Network-capable applications, like games, request access to the local network from the operating system (DOS or Windows in different manners). With *Kali* running, these requests are intercepted. For each request to send data, query the network, or receive data, *Kali* would provide a "fake" response so the games would continue to work, unaware that these requests were doing extra work to send and receive this data across the Internet.

Scott Coleman: Because *Kali* looks and behaves exactly the same as the real network driver, the application has no idea that the packets it is sending are actually being routed over the Internet instead of the LAN.

Craddock: What features gave you the most trouble, either in writing the code or testing it?

Jay Cotton: Providing IPX emulation for DOS applications running in Windows required something called a VxD: a virtual device driver. The tools needed to write these drivers and the coordination needed to communicate between the driver and the main application necessitated the hiring of new talent. Brian Hayes came on board at this time and his contribution made *Kali95* possible. At the time, I knew nothing of Windows and without the help of Brian and another employee, a long-time friend Vance Kessler, I wouldn't have been able to create *Kali95*.

Scott Coleman: Probably the chat functions. Those took a while to polish and make user-friendly.

Craddock: What was the process of adding support for new games to *Kali*? Was it just, "This game supports IPX, so let's add it?" Or were you a bit choosier?

Jay Cotton:	We weren't choosy at all! If anyone reported a game worked on *Kali*, we added it to the list. However, we later had to remove some games from the list because they turned out not to work well enough. We did test many of the games, and many developers sent pre-releases of games to us to make sure we would be able to provide support.
Craddock:	I have to tell you, using *Kali* for the first time was like magic. I remember telling it to search my hard drive for compatible games and watching the list grow: *Doom, Quake, Duke Nukem 3D, WarCraft II, Diablo, Rise of the Triad, Command & Conquer.* Then jumping into a game and playing with other people. It blew my 14-year-old mind. Was using your technology as exciting for you? I know that sometimes the wizard behind the curtain is less awed by results since, of course, they know how all the moving parts click together.
Jay Cotton:	I was just as excited! Features like you mention here, automatically finding games, were being added as fast as we could write them. There was so much potential, and without any road map to follow, we'd show up to work on any random day with new ideas and often have them out in beta before the end of the day!
Scott Coleman:	The magic for me was twofold: While *Kali* and *iFrag* were primarily a means for me to find and frag other players, doing something really cool that nobody else had done before was extremely gratifying.
Craddock:	When I started playing PC games, it seemed like everyone I knew used *Kali*. How long did *Kali* take to become popular?
Scott Coleman:	It was popular immediately. Most of the people who had been playing *Doom* with us on *iFrag* wanted to use *Kali*, as well. It snowballed from there as other gamers from outside the *iFrag* community heard about it.
Jay Cotton:	*Kali* usage grew exponentially for the first three years. Because of the very low cost to operate *Kali*, it was making money after the first week of going live. In only a few months, I was able to quit my old job and started working on *Kali* full time. Within a year, we had thousands of users on *Kali* every day.
Craddock:	I didn't start using the service until *Kali95* and understand the DOS version was difficult to use at first. One thing I loved was the simplicity of *Kali's* user interface in Windows 95. How important was accessibility and UI as the service expanded?
Jay Cotton:	Supporting the DOS version of *Kali* used up nearly all of my time. I would sometimes answer as many as a dozen emails, or spend an hour in chat helping individual users get their Internet connection set up and *Kali* working. The process was daunting, with different setups needed for every ISP [Internet Service Provider] and modem or Ethernet card.
	Kali95 eliminated over half of the setup support needed simply because Windows 95 came with wizards and tools to help simplify the Internet connection. Windows 95 didn't solve all of our problems, but more and more users were able to download *Kali95* and get started without any technical

knowledge, and this greatly increased the number of people willing and able to use *Kali*.

David Craddock: Blizzard included a file with *WarCraft II* that improved the game's compatibility with *Kali*. Did you hear from Blizzard during *WarCraft II*'s development? Were they fans of *Kali* and your work?

Jay Cotton: I talked to a few Blizzard employees over the years and from them learned that many of the people working at Blizzard were huge fans of *Kali*. For a couple of years, *WarCraft II* was by far *Kali*'s most popular game, and this was possible because of performance tweaks made by Blizzard to improve [the game's networking performance] over *Kali*.

David Craddock: Blizzard's Battle.net gave rise to free online services packaged in with games. How did you view the arrival of Battle.net and other free-to-play services?

Jay Cotton: Battle.net was inevitable and predictable and definitely the beginning of the end for *Kali*. There were a few other games to include Internet support before Battle.net, but Battle.net was different in that it was a closed world. You couldn't join a Battle.net game from the outside (e.g. from *Kali*). This forced users to choose where to play. Eventually, when it became harder and slower to add support to new versions of *Diablo* and *StarCraft*, users eventually migrated to Battle.net. Although we supported many other games, the titles produced by Blizzard accounted for 80–90 percent of *Kali* usage.

Craddock: Scott, what made you decide to leave *Kali* Inc.?

Scott Coleman: The popularity of *iFrag* and *Kali* caught the attention of the folks at Interplay Productions, the publisher of Descent, and they offered me a job in California. I was faced with a choice: accept the job offer from Interplay, or move to Georgia to continue working on *Kali* with Jay.

Working for an established company seemed like a safer bet at the time, so I handed *Kali* off to Jay and moved to California. But that's another chapter.

David Craddock: Jay, what is your involvement with *Kali* today?

Jay Cotton: I pay for a virtual server (it moves from time to time) to run the *Kali* website, tracker, and now defunct master server. I make just enough money on website ads to pay for the server. *Kali* is now free to play. I keep it running just out of habit.

11

Kyoko Higo
Marketing Final Fantasy VII

In 2017, I wrote an article about *Final Fantasy VII*'s aggressive marketing campaign in the U.S. My goal, as usual, was to get as many perspectives as possible. I nailed down interviews with folks from Sony Computer Entertainment America (SCEA) and SCE Europe, but one of my favorite conversations was with Kyoko Higo, a junior-level marketer who joined Square US when the company was just getting started.

Working as a contractor specializing in business development, branding, and communication since 2006, Higo spent her time at Square juggling dozens of plates in an effort to introduce FF7 to western audiences. In our conversation, she was quick to point out that everyone at Square US felt the same sense of enormous responsibility she did. We talked about the oblique angle at which she entered the games industry, her crash course in website design, and the impact FF7 had not just on RPGs, but on marketing.

**

Craddock: You didn't take a direct route to the games industry. I believe Square US was your first job in the business. Could you tell me what led you there?

Kyoko Higo: It was by chance, very by chance. I was actually not in the video game or software or any sort of tech-related field. I was working at American Honda, which is the US headquarters of Honda. Squaresoft USA had just opened their offices in Costa Mesa, and they were looking for bilingual staff. My then-boss, Junichi Yanagihara, had just recently moved over from Japan. Yoshinori [Kitase, game director on FF7] was already based in the US.

Long story short, we knew that there was going to be a lot of communication going back and forth with headquarters. Our newly opened studio was basically kind of a start-up. I got this call from an agency asking if I'd be interested in interviewing for this Japanese video game company: "Do you know *Final Fantasy*? Do you know Squaresoft?" I said, "I do know them, but I had no idea they had an office out here."

I went for an interview. I think at that time, I know we had an office manager, and I know we had some desks that were filling up, but I don't think we even had a proper, fully staffed admin side of the company. We had just hired a QA manager. I went in and interviewed, and I was starting to feel like I wanted to challenge myself with something a little more fast paced. I was working in the legal field at Honda, and even though I was very young at that time and didn't know what else was really out there, it was a slower-paced field, or industry, that I was working in. So I did have interest in doing something around software or tech. [Squaresoft] perked my interest a little bit, and the rest is history.

Craddock: *Final Fantasy VII* was developed at Square's headquarters in Japan. What was Square US's role in bringing FF7 to market?

Kyoko Higo: Even though we were not the publisher, because Sony Computer Entertainment America and Sony Computer Entertainment Europe were the publishers, we were the entity that helped sort of bridge that relationship. Here's Square US and Tokyo with all the development, production, and business for the domestic market successfully up and running. If it weren't for our [involvement], [Square in Tokyo] would have had to pretty much deal directly with SCEA and SCEE.

In a sense, you could say we were middlemen, but we also had the ownership of the franchise and the products [such as strategy guides] that were being put out. We were not just a spokesperson on behalf of headquarters and the dev team; we wanted to plant ourselves here in the US and see what the business development opportunities were going to be for Square's future. I think we were primarily responsible for bringing something, a Japanese entity that was already running successfully in Japan, and open doors here in the states.

Craddock: What were your duties as an assistant marketing associate?

Kyoko Higo: That was my title. I think officially, when I signed my employment contract, it might have been just a plain marketing assistant. But the assistant marketing associate title and role were pretty wide ranging. The three of us in the marketing department [handled] anything that had to do with the exchange of assets, and back then we were doing this on Zip drives. They had to be FedExed. There were no FTPs, no servers in terms of transferring over and sharing assets.

On average, there would be a FedEx delivery with a bunch of Zip drives. The assets were mainly for marketing purposes, but there may have been some things that were more, "Here, please share this with the localization team or the QA team." I don't remember clearly, but they were delivered on Zip disks. Opening up those drives, archiving assets, all the communication between David's team at SCEA, communication between Chris Ansell's team at SCEE. BradyGames was our official strategy-guide partner; that was the case with a lot of games back then: Working with the editorial team, a lot of asset exchanges with them.

They also generated a lot of screenshots. Going through the build, they would take their own, but we still needed to approve the content, so working with BradyGames was another [responsibility].

One memory I have that is very, very clear to me is that on the day I started, I was given this manila file that said, Website/Domain Registration. I opened that up and there were printouts of confirmations of us registering for XYZ domains. One of them was squaresoft.com. I was basically told, "We have the domain name, but we don't have a website built yet." And if you went to squaresoft.com at that time, it was the Under Construction icon, that animated gif.

So [we were working on] strategy guides, being a liaison between Sony [companies], the website. We also exhibited within Sony's E3 booth, within Sony Europe's ECTS expo, which was in London in '97. Those were my first sort of major overseas trips primarily for *Final Fantasy VII*, but obviously we'd been working together, exchanging emails and phone calls all this time. We finally got to meet our team at SCEE; they welcomed us to their offices. They actually extended an offer to take us around to other countries in Europe so that we had insight into what the retail market looked like. We had a stopover in Frankfurt, and then Paris. I don't think we ever went to Italy; I think it was Frankfurt and Paris.

Craddock: FF7's marketing was driven by three entities: Sony Computer Entertainment America, Sony Computer Entertainment Europe, and Square US. How did the three entities work out collaboration? Who did what?

Kyoko Higo: There was this initial meet-and-greet and familiarization on both sides. I think once we got comfortable, we knew that they understood [how to market the game effectively]. They had the resources, the budget, and the people. By people, what I mean is they had TBWA/Chiat/Day as their advertising agency. They were generally the ones that came up with the concepts, and then they would present to us.

It was mostly us coming up to Foster City and having meetings. We would do some initial feedback rounds, and kind of homing in on [concepts]. Eventually Sakaguchi-san had to approve it. We were kind of doing the initial rounds of, "We think this will probably be received better from [Hironobu Sakaguchi-san [creator of *Final Fantasy*]." Or, let's say Sony presented more than a few ideas: we'd narrow down to a few. Whether they were similar directions or quite different, we wanted to know we were equipped with enough options to present to Sakaguchi-san.

Once that happened, Junichi Yanagihara, my boss, would then usually fly out to Tokyo. On a rare occasion he might have been at the Marina del Rey office; I don't remember. I think it was more going to Tokyo. It wasn't like these days where we can do a Skype call and approve something. The time and energy was on a slightly different level than we're used to today.

Though they haven't aged well, *Final Fantasy VII*'s cinematics were the focal point of Square USA's and Sony's marketing campaign.

Hey, where is everyone?

Craddock: How much pressure did you feel on this assignment? Because technically, Square US is a sister studio to the Japanese headquarters. But at the same time, your first job is bringing *Final Fantasy VII*, this multi-million-dollar project, this juggernaut, to a new audience. It was Square's baby. What was it like handling that responsibility?

Kyoko Higo: With the FedEx delivery of the Zip drive, we would get a copy of at least one *Famitsu* [magazine]. It was like our weekly goody package. I think what happened was is that there was one person on the team at HQ that would centralize all the shipments to our office. Once we opened it, it was like, "Here's *Famitsu*, here's merchandise samples, here's some marketing." That's just how it got disseminated.

 Famitsu is a weekly magazine, so they were covering the game almost every week. It was a bit overwhelming for us because that was just not how it was done out here. Here we have monthly magazines and were trying to visit editorial teams, whether it was Ziff Davis or Future. We knew we had to pack in as much as we could in a month, and then there was Japan putting out mini strategy guides, or part 20 of a 60-part series in weekly *Famitsu*.

 All of it felt a little overwhelming for us. They were doing so much even at that point, whether it was merchandise or interviews with Sakaguchi and the rest of the team, music, putting out CDs and calendars. There was so much that Japan was doing, and here we are, feeling all this pressure and going to E3 that year. Thanks to Sony, we had a handful of kiosks, but we thought we were still a very small company. All of us were taking turns as kiosk attendees at E3. In the meantime in Japan, sales are going well and media is covering it.

 I think it was just that the better they did, the more pressure was on us. Sony's marketing team had enough confidence, and I'm sure the news out of Japan was only helping them to feed their energy and confidence, too. They knew enough to not do the exact same thing that Japan did. We had to take our

own approach to be relevant and more western minded. I definitely give credit to them for coming up with the ad campaigns that we all ended up seeing.

Craddock: It sounds like Square US was starting at square one, more or less. The website, for instance: It was under construction when you got there. Did you play a part in building it?

Kyoko Higo: One of my first tasks at Squaresoft, and this was related to *Final Fantasy VII* because that was the big title that was going to ship in less than a year, is that I was responsible for finding website designers, and working with the designers to create squaresoft.com's first website. It was a task that I'd never done. What a lot of people may not know is that if you worked in advertising or marketing back then, unlike today where you have boutique agencies or specific firms and globally successful designers that have started up their own Web presence for all sorts of digital marketing, back then [website design] was a smaller division within a larger advertising agency.

Let's say whether it's Saatchi & Saatchi, a lot of the brand names retain these agencies for their advertisement campaigns. But slowly and surely, you started to see that internally they were starting to build their own website design teams. Well, there we were, a small Japanese startup. We don't have a budget to go to a major agency. Sony was [flush with cash], but we were nobody.

I didn't have a deep enough knowledge to know who or where to go, so I used any contacts I had and sort of scouted out a very small team of web designers. I think at that time they were also a startup. They had a small office in Hollywood. I went in and said, "Look, we're a brand-new video game company out of Japan. We're going to be shipping this huge release; we don't even have our website up and running. We just need someone to work with us."

We hired them, and I worked very closely, even commuting to the studio once a week: to deliver assets, and it just made sense for me to work [on-site] with them. We finally got it up and running. I wish I still kept files. The very first iteration of squaresoft.com featured *Final Fantasy VII*'s key visuals, like Cloud. That remained our homepage for a while. It wasn't just a homepage. We had several pages, or tabs, alongside it, but the front or main page featured *Final Fantasy VII*.

I don't know how long that project took, but it was definitely a learning experience. I ended up buying myself an *HTML for Dummies* book so I could learn it. For a while I was actually the person behind updating some of those items. I did that. I was pretty proud that I went through *HTML for Dummies* and started writing updates. That was a big task.

Sony's entire marketing effort—and I think David [Bamberger, marketing executive at Sony Computer Entertainment America] said something upward of $10 million was spent—went into print, a lot on TV, and we had some exclusive giveaways of jackets and prepaid phone cards from Best Buy and what not. That was all them investing and spending on the game for us. They also had, if I remember correctly, product pages that are more of a template. They have that now, too, if you go to playstation.com. I believe they built something

that was a little bit more robust for *Final Fantasy VII*. As a publisher, they had their own web section for *Final Fantasy VII*.

As this newly established US arm of Square, squaresoft.com's traffic grew, definitely. One smart thing that we did early on when we launched the website is we had one simple box that said, If you're interested, please leave your email. Whether we had concrete plans to issue newsletters or not, we added that function.

Craddock: Did you have access to analytics or other data that measured the impact of the website and the email mailing list on FF7's sales?

Kyoko Higo: Not by the time *Final Fantasy VII* launched, but I remember clearly that we would have regular meetings with our web designer. I would check into that database regularly, but not often enough, and they would be on the lookout, too; they would check the database, too. I want to estimate that by the time *Final Fantasy VIII* came out, we had roughly a million email addresses. It was right by the time *VIII* came out, or between *VIII* and *IX*. I know that for sure because with *Final Fantasy IX*, we did our very first fan event at the Metreon [theater], which back then was owned by Sony in San Francisco. On one corner they used to have that PlayStation store.

This was pre-social media days. When we launched *Final Fantasy IX*, we had a very successful fan event at the Metreon. In order to get the word out, I remember very clearly we went into our [email] database. That was our first major effort to not just clean up the database, but use the filter function [to find fans] who were local, who were on the west coast. Basically we were just starting to use our database effectively. Because this was so localized, a one-city, one-market event, we were contemplating, "Should we email-blast everyone? Should it be regional? Should it just be the Bay Area? Should it be the state of California?" I remember that when we were considering that, our database had hit about a million email addresses.

If it weren't for the fact that we added that function from the very beginning, we may have not had that many. We may have had a good amount, but I think it was a smart idea that we did that from the get-go. I don't know what the numbers are today, but that was our starting point.

It was definitely something that we felt was not just working, but they wanted to be part of our community. It just showed us that so many people were very interested, either starting before [*Final Fantasy VII*] came out, or after. We did hit the million-units [sold] mark approximately three months after we shipped it in September. By December, Sony had told us that we passed the million mark just in the US. I am curious what the [email] numbers were prior to shipping *Final Fantasy VII*, and whether that sort of momentum gradually started growing at its own pace before or after *Final Fantasy VIII*. We were pretty proud knowing that so many people had interest in what we were doing.

Craddock: Did your Japanese background facilitate the effort to bring FF7 from the east to the west?

Kyoko Higo: Another huge task was even though I was hired as someone in the marketing department, we didn't have enough resources in terms of translators. Not just because we're bilingual; that didn't mean our job was to be a translator from 9:00 to 5:00 and that's it. That was a separate job, but we were kind of short on translators.

Our QA team, they're testing all day long, and then what ended up happening was that I sort of worked two shifts. There was your 9:00 to 5:00, doing my marketing thing. Then we'd take a break, and then starting at about 6:00 or 7:00, the QA manager, myself, and the two other marketing associates who also happened to be bilingual, would all sit down around a circular table. The QA manager was nice; he would either give us snacks or share his dinner or whatever. All we did was we went through that day's bugs. It was a daily bug meeting.

He would call out what level bug it was: must-fix, A, B, whatever. All the must-fix, the priority-ones, were marked so that then we could go back to our desks, and the three of us would translate those bugs that had to be sent back to Japan. There was no bug [database]. We didn't facilitate it the way we can do [now]. The three of us would divide this very thick bug report. Some days it would be an inch thick. It was like going through a white paper or report every day. We would divide our work, and literally I would have sheets of paper next to me, a text pad open, and we would have to translate the bug in its entirety.

It's not like I copy over what I get from the QA team. If there was a bug called bug 101, I'm typing bug 101, and then starting to type what the bug is in Japanese, and what the fix is in Japanese. Maybe I shouldn't say all this because your readers will wonder, oh my gosh, you guys were working how many hours? But these were the days before EA spouse [series of blogs written by significant others of Electronic Arts employees upset at the company's grueling schedule and practices]. We were all working like crazy. It would take easily more than a few hours to translate that daily bug report. We would combine our text files and then email it off to Japan.

That was a huge task. The three of us were just basically helping the QA team, but in essence it was kind of our second job. I don't remember the total length of how many months we ended up doing that. It wasn't in the beginning; this was toward when there were so many bugs coming out and [QA] just didn't have enough resources, so we had to pitch in and help and come in on the weekends. That was definitely a huge part of getting the builds to be iterated on and pushing them out. It was sort of like working two shifts.

It is true that our localization department [had a team]. You could say we had a team, but it was not of a scale or structure that you would expect today of a complete localization team. It was a very tiny team. They worked closely with the QA team; we worked closely with the QA team. It was a team, almost a family effort to try and get this game out.

Craddock: I had a Nintendo 64 during the "console war" between Sony and Nintendo, but what I remember is hearing more buzz around FF7 than I'd heard about

any other Japanese RPG. Is it safe to say that part of Square's and Sony's job was to introduce mainstream audiences in the west to that type of game?

Kyoko Higo: "Introduce" is another term. If you were someone who was already following Japanese RPGs, you might say, "Whoa, I knew about this before *Final Fantasy VII* came out and landed as a blockbuster title," but I think it's safe to say that our job was to help introduce JRPGs.

The thing about the ad campaigns is that we weren't trying to label it. It was more about the visual impact, kind of the "wow" factor we were going for: that video games can now express this and really take you on a journey and an experience. We didn't go out and say, "Here are bullet points: this is a Japanese RPG." It isn't like we were avoiding it, but we were trying to introduce this video game that we thought would have a wider appeal than previous Japanese games that had made it across to the US. We wanted to be borderless in that

Cloud as depicted in *Final Fantasy VII*'s cinematics.

sense.

Craddock: I remember reading magazines around the time of FF7's release. The game's advertisements stood out to me because they didn't really focus on the game. They took jabs at Nintendo and emphasized the game's cinematic qualities.

Kyoko Higo: The letterbox print ads, if you look at them, we were sort of mimicking to give you the impression that this was going to be a cinematic journey and experience, but, hey, you can actually play it on a video game console. The pull-in effect was to show off that it was going to give you that experience as you are mesmerized by film, TV, and other media that you were already consuming, but that this would be an interactive experience.

If we said too much, if we used too many words to describe it, it would have been too complex or confusing. *Final Fantasy VII* just was not a game

that called for that kind of explanation. It was really trying to get you into the world as quickly as possible. Probably the best way we could do that was to really show off the cinematic quality of the game.

I think in that sense, David's team and Andrew House's team really got it. They took ownership of it. From our standpoint, we were so honored but also so happy that they were as excited and so into the game itself that they got the element that would attract all the eyeballs. It was about the presentation; we wanted our first impression to last very long for the audience.

Craddock: The advertisements were so aggressive in the US. I remember one two-page spread showing a lavish scene from a cinematic, and the caption was something like, "Someone get the guys who make games on cartridges a cigarette and a blindfold." I know there was some bad blood between Sony and Nintendo because of how Nintendo reneged on the deal to create the PlayStation CD-ROM add-on for Super NES. Was FF7's aggressive tone intentional?

Kyoko Higo: I would definitely give credit to the Sony team for a lot of the copy and its boldness, what ended up being boldness. I could be wrong, but they were not just on this project, but kind of betting on it, too. This was going to be a hardware driver. This was going to push hardware sales. They had the system; now they had content. We used to always say, and today we say it too: content is king. I think they wanted to go out with a little bit of that edge and boldness to really make a statement.

The fact that we were a multi-disc game, if we were to transfer over the data on those discs, we tried to figure out how many cartridges you'd need to buy. They really wanted to hit all those points: the tech was there, the content was there. The narrative that came out of that—not just the game, but the [conversing] we end up doing as consumers—it was going to create some sort of movement as well. They were trying to hit all those points.

I don't say we had any issues [with the tone]. Japanese companies are typically very conservative. One could say, "Wow, that was really bold for Squaresoft to approve," but I really think we were trying, as one big unit between Sony and Square, to make a pretty bold statement. It was just a part of that campaign.

Craddock: What do you remember from the game's launch? Did you have any favorite marketing materials or initiatives, such as the website?

Kyoko Higo: I know we all have our favorites, but not a lot of games that came out during that time of year could have [made good on marketing]. It felt very dynamic. It felt monstrous, this grand thing. It almost felt like a ceremony. It was this unveiling of this large thing that was now going to land on this hardware, this gaming console. Like, "Here it is." There was this opening ceremony, [the game] came out, and then what do you know: in three months a million people had purchased it.

I don't think it was your typical Japanese-game-company move, but the fact that Sony believed in it really helped. I know we started planning our marketing and advertising campaigns X months out, but it had come out in Japan of January of that year, so we did have some time to learn and see the reaction in

its own market, its home country. Not that we would directly take that and use it for something, but I think there was a lot of interpreting what the success was all about, why was it a success, and how are people responding.

We did get to use a little bit of that time to sort of massage it and marinate our ideas a little bit more. I know that at least in our office, our parent company had put out a home-run hit in their country; now it was our turn. We shouldn't and didn't have to copy and paste what they were doing, but there was a lot of learning that we all did just to learn how our parent company and team that worked on it better, and we were also feeling more and more responsible to make it a success in the US.

Our offices were really close to a Best Buy in Costa Mesa. We also were close to South Coast Plaza. There were these huge Cloud standees that Sony spent so much money on, but back then, that was the retail environment: the big publishers were able to facilitate these standees to be shipped to every single Electronics Boutique and Babbage's. You'd walk in and see this four-foot Cloud standee at the end of an aisle. We definitely did our weekly lunch visits and checked out when the standees were in stores, when the BradyGames strategy guides were coming in.

When the game shipped, I remember we walked over not just to Best Buy, but to EB and Babbage's to just kind of look around and take the temperature of the room: Are people coming in and asking the store employees for *Final Fantasy VII*? We did that a lot.

We also had a launch event here in the Bay Area at one of the malls. I don't know if Sakaguchi-san made it to that one, but I know my boss Junichi Yanagihara came up. There was a long line, and we gave away posters and goodies. That was really our only way back then how to see for ourselves if people were coming in to buy the game on day one or over the weekend, and to hear responses from people with our own eyes and ears. We definitely did our share of checking in at retail environments.

I think it was kind of reassuring, and also those were the moments that made us very happy and proud that we were part of a huge release.

Craddock: You obviously knew that FF7 was a big deal while you were working on it, but did you ever think it would make such an impact that you'd still be asked by people like me to talk about it 20 years later?

Kyoko Higo: Now that I've been in games for 20 years, I realize I do owe a lot to [that experience]. A lot of it was just getting *Final Fantasy VII* out. It was primarily marketing, but also getting to tap into the in-between of QA and localization, seeing how strategy guides are made, building a website. I owe so much to that project. It gave me the opportunity to view our department and our primary role as marketing from a very different angle. We were such a small team, so we all worked on so many things at once.

I've been an independent so I can't speak on behalf of other marketing professionals in our industry, but now you might be wanted for a very specific role or task or discipline, even within marketing. You have social media, you have

channel marketing, retail marketing, and all that. Back then I was able to work on so many different things that exposed me to the entire chain of events of what marketing is and has to go through to get a game like that, of that scale, [launched]. I was able to see that firsthand. It was a very precious and priceless experience for me.

After that, as the company grew, we started to form in our departments in a [structured] way: we had sales, we had marketing. We became more structured and legitimate. I think with the experience of shipping *Final Fantasy VII*, we were able to share and pass on that experience to our new hires, and build bigger teams. There's so much experience that I owe to that product and company.

Craddock: Outside of the gameplay and the advancements it made as a cinematic experience, it also changed how video games were marketed.

Kyoko Higo: Trying to market or communicate a video game product through, or using that cinematic appeal that you're going to get as part of the experience, is something that *Final Fantasy VII*'s campaign did really well. A lot of people probably wouldn't have thought you'd get that experience playing a video game, but if you sum it up, you do get those moments where you're just in awe. You're not just playing a game anymore. To try and communicate that in a print ad, the mediums available to us, it was so difficult to get that point across. I think the VII campaign did that really well in an elegant, sophisticated, and bold way, but not being too highbrow about it.

It spoke to the audience enough to make you do a double take: Wait, what was that again? It wasn't too foreign in that sense. You were intrigued to where you wanted to know more about it. It wasn't the type of campaign that was so in-your-face or matter-of-fact. I think that kind of mystique or appeal is something that the VII campaign did really well.

12

Meagan Marie
Senior Community Manager
at Crystal Dynamics

Meagan Marie is living proof that dreams do come true—if you do as *Game Informer*'s editor-in-chief requests and go to college, and then reapply to your dream job. Persistence pays. Marie has persistence to spare. Crystal Dynamics' senior community manager since 2014, Marie grew up idolizing Lara Croft. Now, she helps shape the direction of the *Tomb Raider* brand and Lara's character, as well as record Ms. Croft's history through endeavors such as the excellent *20 Years of Tomb Raider* hardcover book.

Marie and I talked about her path into the games industry, why she admires Lara Croft, and how her crushing disappointment at being turned down by *Game Informer* spurred her to try again.

**

Craddock: You've been involved with Crystal Dynamics and *Tomb Raider* for several years, now. What captivated you about games, and about Lara Croft and tomb raiding in particular?

Meagan Marie: I've been into gaming my whole life. I don't remember not playing games; the farthest reaches of my memories are gaming related. My brothers and I played games together. Even if they weren't co-op, one of us would have the controller and the others would shout "Do this!" or "Use this spell!" and so on.

My dad brought home *Tomb Raider* one day, and it was sort of the first time I had ever really seen myself in a character. Certainly there had been female characters in games before, but seeing Lara on the front of the box, this incredibly intelligent, brave, and adventurous woman, and watching her

story unfold, resonated with me and inspired me throughout my formative years. My brothers thought it was cool, but I don't think they had the same connection I did because it was rare to see that sort of [female] representation. I guess the rest is history. I've always followed *Tomb Raider*; it's been meaningful in my life since then.

Craddock: What qualities did you feel Lara had as a female lead that other video game heroines didn't?

Meagan Marie: At the time, it was the fact that Lara was very well-realized and a recognizable woman, in charge of her own adventures. *Ms. Pac-Man* is a female-esque character, and Samus' [Aran] gender wasn't front and center. Having Lara out there as this beacon, representing femininity and having all these aspirational qualities kind of made her such a perfect character for inspiring someone of my age. She had all those qualities: intelligent, adventurous, brave. She also had this unique duality of being an aristocrat but loving to play in the dirt and get her hands dirty; she could pick up and go wherever she wanted in the world.

The combination of her being this very feminine character and having all these qualities I liked. It was an inspirational combination at the time.

Craddock: How did you get started in the games industry?

Meagan Marie: One of my motto is "always live your passions." That's why I love cosplay so much: you're putting yourself into the shoes of the characters and worlds that you love. On Myspace, I geeked out over everything. I looked into coding so I could customize my background; I liked music and all that sort of stuff for my page. I connected with several other like-minded women, and I started doing freelance work for The Girl Gaming Network. It eventually became the Girls Entertainment Network.

That was going through college and honing my writing skills. I knew at that point that I wanted to work for *Game Informer* magazine. They were based out of my region and it was a magazine I read regularly growing up; GEN was a great opportunity for me to hone my writing voice and get out there and get working.

I did that a lot through college. I paid my out way to events across the country; slept on the floor in a room with 10 other girls who were also trying to save money. It was a great experience, and a way to get your foot in the door.

Craddock: And did that experience lead to joining *Game Informer*?

Meagan Marie: I had read *Game Informer* for years. One day I looked at the return address on the label and realized it was basically 20 minutes away from me. I was floored by that, because I didn't really, at the time, realize there were opportunities to work in gaming in Minnesota, where I'm from. I made my mind up [to work there] when I was 16 or 17.

It's funny. I was talking about my Myspace page: my tagline was "Future *Game Informer* Editor." One of the staff editors saw that and we started talking. He told me they had an application for a spot open. This was when I was in college; I hadn't intended to apply until after I graduated. I went to school for graphic design, journalism, and mass communication. I figured I'd write for the magazine or do layouts for them, and if that didn't work out I intended to go into UI design in gaming.

I remember I stayed up all night playing *Dirge of Cerberus* so I could write a mock review to submit with my application. I remember getting a call from Andy McNamara, the editor-in-chief. He told me that they were, unfortunately, not going to hire me. He wanted to tell me over the phone because he wanted me to finish college. He said, "This is very important. A lot of us kind of got into the magazine and writing by bypassing college, straight into our careers. You're in the middle of college and we want you to finish."

Craddock: Oh, wow. I... wow. I guess on the one hand, Andy was right: This business is precarious and slippery, so you always want to have a Plan B. But that must have been hard to hear.

Meagan Marie: I remember being devastated at the time. I thought I had my dream job slip through my fingers. I finished school and kept working really hard, paying my way out to events, writing, building my portfolio. I sent them my resume and application again two days after I graduated. A couple of weeks later I got the gig, and launched right into working for them for several years.

They told me that they liked my writing and my application and everything, so I did feel like I had a good chance when I reapplied. It just gave me that extra fuel to make sure I worked hard and was prepared. In retrospect, I'm glad they turned me down. At the time I was seriously devastated. I remember getting the call and I was in a public place, a lounge or something in one of the dormitories. I just started crying, like, "Oh, god, no! It's over!" Obviously that was just me being dramatic.

I'm really glad, looking back, that I stuck with it and graduated. There was a lot of stuff I learned [in college] that was applicable. Even though I was an editor at the magazine and did writing, I heavily contributed to graphic design with my own story. I designed the *Gears of War 3* cover story hub [online], and the InFamous cover story hub. I was very self-sufficient in terms of being able to do my own graphics for online stories, so I'm glad I stuck with it.

A lifelong fan of Lara Croft, Marie was ecstatic to play a part in *Game Informer* magazine's reveal of the character's new look and origin story.

Craddock:	The fact that you stuck it out is testament to your belief that your passions would help you carve your path.
Meagan Marie:	I guess they have. It goes back to what I said about living your passions, and I'm not capable of not living my passions. My parents are super supportive. When I got the *Portal 2* cover story, my mom read up on Portal, and she knows nothing about gaming, really. We would drive by a billboard, and she saw a *Portal 2* ad and said, "Oh! The cake is a lie! The cake is a lie! Right?" They're always super supportive.

My dad, once, was very well-meaning. I was starting to apply for jobs and hoping the *Game Informer* thing would work, and he said, "You know, you're great at making these costumes, but I hope employers don't think that's strange. You've got to be aware of your public image." I appreciated it, and I said thank you, but I've always felt that level of living your passion—in my case, being geeky on all fronts and being unapologetic about it—shows that you're involved with the community.

You work in gaming, too. Gaming and tech can be very demanding industries. Having passion is a really important thing for employers and partners [to see].

Craddock: In prepping for our chat, I was reading up on you and realized you wrote the *Tomb Raider* 2013 cover story. That must have been huge for you. How did you land that story?

Meagan Marie: I heard rumblings. I had my first cover story, which was *Portal 2*, and I think it went really well and I felt ready for another one. I heard rumblings there was a new *Tomb Raider* game. Eventually Crystal Dynamics came in and pitched the team on it. We all sat around saying, "Is this something we want to take on as a cover?"

Andy's an amazing guy, totally rational and supportive, but I was ready to march into his office and say, "If I don't get this, I'll quit." It never would have come to that; they knew that if there was anybody on the staff who was qualified to write a *Tomb Raider* cover story, it was me. I think the team at Crystal actually hoped I would. When they came in to pitch, they saw my desk, which was basically a *Tomb Raider* shrine: all my toys and statues and so on. They knew I knew my stuff and that I was a big fan, but the pressure was incredible. I don't think I'd agonized over anything quite as much as I did that cover story.

Cover stories in general are a huge amount of pressure, because you're unveiling something to the world and you hope that you do it justice; it's the culmination of so many people's hard work. To take so many people's stories, put it into a several-page spread, and try to capture the heart of their work, is so much pressure. Combining that with a love for the franchise and wanting to do it justice made it very, very intense.

I remember the first time they showed it, I was surprised by the direction. Like, oh my gosh, this is so different. But I was on board. I was on board pretty much immediately. I heard the direction they wanted to take it, and how it would be the first step in evolving Lara as a character, [and] I got it. It was a very genuine passion that I felt from the first time I saw it.

Craddock: Before we move on to your work at Crystal Dynamics, I'm curious about what you wanted to see from a reboot. It was a controversial game for a lot of people, because there was a lot less tomb raiding in *Tomb Raider* than they expected. What did you want from the game?

Meagan Marie: What I really connected with in terms of the reboot was being there for her formative years. You got a taste of that in [*Tomb Raider*] *Legend* with the plane crash; you saw Lara being that globetrotting adventurer who prefers the isolation of tombs to high society. Seeing her as a younger woman in a modern age, seeing her hold a smartphone and having Beats by Dre in her ears—it made her more identifiable to me. I still knew and understood she was going to become this great character, and that she is already an extraordinary person. Being privy to experiencing those [formative] moments that made her into an iconic character was something I thought was incredible and a privilege.

Craddock How did you make the jump from *Game Informer* to Crystal Dynamics?

Meagan Marie: It was totally out of the blue. I wasn't expecting a job offer at all. I think I clicked with the *Tomb Raider* team, and they'd been looking for a community

manager. Knowing that I knew the franchise so well, and that I had a background in communication and writing, made me an ideal candidate.

It didn't take very long. The cover story debuted, and I accepted a job to move out there four or five weeks later. It was a huge life change; it was scary moving across the country. But it felt right. I always say that *Game Informer* was my dream job, because it was. I absolutely loved working there; they're a great crew of people who are all very proud of their work.

But Crystal Dynamics was the dream job I never dreamed of. I never thought I'd be working on the [*Tomb Raider*] franchise, and with a character that inspired me. Lara inspired me and helped dictate my career. Now I get to weigh in on her future, and that's not lost on me. It's an incredible trade-off.

Craddock: What were your earlier initiatives at the company?

Meagan Marie: One of first things I did when I started at Crystal was try to start formalizing aspects of the community and give them more structure so we could look at them as an entity. The easiest way to reward fans for their hard work is to give them visibility: to say hey, we've seen this, we love it, it's incredible.

I created the official fan site program, which has been running for about five years now. Fan sites apply to the program; there are very relaxed conditions: you have to post an original news post or something at least twice a month, just so we know we're not giving you exposure only for you to abandon your site. They join the program, they get an official badge marking them as an official fan site, they get access to an FTP with all these assets, they get first looks at unreleased assets, they get a yearly goody bag.

We're trying to increase [benefits] for things like private dev streams, access to events, fast passes to get through lines, and so on. That's something we're really proud of. We operate as a pretty lean community team: it was me for the first four years, and now I have someone who helps out; her name is Robin Huey. Since we operate lean, our fan sites are so important to us. They're able to help us translate things for people in different markers where we might not have an official Square Enix office, and we put together our FAQs based on that.

It's been a really rewarding program. We have fan sites everywhere, from Iraq and Australia to New Zealand and all over the world. We have tons in Brazil, tons in the Czech Republic. It's really rewarding working with them.

When it comes to cosplay, we started a feature called Croft Couture, which was showing off some of the regular cosplayers in the community in features online. That's evolved into an ambassador program, and a new program kicked off last year. Robin and I have been working at updating it and tweaking it, and we're very happy with how it's turned out.

Up until [*Tomb Raider*] *Underworld*, there were official models. That's something we've moved away from because we wanted Lara to represent herself in-game. But there was definitely a hole in conventions for fans wanting to meet someone who embodies Lara: to pose and take pictures with her, and so on. Cosplayers apply, and we select them from around the world and hire

them to represent Lara at local events. This year we hired two: a classic Lara and a reboot Lara to show the progression of the franchise.

It's been great because you give a lot of the community members a chance to be recognized for their hard work. Plus they always speak the local language and they look like their local audience; it shows that Lara Croft is a state of mind more so than a specific [physical] appearance. We can all be Lara. I like that, both from a personal perspective and how it's united the community.

We also highlight lots of user-generated content. We're constantly show-casing fan art, films, and stuff like that.

Craddock: I'm very excited to read your *20 Years of Tomb Raider* hardcover. Was that project given to you, or did you push for it?

Meagan Marie: I put together a wish list for Lara's 20th anniversary; this was around two years ago [2014]. It [a book] was one item that had always been on there. We were working with our partners and decided to do this book with Prima, a fantastic partner. Really, I think what happened is when I would talk about it, I was very enthusiastic and they picked up on that. We would talk about ideas, looking for authors, and so on. I started talking about what an ideal structure for the book would be, who we should talk to for interviews, and so on.

Eventually they said, "So, how involved do you want to be with this, Meagan?" I paused and said, "How involved can I be?" They said, "Well, if you want to write it, you can." I asked my bosses, and they approved. It was a project on nights and weekends. It was a very tough timeline to turn around the entire thing: over a period of five months, and about a month of editing, looking at layouts, and so on.

It was just an amazing experience for someone who's been a fan for so long to get to talk to so many people I've looked up to.

Craddock: So you were juggling your everyday duties at Crystal, and writing the book? What was that schedule like?

Meagan Marie: I had to establish a pretty strict schedule. I just needed to basically set a sched-ule that I knew I could stick to every day, that I knew was optimal for myself. I chose to write in the mornings, when my brain power is the highest. I would come in at 3:00 a.m., and I would write until 9:00, work until 5:00, and then write from 5:00 until 7:00 or 8:00 p.m. and then crash out for a few hours.

It was a pretty rigid schedule, but it definitely worked best for me. I could approach writing every morning with a clear mind and tackle it that way. I put in 12 or 13 hours, if not more, on the weekends. It was definitely very, very intense. I worked at work because if I had to work at home, being so close to my bed would have been a little tempting: "Oh, I think I'll just take a nap."

It worked well, once I got the schedule underway. I have to give my boy-friend some credit. He made sure I stayed alive and took care of all the house stuff. He was like, "You focus on writing; I'll get you some dinner." I had such a great support group. It was very intense but very rewarding. We had a tight timeline, but I had a friend who worked downstairs at DreamWorks. She'd text me: "Meagan, have you eaten?" I'd say no. She'd bring me a

peanut-butter-and-jelly sandwich because you just kind of get into a zone when you're writing, and it's difficult to think of stuff like that. My group of friends all got their own thanks in the book, because they played a very important part of making sure it got published.

Craddock: I'm always interested to talk to fellow nonfiction writers about how they find contacts and score interviews, especially ones that make or break a project. What was your process?

Meagan Marie: This being my first time writing a book, I have to admit that was one of the biggest surprises: how little time the writing actually took. It was the organization [that took longest]. I put together a comprehensive table of contents that was maybe 800 cells in an Excel document. That helped give me a structure right away.

It was finding people—getting contact information, reaching out to them, scheduling interviews, conducting interviews, transcribing interviews, and so on—that took so long. Then, once I had all of that information, I could finally start writing. That was definitely a surprise to me: how long all of that took.

I broke my months down into milestones. I worked backwards: I started with the end of the book, which is an appendix, then I went to fans, movies, comics, and games, because that gave me the most amount of time to seed interviews for bigger sections, particularly games. I would spend the first two weeks of every month just coordinating everything. Once everything came together in the last week, that's when I sat down and banged out writing.

I tried to tackle sections as I could: If I had all the interviews, or if there was a side bar with someone, but it was definitely difficult to manage. There were 60 key contributors—people I interviewed from games, comics, and so on. Then there were 250 contributors in terms of people contributing assets. For a single cosplayer photo I have to get permission from the cosplayer and the photographer.

Thank goodness for DocuSign, being able to sign and send release forms digitally. But on top of that I did have to manage over 300 documents with signatures, asset release forms for things. A lot of these assets were so old, you didn't have them at high enough resolution or you didn't have them at all. Asset management was absolutely an incredible undertaking, but I think as a result we ended up with some really fantastic assets.

One I was particularly proud of was finding an image of the *Tomb Raider* race car. I used archive.org to find stuff on classic *Tomb Raider* and classic sites, fan sites, and so on. The problem was most images were thumbnails, too small to use [in a book]. I'd think, *I know there must be a larger image of this.* So you take the thumbnail, you try Google Image search to see if anybody has it at a higher resolution. A lot of times, because these are 15–20-year-old assets, that's just not possible.

I found a thumbnail of the *Tomb Raider* race car and I knew I needed a bigger picture because it's just so cool. It took weeks of digging around. Eventually I found a racing forum where a photographer had been at that

race, so I had to create a forum account in this racing forum to reach out to this guy. It was just this long process, but funnily enough, once I got this email address he responded to me within a day and said, "Yeah, go ahead and put the photo in the book. Here's a bigger resolution." It was such a small victory, but so funny because it was incredible how much work it took to get that one photo. I think it was worth it.

Craddock: What were some of the most interesting things you learned?

Meagan Marie: I think one of the most interesting conversations was an interview I did with the set dresser from the movies. She was just wonderful. Her name was Sonja Kraus. I've never been involved in any sort of Hollywood production, even tangentially, so it was really cool to learn about all the thought that went into everything. How you source four containers full of props from China so you can shoot in the Pinewood studios in London, and sending buyers places. She would travel with everybody and make sure the sets were dressed at every location. Their experience filming in Cambodia as the first film crew there in decades, and so on.

I felt I got a lot of interesting anecdotes from her.

It was really great talking to Jeremy Smith, creator of Core Design. He's so funny, and very honest. It was great learning from him. Richard Morton, one of the designers on several of the games, had some great stuff and unpublished design docs and so on. It was really cool to add a section based on games that never were, based in large part on my conversations with him and Richard Morton, who was the writer on [*Tomb Raider*] *The Angel of Darkness*. They had all this great content on what was going to happen with the Angel trilogy, and another idea for a game that was never even talked about.

Learning all these different things, considerations for the franchise, was really cool.

Tomb Raider (2013).

Craddock: Has working on the Lara Croft brand these past few years changed your perception of what the character represents, or should represent?

Meagan Marie: At some point you feel like you can't have any more affinity for a character, but working on this book did make me love Lara even more. She continues to be so inspirational. Seeing all of the work, all of the effort that has gone into making this character being able to stand for 20 years, is incredible.

Also talking to fellow fans, and seeing these "Dear Lara" letters where fans wrote to her as if she were a real person, and say thank you for things she did to inspire and help them, really affirmed my own feelings on her. It's an honor to work on the franchise every day, and to work with Lara. She continues to inspire me.

What I love about the reboot of Lara is that she's not perfect. She doubts herself at times and doesn't always have the answers. I feel like that's so relatable. To have a character who is so relatable but still so inspirational in so many ways, and so competent and capable and honest, is great.

Index

Page numbers in *italics* refer to Figures.